WILDLIFE PHOTOGRAPHY

The Art and Technique
of Ten Masters

Edited by Ann Guilfoyle

Text by Susan Rayfield

AMPHOTO

American Photographic Book Publishing
An imprint of Watson-Guptill Publications
New York, New York

This book was conceived and prepared
under the supervision of AG Editions.

First published in 1982 in New York, New York by
Amphoto: American Photographic Book Publishing,
an imprint of Watson-Guptill Publications,
a division of Billboard Publications, Inc.
1515 Broadway, New York, NY 10036

Library of Congress Cataloging in Publication Data

Guilfoyle, Ann.
 Wildlife photography.
 Bibliography: p.
 Includes index.
 1. Nature photography. 2. Photography of ani-
mals.
I. Rayfield, Susan. II. Title.
TR721.G75 778.9'3'0922 81-20609
ISBN 0-8174-6417-4 AACR2
ISBN 0-8174-6418-2 (pbk)

First Paperback Printing, 1987

Manufactured in Japan.

3 4 5 6 7 8 9 / 93 92 91 90 89

Introduction

The men and women in this volume represent the best of wildlife photography today. Although their temperaments and techniques may vary widely, all share a fascination with the natural world, an ever-renewable sense of wonder at life around them, and a desire to convey their experiences to others, through the medium of film.

Some are biologists or scientific researchers, others bring to their work years of personal field observation. Several have traveled to remote wilderness areas in search of their subjects, many have found an equally rich world in a backyard patch of grass. All have a deep respect for the wildlife they document, and are committed to its conservation.

Finally, they are superb technicians, willing to reveal here the knowledge they have gained from years of professional experience. Yet there is a quality to their work that transcends technique and experience — an almost mystical bond between the eye and the hand, between what is perceived and the image recorded. Their sensitivity to the natural environment can be evoked by a fresh insight into an animal's behavior, or simply by the quality of light, color, patterns, shapes, textures, feelings of the moment, memories. It is this difference between merely looking and truly seeing and feeling that marks them as being among the best in the world.

Each has a personal statement to make about wildness, the wilderness, and the creatures that inhabit it. Their observations, and the photographs on the following pages, are eloquent testimony to that special vision.

Susan Rayfield

Contents

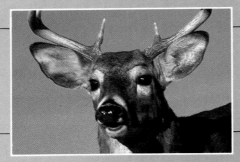
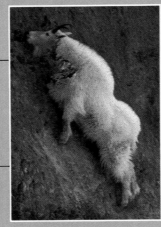
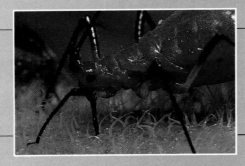
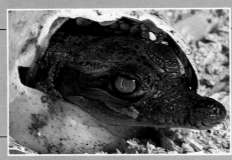
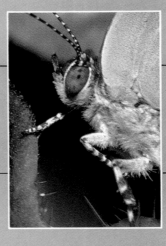

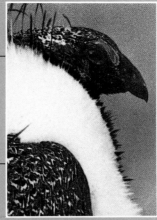
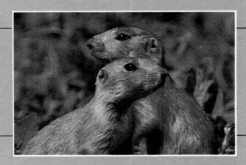
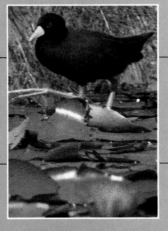
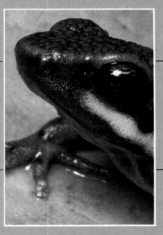

The Photographers

LEONARD LEE RUE III
Animal Portraitist

Leonard Lee Rue has a special way of communicating with animals, and often seems to capture the essence of their personalities through his lens. He always gets to know individuals in the course of his work, recognizing certain deer by their antler development, and squirrels by the notches in their ears, acquired in territorial fights. "I'm a portraitist," says Rue. "I live with my animals. Anyone seeing one of my photos need never again wonder what that animal looks like."

A self-taught man who dropped out of high school, Rue has been documenting the life history of animals for 35 years, and is one of America's most prolific wildlife photographers. He shoots 50,000 slides a year and prints as many as 600 black-and-white photos a day for magazine and book editors around the country. His work appears in at least 50 publications a month, and he once had five national magazine covers at the same time. His pictures have appeared in *National Geographic, National Wildlife, Audubon, Outdoor Life, Field and Stream, American Forests, Natural History, Time,* and *Newsweek,* as well as most state conservation publications and many encyclopedias, textbooks and calendars.

He is an active spokesman for wildlife conservation, and when not photographing animals, gives slide lectures and seminars, and conducts field trips and outdoor education workshops at summer camps. He is the author of 18 books, illustrated with his own pictures, on such subjects as the red fox, raccoon, beaver, ruffed grouse and his most recent, the white-tailed deer. Rue has been studying deer for 30 years, and for that volume alone took over 25,000 photographs. Often Rue has to sit for many hours at a time waiting for action. Reading or constructive writing breaks up his concentration, and he knows that the moment he takes his eyes away from the shooting hole he is likely to miss something important, so he uses the time between photographic events to take copious observation notes. Such is his passion for gathering field details that Rue was once found sitting on a sleeping bull walrus, recording the size of its flippers. "I'll measure any critter I can put my tape on," he says, "so I will have accurate data for my books." The walrus never even woke up.

Long before Rue became a photographer and writer, he was a naturalist. Raised on a hilltop farm near the Delaware River, just 20 miles from his current home in Blairstown, New Jersey, he trapped foxes as a boy to help supplement his family's income

Caught by surprise 2,000 feet up a cliff in Colorado, a young mountain goat played hide and seek until the photographer anticipated its direction and they met on the other side. This is Rue's favorite picture of his favorite subject.

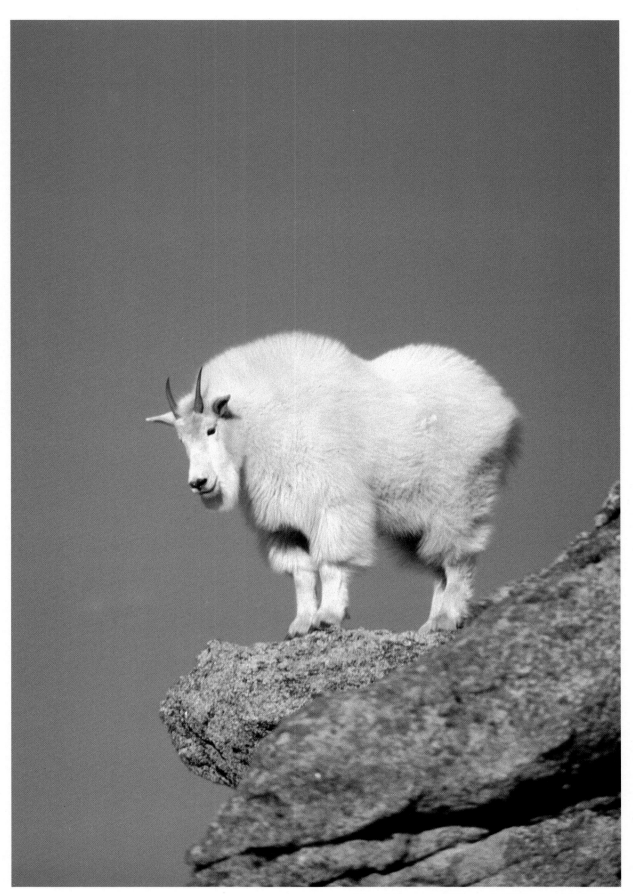

Mountain goat: 600mm, 1/125 sec., f/11, K 64

during the Depression. This led to his lifelong interest in natural history. Later, he worked at cutting timber, and spent 17 years guiding canoe trips through the Canadian wilderness. He bought a box camera when he was 11; by the age of 19 he was writing a nature column for the *Washington Star*.

Hazards

His interest in wildlife photography has taken Rue from the mountains of Argentina to Africa's plains. He has made three trips to Europe, five to Alaska, and recently returned from a journey to Nepal. Wherever he is, Rue finds that cruising the roads, binoculars at hand, is the most efficient way to spot wildlife, and has trained his eyes to separate mountain goats from patches of hillside snow, and to find a deer among a tangle of brush. Rue always gets close to his subjects, using the shortest practical lens, which has led to some hazardous encounters. He has been charged by rhinos, elephants, and a wounded cape buffalo, but feels that bears are the most dangerous of all because they can pursue him anywhere—on the ground, in the water, or up a tree.

Every animal has a flight and attack distance, and Rue has learned to recognize the danger signals. "I remember one time I was working up at Horseshoe Lake in McKinley National Park, Alaska," he says, "when I spotted two cow moose that were just over a year old, without calves, on the far side. I photographed them across the lake, and then they slowly made their way over to my side. I thought, 'Oh good, I can use a shorter lens.' I didn't push the animals at all. They went on down the path and one disappeared from sight, but the other one was browsing there, so I got on the path very cautiously and took a picture. All of a sudden, she turned around and started coming toward me. Now with moose the first thing that happens is that the ears go back, then the mane goes up and then the tongue comes out. And I mean, when you see the tongue you're going to be run over—no ifs, ands or buts. It usually works in that sequence. This one gave all three danger signals at once. I had quickly measured the distance in my mind between me and the nearest tree and knew I couldn't get to it; she was too close. I was going to hit her in the head with my Hasselblad camera, but as I brought my arm back the motion scared her and she veered off. I thought to myself 'My God, that's an $1800 rock I was going to hit her with!'"

Another time, Rue was photographing a trophy-sized bull elk in Yellowstone, and had to walk around one of the cows in the harem to get close to him. "When I came back she was still on the trail," he remembers. "I went around a couple of bushes and she went around some bushes on the other side. I figured it was a coincidence, and so I stepped back on the trail. She went back on the trail. Then I knew that she was stalking me. I looked for a big hunk of wood, and when

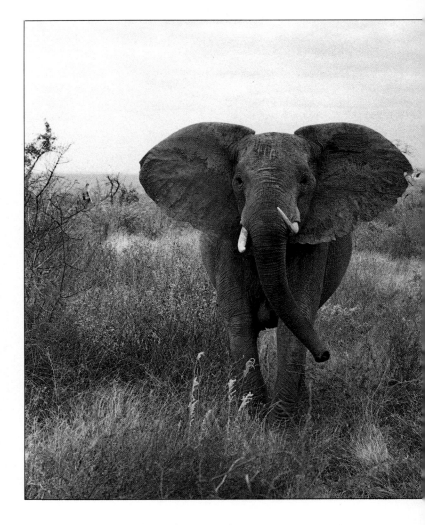

she heard me thrashing around, her ears went back and it was clear that she meant business. She started to come for me, but I stood my ground. She finally gave up that nonsense, but she definitely had plans to do me in. This is unusual for a cow without a calf. She was full grown and you know, if a deer can seriously hurt you by standing up and striking with its razor sharp front feet, one kick from an elk could split you from one end to the other. Now a moose will bite you; cow moose have been known to grab people with their mouths. But the most dangerous thing is when they rear up. A cow moose is six feet at the shoulder, and can weigh up to 800 pounds. If she hits you with one of those hooves—the damn thing is four-and-half inches across—let's face it, you're dead."

Wildlife Ethics

Most often, Rue's sense of caring and respect for the animals that he photographs is reciprocated. One day he watched as a half-tame deer lay down in the woods and began to give birth to two fawns. He waited quietly as she delivered the first, then moved in to record the birth of the second fawn. Afterwards, as the doe lay there exhausted and he continued to move around taking pictures, the fawns came up to him. "It was one of the most humbling things in my life to sit there with those two little guys in my arms," Rue recalls. "They were still damp, maybe half an hour old,

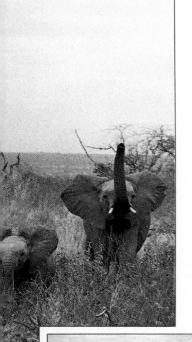

In the course of his career, Rue has been attacked by many animals, including elk, moose and bear. In Africa, he once found himself going full speed backwards as a rhino tried to thrust its horn through the radiator of his Land Rover. Here, in a remarkable series of pictures, a cow elephant is shown charging to within five feet of Rue's vehicle, forcing his retreat from the area.

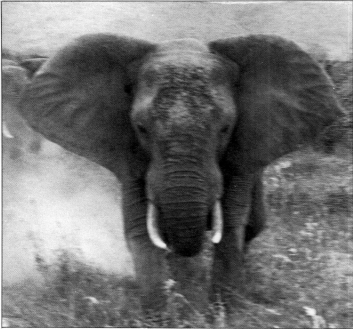

and so trusting, so totally fearless. It filled me with awe."

Since the female was partly tame, Rue knew that she would nurse them even after he had handled the fawns; otherwise, he wouldn't have touched them. Rue has lived with animals all his life, and has a strong sense of wildlife ethics. He does nothing that would attract predators or people to an animal and tries not to disturb their natural behavior patterns, believing that wildlife have enough problems as it is. Rue advises, "Never handle a wild fawn because sometimes the mother will abandon it. Don't uncover a rabbit's nest—open it with a stick, take your pictures, then cover it back up again. Don't cut down surrounding vegetation, tie it back. Don't bother birds on the nest in the heat of the day. If you keep the parents away, the eggs will quickly cook in the sun or in cold weather,

they will become chilled. When I'm photographing birds, if the mother has been off the nest for a while, I will not resume shooting as soon as she comes back, but will sit and wait for ten minutes, to let her warm those eggs up. You have to be very careful."

Equipment

For many years Rue worked with a Hasselblad, finally giving up its 2¼-inch format in favor of a 35mm single lens reflex system (SLR) after two customers on the same weekend suggested that he do so. Rue found that he was glad to get away from the grainy Ektachrome film he had to use with the Hasselblad, and now relies on Kodachrome 64 for most of his work, using high-speed Ektachrome 400 only in an emergency. For black-and-white, which is now shot by an assistant while Rue handles the color, he uses Kodak Plus-X Pan professional film, with Tri-X as a backup when a fast film is required. He shoots about 20 rolls of 36 exposures a day, getting an average of five acceptable frames per roll.

Professing a lack of technical knowledge about camera equipment, Rue claims, "My entire family are mechanics and engineers, but I have all I can do to put a camera on a tripod if it has a thread." Between one of his sons, his assistant, and himself, Rue owns 15 Nikon camera bodies and five motor drives, as well as a 24mm, 55mm macro, 80–200mm zoom, 50–300mm zoom, and 400mm and 600mm lens. His favorite long lens is the Nikkor 400mm f/3.5 ED, which is very sharp and fast for its size. He uses a 2X tele extender to double the focal length of the longer lenses when needed. Since all are different, Rue advocates testing each lens carefully before taking it out in the field. "You've got to know your equipment," he says. "When I buy a gun I

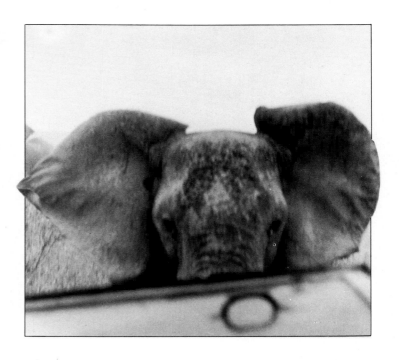

Leonard Lee Rue III *is the most published wildlife photographer in America. During his 35-year career as a working naturalist, he has been the author-photographer of 18 books, and at last count, the pictures in his files numbered well over one million. His portraits of animals in their environment have graced the pages of every major nature publication in this country and abroad.*

BLINDS

Rue does much of his work from blinds made of pipes and plastic, camouflaging them with natural materials to disguise them both from the animals and from people who might destroy or steal them. He plans to market his own design in the near future. Fourteen years ago, he built a permanent wooden blind along a fence on a private estate, where deer come in regularly to be fed. It is now so vine-covered that Rue must cut out the shooting holes every fall, and the deer have become so accustomed to it that they pay no attention to him, allowing Rue to get some unusual and intimate photographs.

Before setting up a blind, he determines the route the animals are using, knowing that he can't force them to go a way they never have before. He figures out when they are most active, what direction the light will be coming from, and, most importantly, which way the wind is blowing. Although scent does not frighten birds, it will scare off mammals. Rue recalls, "One day it was absolutely calm, and I could actually see my scent 'moving out,' and as my scent went out, the deer moved back. It was just as if you had pushed them back with a barrier." Sometimes Rue lures animals to the blind, using whatever food they would be finding naturally. He leaves the blind in place for a few days to allow the animals to become used to it, and always enters it early and stays inside until the animals have left, so that they never see him go in or out. When he has to be in an area before dawn, he builds a blind large enough to sleep in. To avoid some of the discomfort caused by hours of sitting quietly in one position, he sits on a small stool or folding chair, and warms the blind with a portable heater in cold weather.

Rue chooses his equipment, in part, for how quiet it is. Even when he is as silent as possible, the slightest sound can spook the animals. "I've clicked the camera and had the damn thing explode like I'd spun a firecracker out among them," says Rue. It is important that the blind not flutter or shake, as wildlife will get used to almost anything as long as it doesn't move. "The hardest thing to teach somebody today, especially kids, is to sit still," Rue says. "It's impossible for someone to remain quiet in the woods without training. I mean, don't scratch your nose, don't blow your nose, don't wiggle your foot, don't move your hand. I like to say, 'Don't just do something, *sit there.*' It's a discipline, and not many people have it. I can sit forever. I have all the patience in the world, I just don't have time to use it. I have lectures to give, books to write, places to be. Wildlife has forever, you know, we don't."

take it on the firing range to see where it is shooting before I hunt with it. It's the same thing with a new lens." Rue checks lens resolution by photographing a fur coat or a stuffed animal, and also checks the accuracy of the through-the-lens metering.

All of his equipment is either black or painted flat black to prevent it from reflecting highlights that might startle the animals. He always uses a lens hood to diminish glare, and keeps haze filters permanently on the lenses to protect them from scratches and dirt. Rue no longer winterizes his equipment after he found that it functioned in Yellowstone in winter, with a wind chill factor of $-100°$ F, as long as it was protected under his down jacket when not in use.

To ensure needle-sharp pictures, Rue does most of his work from a tripod, and claims to have two-inch grooves in his shoulders from carrying sturdy Gitzo and Husky models with him wherever he goes. With such a rock-steady camera support, he can go to a slower shutter speed and use a smaller f-stop. This gives his images greater depth of field, so that more of the picture is in focus.

Because he feels that flash gives an artificial look to many photographs, Rue avoids it whenever he can, using it only when he is forced to work at night or to stop fast action. Ironically, however, he received his greatest recognition for a remarkable nocturnal picture series of airborne flying squirrels, taken in the late 1950s. Since high-speed electronic flash units were not readily available at that time, Rue built his own speed light, powering it with a 12-pound car battery. It flashed at a 40,000th of a second.

Rue often sets up a remote-control release when he doesn't have the time or opportunity to use a blind. He uses lightweight stereo wire to cover the distance between himself and the camera. He photographs animals such as chipmunks by pre-focusing the camera at a spot near their entrance holes, and firing it when one of them comes into range.

Rue finds that when he gets away from handling his equipment on a daily basis, it takes time to become familiar with it again. "Only by constant use do you get to make the camera a subservient tool," he says. "Otherwise it can be an overpowering monster." He recommends that photographers settle on one type of camera and film and stick with it. "Don't experiment with everything that comes down the pike or you'll never know where you are."

Exposure

Rue owns several Nikon F3 camera bodies, which have both manual and automatic exposure control. He finds the automatic feature reliable for average situations, but prefers not to use it most of the time because, as he says, "it doesn't have a brain." If he is photographing a wild turkey in the woods, for example, the automatic metering device, which is center-weighted to read the middle of the picture, will give an accurate exposure for the dark bird, but the background will be washed out. Therefore, Rue disregards the turkey and takes a reading off the background, knowing if that reading is correct, the bird will also be properly exposed. Similarly, when shooting a snow scene or a white bird, he takes a reading off the brightest area and then opens the aperture one-and-a-half to two stops to get more detail. "You must know when and how to read the camera's meter," he says, "and you must know when to compensate."

He prefers to work with built-in meters, using a hand-held Luna-Pro for backup, but there are basic conditions for figuring exposure without metering. In the western United States, Rue's standard exposure for ASA 64 film, when there is bright sunlight on the subject, is f/8 at a 125th of a second. In shade, Rue usually opens the aperture one-and-a-half stops; he usually avoids a densely shaded situation, however, knowing that where there is little light, there is little color. On his own property he will even go so far as to selectively cut woods to open them up for more light. Conditions are brighter in the Western mountains and Rue, more familiar with the subdued light of eastern woods, sometimes has difficulty believing what the meter tells him. Out West, he usually shoots at f/11, in Alaska at f/16. He always uses the fastest possible shutter speed to minimize camera and subject movement, even if he must sacrifice depth of field, and brackets a half and a full f-stop on either side of the preferred exposure. "Film is far less expensive than my time," he says. "You may waste a little film by bracketing but you're coming back with what you have to have. That's what it's all about."

Advice for Beginners

Rue tells novice animal photographers to start in their backyard, beginning with something like wildflowers, to learn the basic techniques. He then recommends practicing with birds at the feeder, using the house for a "blind." When ready to try mammals, Rue suggests easy ones, such as squirrels in a city park, chipmunks at a camp ground, or woodchucks in a field. A woodchuck, or groundhog, is found in a localized area near its den, and has definite daytime hours. It will become used to a blind quickly, and so is easier for a beginner to photograph than shy, nocturnal deer. "My best advice for any aspiring wildlife photographer is to live with the subject as I have done. Nothing takes the place of knowing the animal," says Rue.

"People say I see the world through rose-tinted glasses, and perhaps I do. I look for beauty and I find it. My purpose is to photograph the beauty that God has surrounded us with so that others can see it and be made aware of it. Most of all, I photograph to be in the outdoors with the animals. I love my work. It is my life."

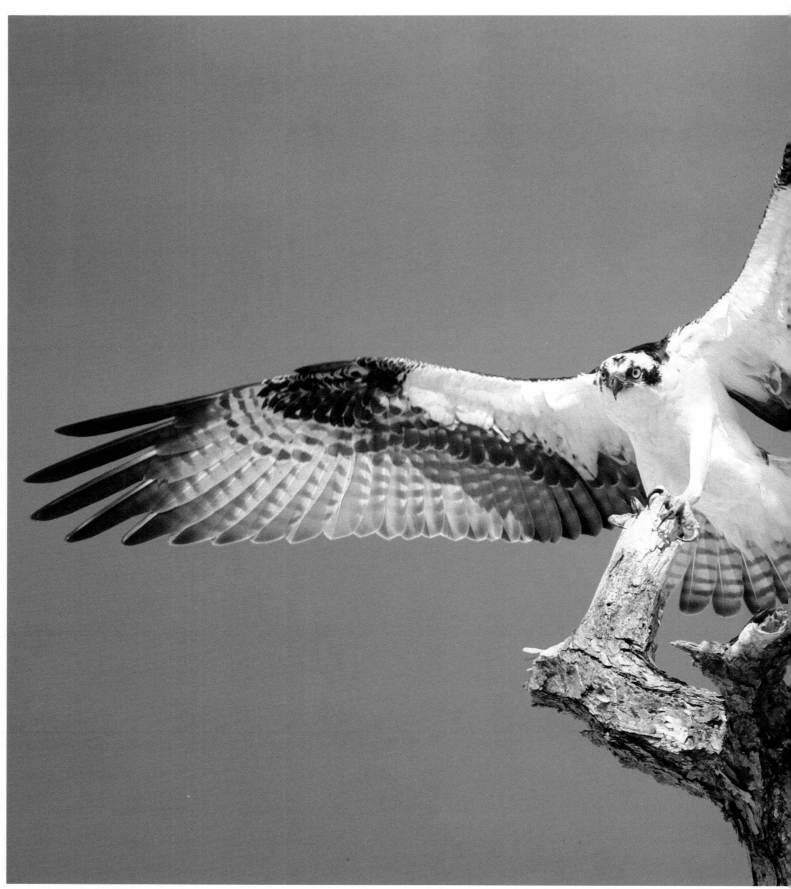

Osprey: 600mm, 1/250 sec., f/6.3, K 64

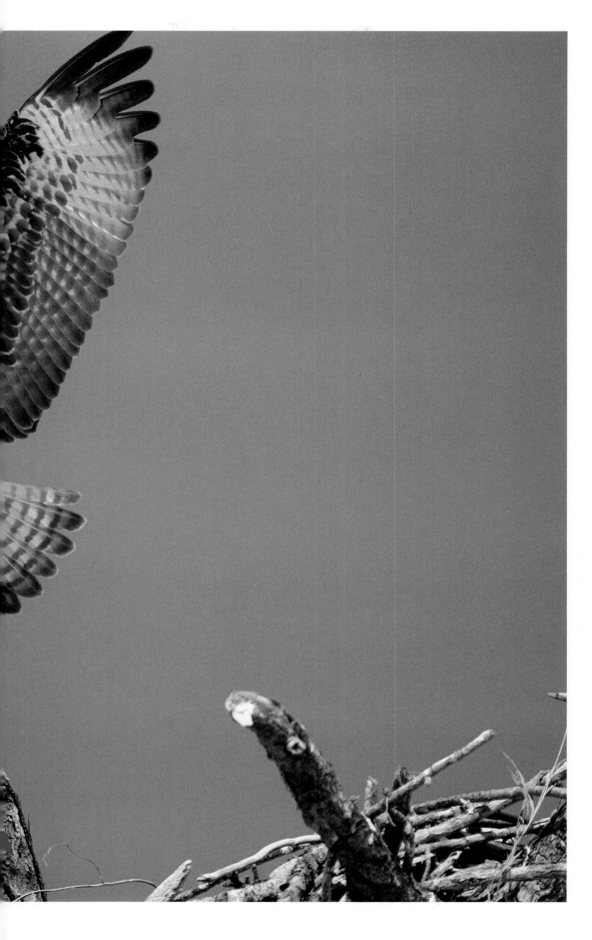

An osprey lands near its nest in the Ding Darling Refuge on Sanibel Island, off the southern coast of Florida. These large fish hawks, with a wingspread of almost six feet, have talons equipped with spiny projections that give them a firm grip on their slippery prey. Ospreys on public lands become accustomed to people and are often quite tame. Rue was able to photograph this one from 150 feet away, without a blind, prefocusing on a branch where the bird always perched before entering the nest.

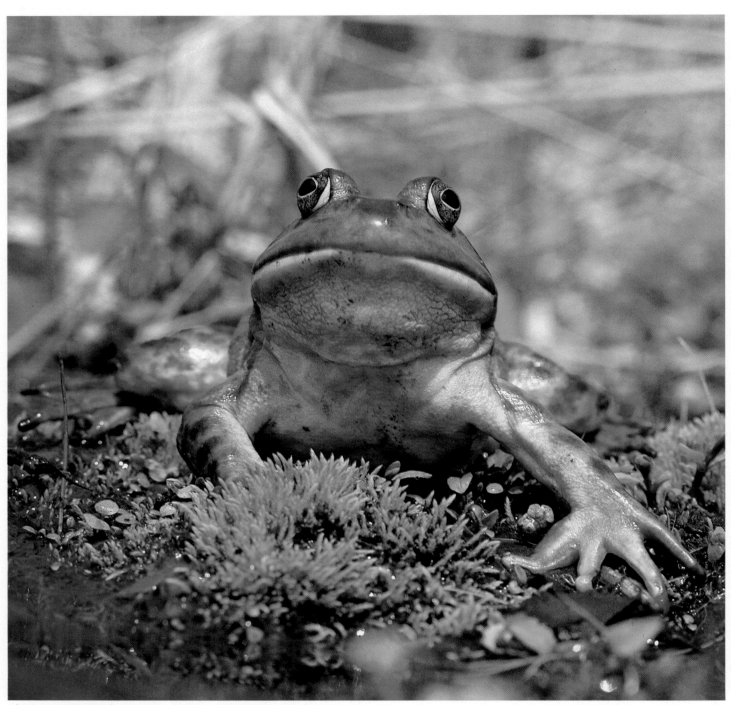

Bull frog: 80–200mm zoom, 1/125 sec., f/9, K 64

Often its habitat tells as much about an animal as the creature itself, whether it is a frog in a marshy pond or a raccoon up a tree. However, an arboreal fox is another matter. Although they can climb, this gray fox (top right) was treed by dogs. Rue photographed it on a sunny winter day, setting his aperture one stop higher than the meter reading to compensate for the bright light. He shot the young raccoon (lower right) at its den tree on his property, from 75 feet away. To photograph the bullfrog (left), Rue crept up slowly to within four feet, then lay in water up to his chin for a low-angle view.

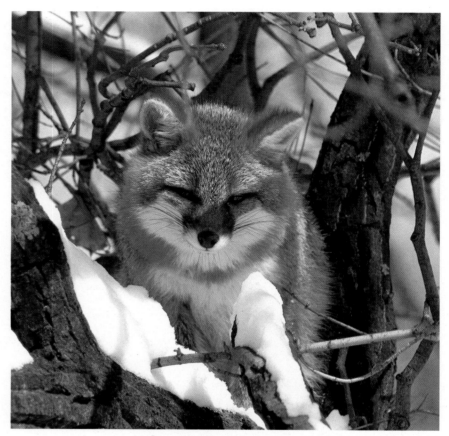

Gray fox: 80–200mm zoom, 1/125 sec., f/11, K 64

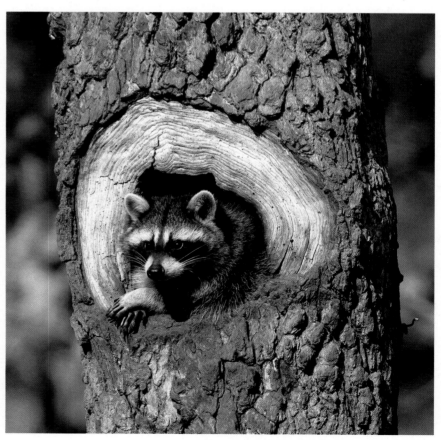

Raccoon: 400mm, 1/125 sec., f/9, K 64

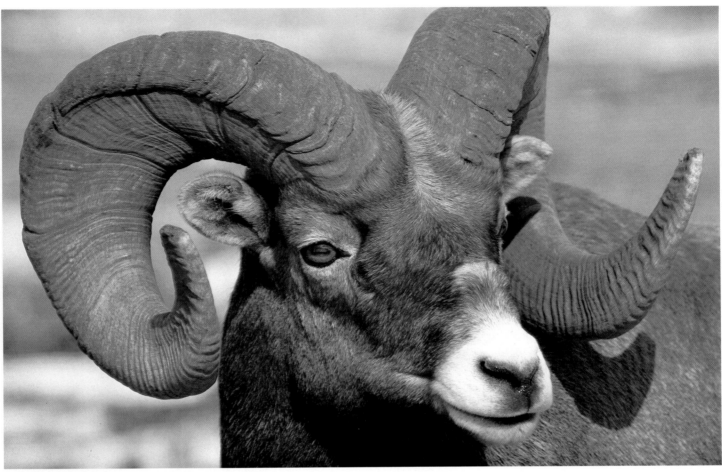

Bighorn sheep: 400 mm, 1/125 sec., f/11, K 64

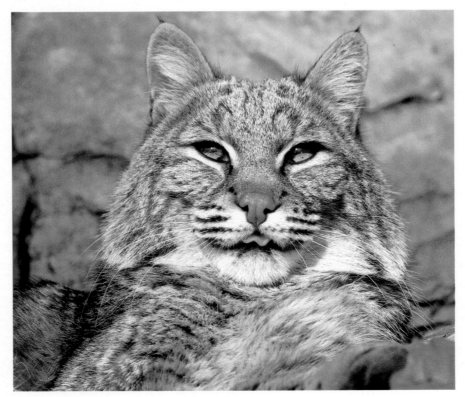

Bobcat: 400 mm, 1/125 sec., f/6.3, K 64

Rue is known for his classic wildlife portraits. "I don't get arty," he says. "I try to portray the animal at what I think is its most alert and attractive." The massive curl on the bighorn sheep (top left) shows that he is in his prime. During rutting season in the fall, rams charge each other at 20 miles an hour, crashing their foreheads together with a crack that can be heard more than a mile away. The bobcat (lower left) was semi-tame, and photographed in a compound. Its full ruff indicates that it is a male. Rue found the walrus on an island off Alaska, its skin pink from basking in the sun. He was able to approach to within 12 feet, being careful to avoid the animal's two-foot-long tusks.

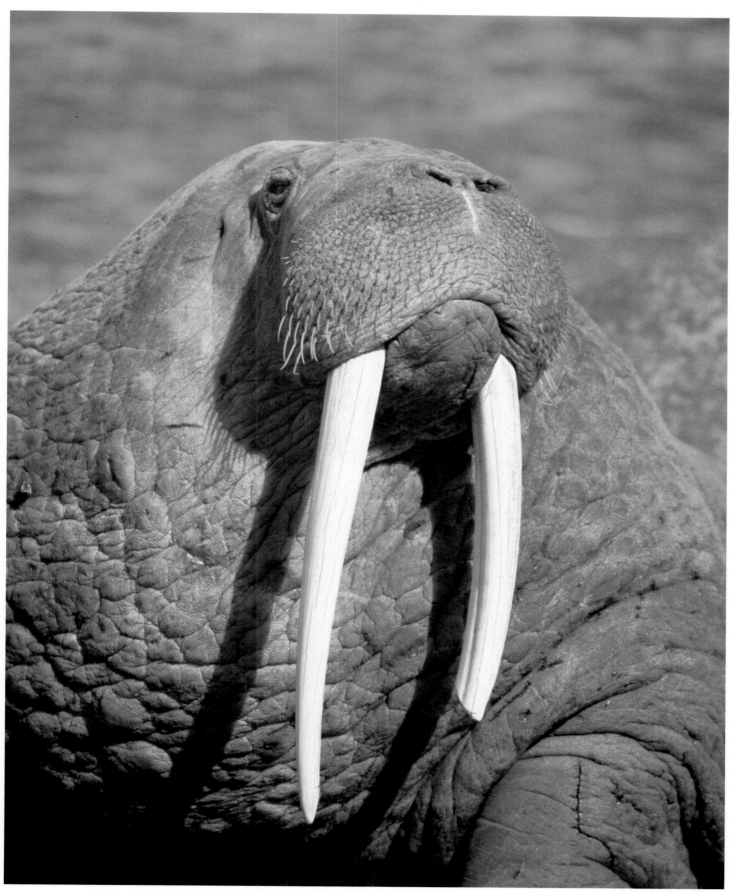

Walrus: Hasselblad, 150mm, 1/125 sec., f/9, E 64

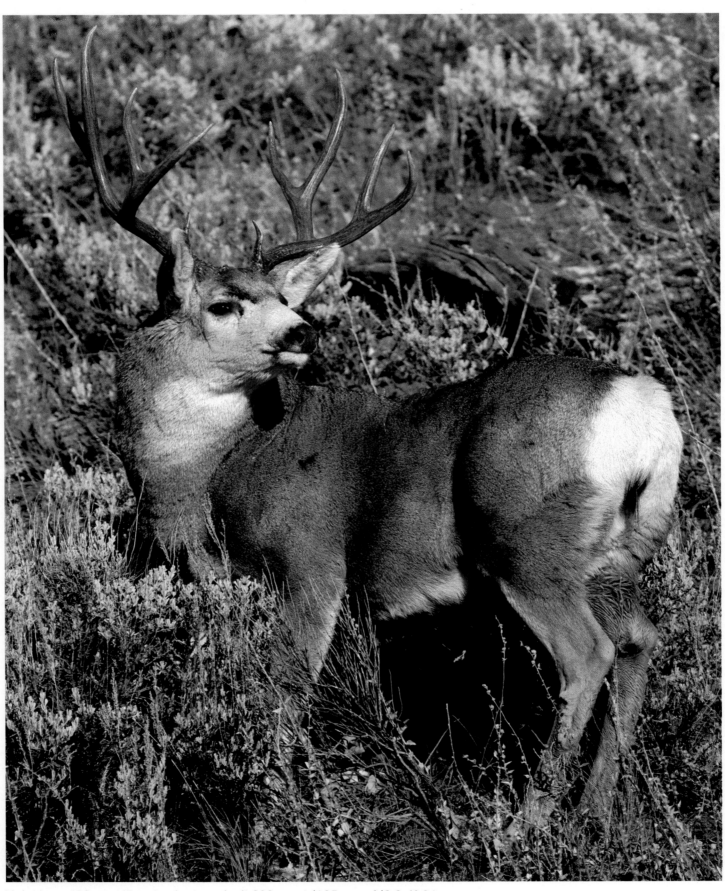

Mule deer: 400mm with extender to make it 600mm, 1/125 sec., f/6.3, K 64

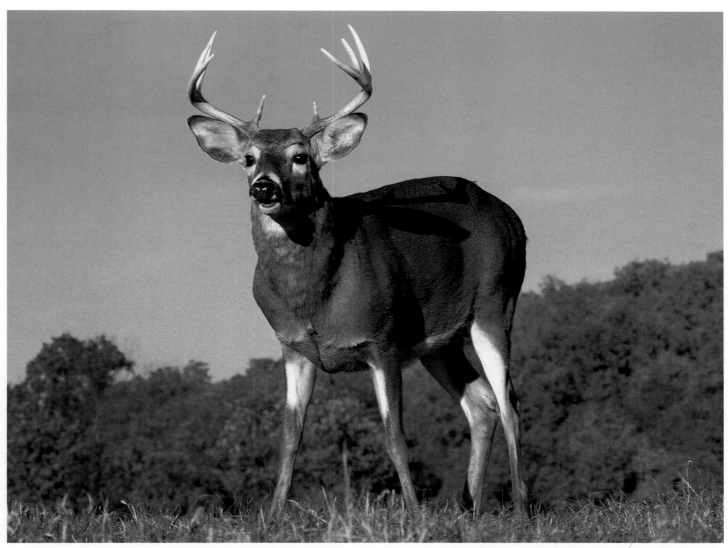

Whitetail deer: 600mm, 1/125 sec., f/6.3, K 64

Many sportsmen say they would like to find the same deer that Rue sees, but he seeks his subjects only in areas off-limits to hunting, such as refuges and private estates. There the animals are less wary and deer with trophy-size antlers can be found. The whitetail (above), dramatically outlined against a blue sky, was photographed in a Pennsylvania preserve, as it grazed in a field in the late afternoon. The well-camouflaged mule deer (left) was photographed in Yellowstone National Park, at the start of the rutting season in November.

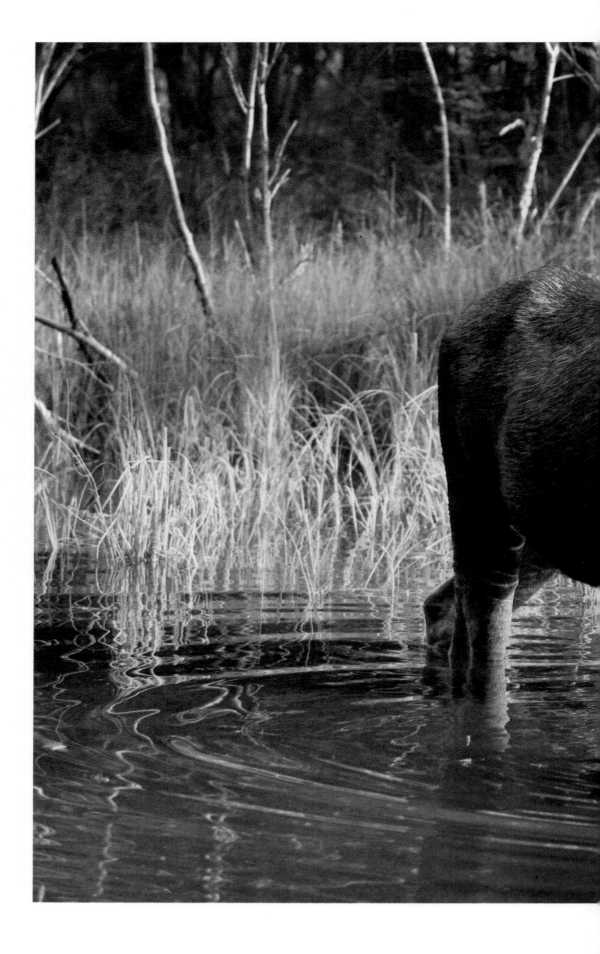

Rue considers this to be one of his finest moose pictures, published here for the first time. The cow had been browsing on underwater plants in a lake in McKinley National Park, Alaska, and her alertness indicates that she was either listening to approaching danger or attentive to a calf hidden in the bushes. The dappled light made exposure difficult but, as usual, Rue took his reading off the background and the moose fell into proper balance. One f-stop lower and the animal would have been overexposed, with no detail in the lighter parts.

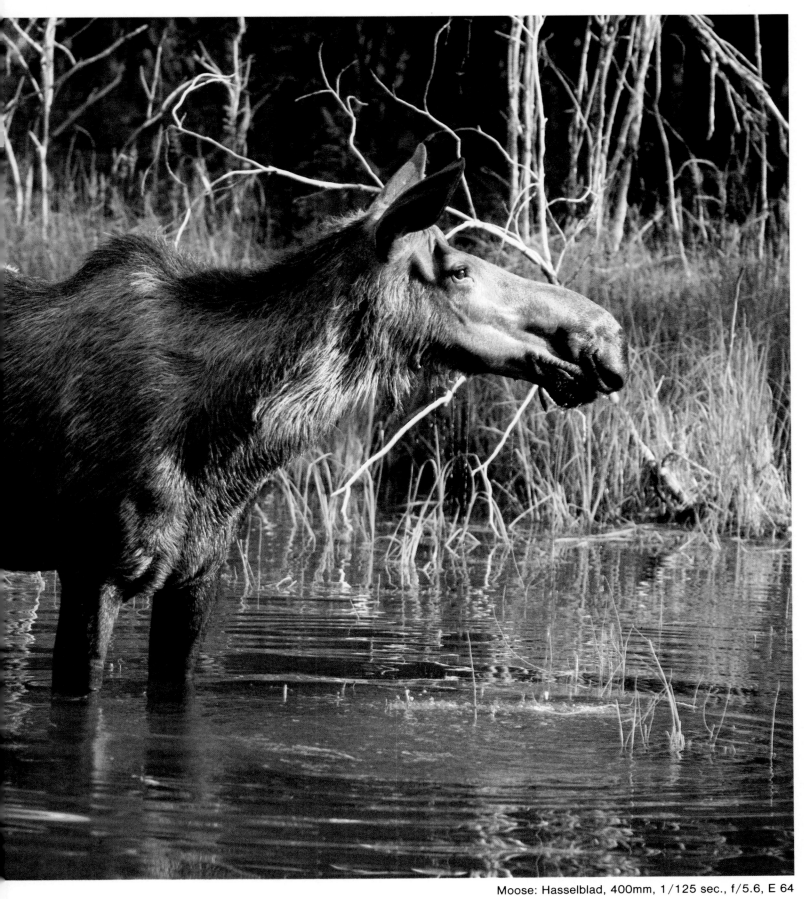

Moose: Hasselblad, 400mm, 1/125 sec., f/5.6, E 64

JEFFREY O. FOOTT
Wilderness Biologist

He travels along steep trails made by mountain goats and bighorn sheep, often moving 40 miles a day with a 50-pound pack. He has camped alone, sometimes for months at a time, in the most remote wilderness areas of North America. He sits in a blind, or against the side of a hill, for many hours, quietly watching the wildlife until they accept his presence as one of their own. Jeffrey O. Foott has lived in the mountains most of his life, and is completely at ease in the natural world he photographs.

Born in Berkeley, California, in 1943, Foott grew up among mountaineers. He made frequent trips to the back country with his father and grandfather, both ardent fishermen and outdoorsmen, and later became involved with the Sierra Club, working for 12 years as a professional mountain-climbing guide in the Tetons. Foott received his training as a marine biologist, documenting the behavior of sea otters with a telephoto lens and a notebook, but found the specialization too confining. "I decided that I liked birds, I liked fish, and I liked other mammals too much to spend my entire life with just one animal," he says. Eventually Foott left biology for photography, and has since filmed a wide range of animal life, from squid, salmon and trumpeter swans to migrating butterflies, manatees, elk and bison.

Foott makes his living primarily as a cinematographer, working with Survival Anglia, the largest wildlife film producer in the world. His material is shown in 96 countries, to an audience of 300 million people. His still photography is mostly accomplished while he is waiting to finish a film sequence; rather than sit in the blind with nothing to do, he fires off his still cameras. After 14 years of such dual shooting, Foott has built up a library of over 60,000 slides, which he sells to a world-wide market.

When asked which medium he prefers, he replies "It's a tradeoff. When I do cinematography I have to carry a lot of gear and have to think more about what I'm doing than with stills. I have to put a sequence together. For instance, if I'm filming swans I have to have a wide shot showing the nest and the trees, the lake in the foreground, and some of the background. Then I need closeups of the chicks and adults and a tight closeup of an adult feeding a chick—and through all this the birds have to be facing in the same direction. If I film a swan in a wide shot against a nice

A brown bear and her cub rest in a grassy area along Alaska's McNeil River, where bears congregate each spring to fish for salmon. The picture could have been risky, as bears are notoriously unpredictable, but it was taken from an observation point where they have become familiar with people over the years.

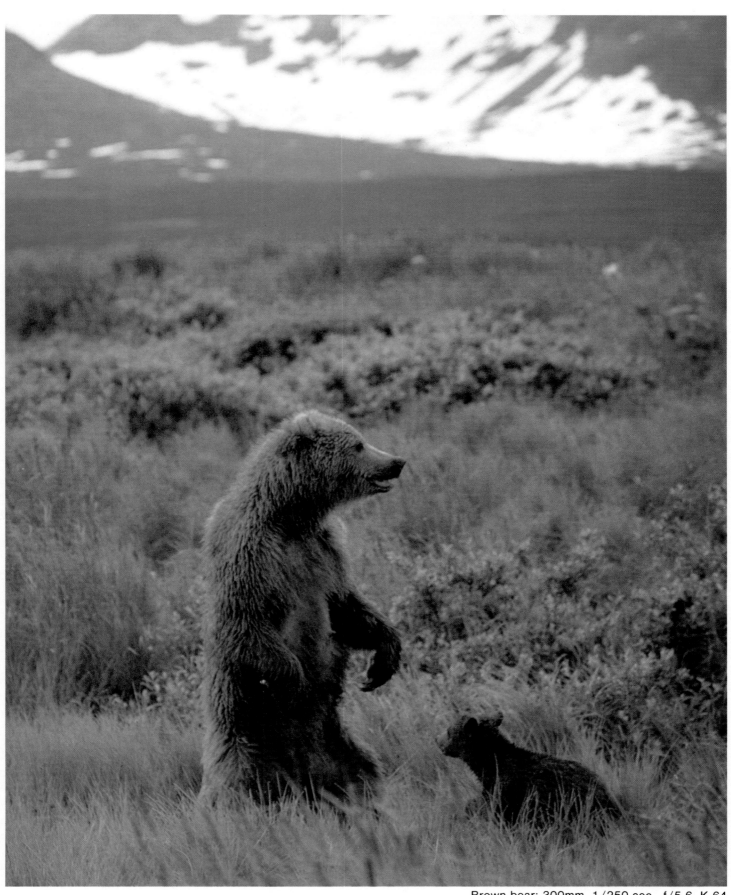

Brown bear: 300mm, 1/250 sec., f/5.6, K 64

background, flying from right to left, and I cut to a closeup, it has to be of a swan flying from right to left. I can't always get all the parts of a sequence at one time. I have to be constantly thinking about what I'm doing, which detracts from the overall enjoyment of just watching the animal. With still pictures, I'm basically freezing a moment in time. I'm capturing just one instant in the life of the animal; the picture doesn't have to depend on what came before or what will come after."

Equipment

Foott began his career with one Nikkormat camera, two lenses (a 55mm macro and a 300mm) and a flash. Since then he has built up his equipment, adding more with the specific needs of each project. He now owns five camera bodies: a Nikon F, two Nikon F2s and two Nikon FMs, and three motor drives, and nine lenses: a Nikon 20mm, 24mm, 35mm, 55mm macro, 105mm, 180mm, 200mm, 300mm and a 500mm mirror lens, plus a 2X tele extender. All of his lenses are equipped with skylight filters. In addition, he has a radio control setup, bellows, Honeywell spot meter, Wein flash meter, Honeywell 892 flash meter with an automatic eye, several 4½-ounce E15B Rollei penlight flashes that are operated with two AA batteries, quartz studio lights, three tripods, and a microscope adapter. Most of his blinds he makes himself. For underwater work, Foott owns three Nikonos camera bodies and 21mm, 28mm, and 35mm lenses, closeup extension tubes (1:1, 1:2), two Oceanic-Farallon flashes (2001 and 2005), a Strobonar 782 flash and housing, and a Sekonic light meter.

When on assignment he takes at least three camera bodies, rotating them while shooting each subject so that, if one fails, he can salvage part of the story with the others. He also carries three motor drives and the tele extender, seven lenses, and two tripods and flashes plus his cine equipment, which consists of an ACL Eclair 16mm camera, two 200-foot magazines, a 12–120mm Angenieux zoom, an Arri graphite-leg, fluid-head tripod, for smooth pans and tilts, as well as his sleeping bag, cooking gear, stove and tent. The logistics for packing in such a load are prodigious. Either Foott is dropped off by bush plane or he hikes to a location, with assistance, and then operates from a base camp, leaving part of his equipment in blinds set up at key locations.

Technique

Foott has converted a model airplane radio control unit into one that fires a camera, which he uses, along with an extended cord setup, to shoot three subjects at once. While photographing pika in the Tetons, for example, he sat at one of the animals' haypile nests with a telephoto, and simultaneously monitored the activity at two other sites, firing the cameras by remote control. He prefers to be in charge of the photography himself, rather than use a trip system whereby the subject takes its own picture, because he feels that the animal usually is startled by the flash and does not appear natural. "Flash is at its best when you can't tell it's being used," he says. "I always try to balance it with natural light."

He uses a spot meter, which is very sensitive to light in a small area, when filming a subject like bald eagles, where there is as much as a four-stop difference between the edge of the bird's white nape and the dark brown of its body. Foott takes a spot meter reading of both areas separately, averaging the difference himself and setting the camera accordingly, rather than relying on a meter built into the camera, which can give a false reading where there's a sharp contrast of light.

For all photography, Foott uses the shortest focal length lens possible. When he shoots hand-held, he follows the rule that the shutter speed of the camera should be higher than the number of millimeters of the lens. Thus, a 55mm macro lens can be hand-held safely at a 60th of a second, but not a 30th; a 200mm can be held at a 250th but not a 125th. A 300mm lens, however, can be held at a 250th of a second with a very steady hand, although a 500th of a second is safer.

The sharpest images are achieved by using a lenshood and a tripod. The shade cuts glare, even a small amount of which can soften definition. Because Foott is often after mammals on the move, and doesn't have time to set up a tripod for every shot, he uses a snap-lock device, known mostly to cinematographers, which enables him to mount the camera on the tripod in just three seconds. Sometimes, he just keeps the camera on the tripod this way, and puts the whole unit in his pack. Foott owns three tripods: a Gitzo, which is very low and light, and is used for shooting flowers and other subjects close to the ground; a heavy Leitz Tiltall, model 4602, for shooting long time exposures, and an old aluminum tripod, that he uses most of the time. It has a screw instead of a crank, which allows the center post to change position rapidly. The tripod head tilts up and down and when he wants to level the camera horizontally, he simply shifts one of the legs. Foott feels that more complicated tripod heads are too heavy and take too much time to set up.

Film

When working with two or three cameras at once, Foott loads two of them with Kodachrome 64, which he exposes at ASA 80, and the other with Kodachrome 25, exposed at ASA 32. Because it is a slower film, he uses Kodachrome 25 with wide-angle lenses and the 105mm, which has an aperture of f/2.8, allowing him to shoot as fast as a 250th of a second and still have enough light. When the background is bright, such as snow or sand, or when the subject is not moving

very fast, Foott can use K 25 with a telephoto, but usually he relies on K 64 for the longer lenses. Occasionally he will shoot with high-speed Ektachrome 400, which he feels is acceptable for photographing subjects in open shade but otherwise has too much contrast to compete with the other films professionally. Foott often uses Ektachrome for underwater work, however, where its graininess can add to, rather than detract from, the quality of the image.

Blinds

Two of Foott's favorite blinds, an ice fisherman tent and a Thermos pop tent, are no longer available. He often constructs blinds on the spot out of burlap and natural materials, but feels that just digging a small depression into the side of a hill, or finding a niche in the rocks, is less likely to spook most mammals. For shooting aquatic subjects, Foott wears chest waders, submerging half his body in the water, and shoots from underneath a tiny tent he designed himself, which fits over the inner tube of a truck tire.

The manner in which Foott sets up a blind depends on the personality of the subject. When he was filming bald eagles, for instance, he had blinds at three different nests, so that if anything happened to one of them it wouldn't put him out of business. His working distances were established by the territorial requirements of the birds. One blind was 40 feet from a nest, another 90 feet, and the other about 140 feet away. Of the three pairs of birds, the most jumpy and difficult to work with were the eagles 140 feet away and the least concerned, the ones he eventually photographed, were only 40 feet away.

Foott advises "A blind shouldn't go up until just before the eggs hatch. If you watch the bird, you'll know when it lays and can look up the incubation time. Heat kills eggs and chicks faster than cold, so don't set up a blind on a hot day because, if the bird leaves the nest, the sun will quickly cook the eggs. Cold, on the other hand, slows down development but doesn't hurt the eggs unless the temperature gets close to freezing, while chicks are sensitive to cold. Guidelines are different for every nest and every situation, and it's necessary to have some feel for the subject. For example, sandhill cranes should be left alone entirely. If they become disturbed they'll break their own eggs and fly away, and that's it for their whole nesting season."

Birds are sensitive to any disturbance. "With some you simply can't put up a blind next to the nest and begin to work," says Foott. "This upsets the birds and they desert the nest. After I find a nest that I want to work, and select the best location for the blind, I put it up 60 or 80 feet back and gradually move it closer until, after three days or so, it's in the position I want. Meanwhile the birds have a chance to see it and get used to it before it comes within a threatening distance. Similarly, if I have to put a blind in a tree, I

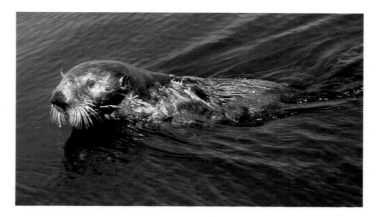

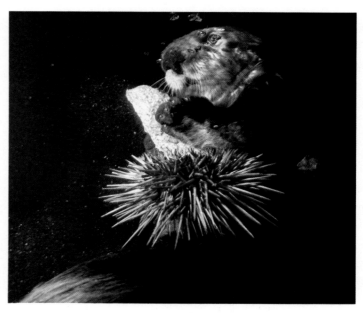

Sea otters inspired Foott's dual career as biologist and photographer. Using camera and notebook, he recorded their behavior for a master's thesis. Years later, he still considers this take to be one of the best available on the subject. Here (top) a sea otter floats on the Pacific while, underwater, another pounds the hard shell of a sea urchin with a rock to get at the soft meat inside.

build the platform first and just leave it for a few days. Then I return with the blind bundled up and leave it on the platform. A day later, I put the blind up halfway, and on the final day, I erect it all the way."

Foott advises, "Always move very slowly when working in a blind, and be as quiet as possible. Make sure that the birds don't see you getting in or out, or the integrity of the blind is destroyed. They know there can be danger in it and they're never quite the same again. This may seem subtle, but if you want the birds to behave naturally instead of acting as though they're looking down the barrel of a shotgun, then you've got to treat the blind with respect. To avoid

Jeffrey O. Foott *is an American wilderness man who has turned his fascination with the out-of-doors into a full time, well-paying career. Since 1967, he has worked simultaneously in motion-picture and still photography to achieve international recognition in both fields. His motion-picture footage can be seen in the productions of Survival Anglia Ltd.; his still photography appears everywhere there is interest in true behavior of wild animals in their home environments.*

WARMTH AND SAFETY

Wilderness photography is a high-risk profession, and many an intrepid photographer has been killed by taking unnecessary chances. Foott cautions never to be alone in remote or dangerous places. "Most of it is common sense, which isn't so common, really," he says. "When I came to a slippery log across a stream, I prefer to walk a mile or so along the bank until I find a place that's narrow enough to jump across.

"People like myself, who spend a lot of time in the wilderness, have learned what they can get away with and what they can't. When I come up against something I think I can't do, I don't do it. Unfortunately, now that the wilderness is more accessible, a lot of people are in there who don't know what their limits are, and their egos are such that they push too far beyond their capabilities and get into trouble."

When surveying an area, Foott carries just one camera and lens, a sweater, and lunch. When doing an in-depth assignment, however, he will be away from civilization and help for extended periods, and must be self-sufficient, cautious, and well-prepared.

To prevent hypothermia, a drop in body temperature that can result in death, Foott wears several layers of warm clothing, shedding some of them as the day progresses. He has found that nylon fabrics and down jackets are warm but noisy, so he wears wool or a new fabric called pile, made by Chouinard of Ventura, California. It is marketed for mountain climbing but Foott finds it equally useful in cold water situations because it wrings out and retains heat even when wet. For more sensitive camera control, Foott works with just a pair of silk glove liners on his hands, insulating himself from contact with the metal of the lens by adding a thick layer of black camera tape to the focus and f-stop rings.

In addition to the correct clothing, it is important to have the right camping gear and equipment. Foott carries a small survival kit consisting of some food, fishing gear, snare wire, matches and a magnifying glass. If he finds himself in an unfamiliar area, particularly in winter when landmarks are not so obvious, he takes along a topographic map, which shows the land contours, and a compass.

having the birds see me, I enter the blind before first light and leave in the middle part of the day, when both adults are often away. Or sometimes, I just stay there all day." Foott feels that blinds are primarily for birds—mammals are harder to fool.

Mammals

"Some animals are best approached where they can see you," says Foott. "Very seldom can you sneak up on a bighorn sheep or a mountain goat, for example. To get close to them I do what I call 'looking for wildflowers.' I walk in zigzags, never directly at them, and act like I'm not paying any attention. When they start to notice me, I pretend to look down at a wildflower, and stop and poke around. Mammals are very aware of eyes and so staring at them, or even pointing a lens directly at them for that matter, can make them uncomfortable. The approach should be casual. The main mistake most people make when trying to get close to animals is that they move too fast. When photographing wildlife, you need a lot of time. I have a diver's watch with an elapsed time ring, and when the animal starts to get nervous, I immediately sit down and set the watch for 15 minutes. I'll stay there until all the time has gone by, which sometimes can be painfully difficult. But by then, the animal should have settled down and I can begin to move toward it again."

To keep his scent from mammals, Foott approaches them from downwind or from a cross wind. He determines wind direction by crumbling some dry earth into powder and watching the direction it blows away. When working on the tundra, he uses a down feather attached by a thread to the top of his pack frame.

"Wildlife photographers should be aware of timing," says Foott. "Many animals that seem quite active, like chipmunks, will stop exactly still every so often, and not move at all. That is the time to shoot the picture. The principle is similar to shooting from a boat that's moving up and down with the waves. At precisely the top of the wave there is no motion at all. With photography, getting a sharp image involves synchronizing your timing with that of the animal."

Foott suggests that a prime place to photograph large mammals is a national park, where they've already had some contact with man. Or choose the opposite, a place where the animals have had no experience with man and so have no fear, such as the high Arctic. "Study the behavior of your subject," says Foott. "Most mammals are creatures of habit—they'll return to certain places to feed, other places to sleep, and other areas for just loafing."

Although Foott has worked around wild mammals most of his life, he is particularly wary of some. "I think the female moose is probably the most dangerous animal in North America when she has a calf," he says. "I was kept in a tree for several hours by one of them in the Tetons. I have also been treed by a bison. The bison, particularly an old bull, should be left alone, or only approached by car. When I shot my bison film, I felt that I should take a tree with me everywhere I went."

Coping with the Unexpected

When Foott photographs animals he knows that anything can happen, and is always ready for the unexpected. While preparing his equipment to film a sea otter he had befriended, the animal suddenly reached out with its paws and opened the underwater housing, flooding the camera with salt water. Resigned to losing two weeks out of a tight shooting schedule, the astonished photographer swam back to the surface, climbed into his boat and headed for shore, then took a plane to Hollywood for the necessary repairs.

"You can't anticipate the action," Foott says, "so just relax, go out and give it a shot, and don't get emotionally tangled up when you don't get what you want. Recently, I was working with sage grouse in Idaho and found it to be a very frustrating experience. I had put up the blind but it wasn't in the right place, so I spent the next day watching the birds closely to see which males were most active on the strutting grounds, and then repositioned the blind near a prime spot. I was in it early the next morning, and was getting ready to shoot, when a coyote came along and went methodically from bird to bird, chasing every one of them off their territories. Unfortunately, the action was too far to one side of the blind, and the light was still too low to shoot. In a sense, the day was wasted, but if you start thinking that way it doesn't help. Altogether I put in twelve days and nights in that blind, and for one reason or another I still haven't gotten any good images, but I'll continue trying until I do."

Foott spends a lot of time with each project and tries to work out techniques to make them better than those of anyone else. He photographed the manatees for two years, on and off, and his sea otter pictures are still the best ever done on the subject, even though he shot them twelve years ago. "If I were satisfied with just an average take," he says, "somebody would come along shortly and realize he could do better, and then all my work would be for nothing. When I shoot a story I want to do it so well that other photographers will say 'What's the point, it's already been done.'"

But the welfare of the animals remains more important to Foott than any commercial success. "Respect is the final word," he says. "If you don't have respect, then you might as well be a politician or something. I have this relationship with wildlife in that they take care of me and I sort of take care of them. For me, the best part of all is when I don't even have a camera, and I'm just out watching the animals. I'm able to move, with a light pack—just go out and come back—and feel good about having a great day."

Foott was nearly trampled while filming the life history of the bison, and has a healthy regard for its short temper and surprising speed. He photographed this bull, taking a dust bath in Yellowstone National Park, from behind a tree 40 feet away. To get detail in the bison's head, which often fills in when photographed, he used a spot meter to take separate readings off the animal and highlights in the dirt, then averaged them carefully, since just one-half of an f-stop either way could have spoiled the picture.

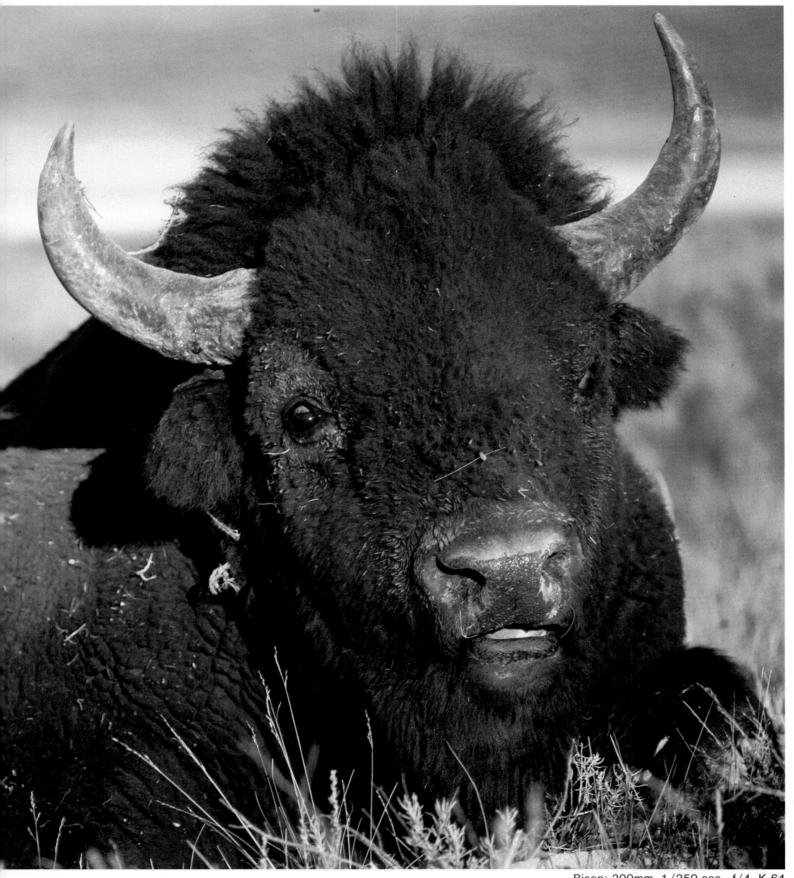

Bison: 200mm, 1/250 sec., f/4, K 64

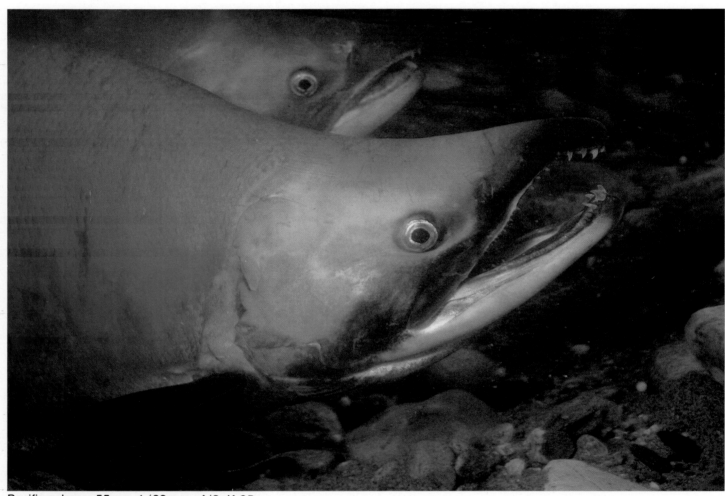

Pacific salmon: 55mm, 1/60 sec., f/8, K 25

Underwater, Foott aims his flash at an angle to prevent back-scatter, where suspended particles bounce light back into the lens and appear on the film as bright spheres. Shooting Pacific salmon in western Canada, as they swam upstream to spawn, proved one of his most difficult assignments. He photographed the story wearing a snorkel, with his head in icy water eight hours a day, and had to hire a lookout to protect him from bears.

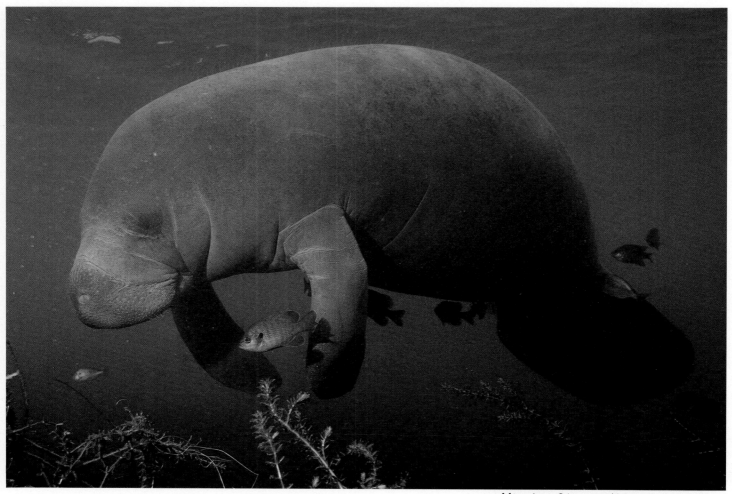

Manatee: 21mm, 1/60 sec., f/5.6, K 25

These manatees were easier to shoot than the salmon. They seek warm springs in winter and are found in south Florida's Crystal River. Foott was charmed by the gentle and affectionate creatures, which enjoyed having their bellies scratched.

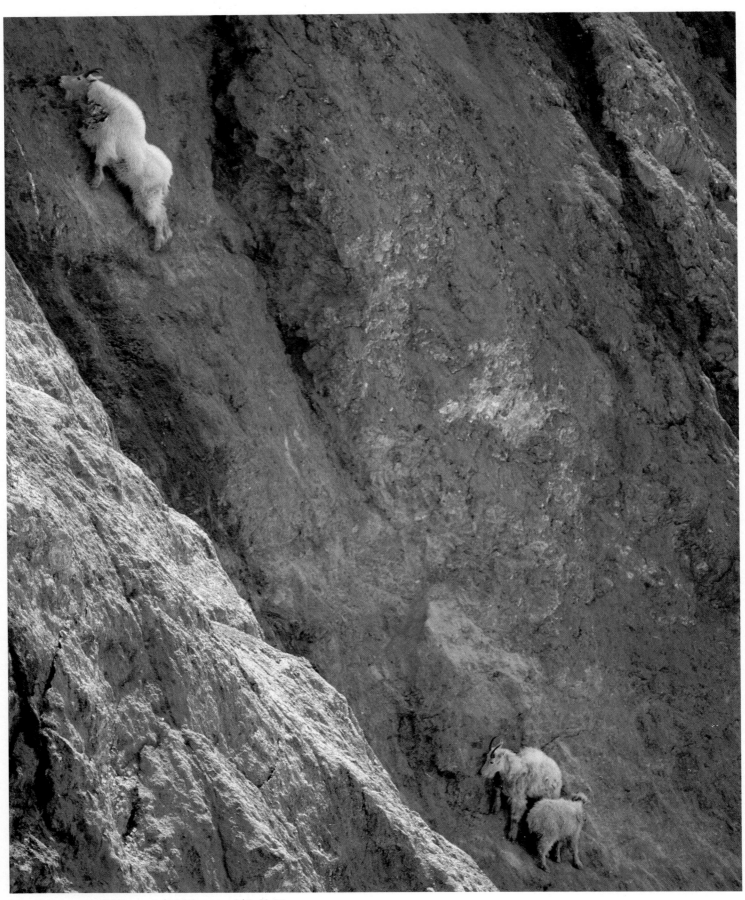

Mountain goats: 200mm, 1/250th sec., f/8, K 64

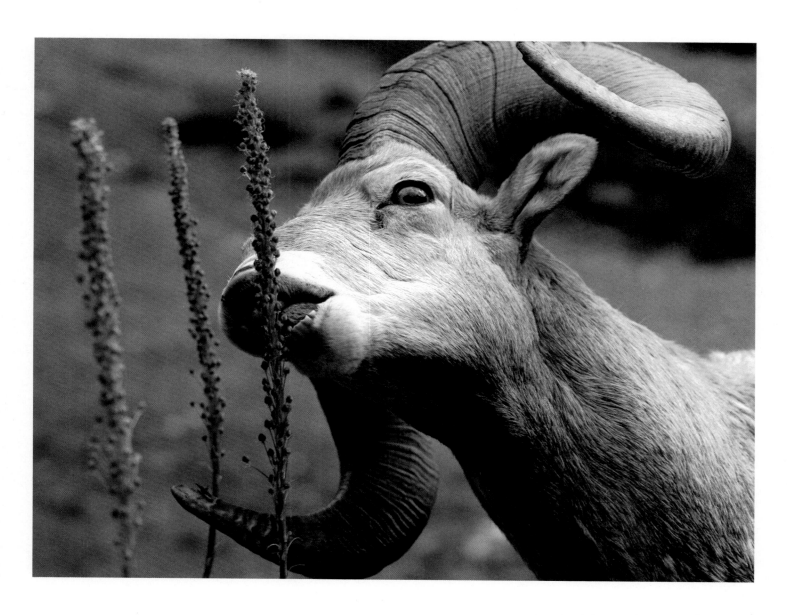

Foott photographs from a cinematographer's point of view, showing the animal in its environment, then moving in for a closer shot. A trio of mountain goats (left) scale a wall in Jasper National Park Canada, 200 feet away from the photographer. Such distant shots are most effective in early morning and late evening, when softer light shortens the contrast range, providing detail in the animal as well as the scenery. A closeup of a bighorn sheep (above), reveals the structure of its teeth. A slightly more distant shot identifies its environment and its meal of bear grass.

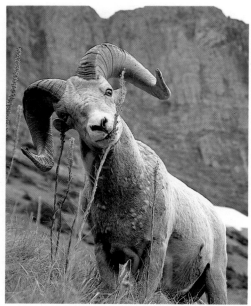

Bighorn sheep: 105mm, 1/125 sec., f/4,
K 64

35

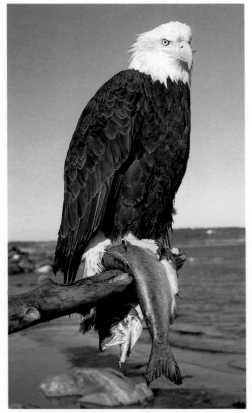

Knowing an animal's behavior pattern helps to anticipate its actions. Foott found that the bald eagle (top left) returned to the same perch every day, and was able to set up his camera 10 feet away, triggering it from 300 yards farther back. The wary pronghorn (bottom left) was photographed just 15 feet away, after a long stalk across the open plains, punctuated by frequent pauses. Even though migrating monarch butterflies (right) stop in the same resting areas along the California coast year after year, Foott searched a week before finding this clump near Big Sur, which he shot from a 20-foot ladder.

Bald eagle: 200mm, 1/250 sec., f/5.6, K 64

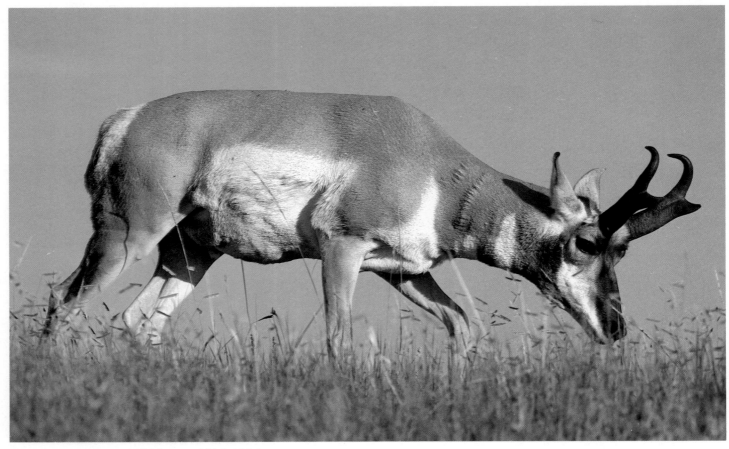

Pronghorn: 300mm, 1/250 sec., f/5.6, K 64

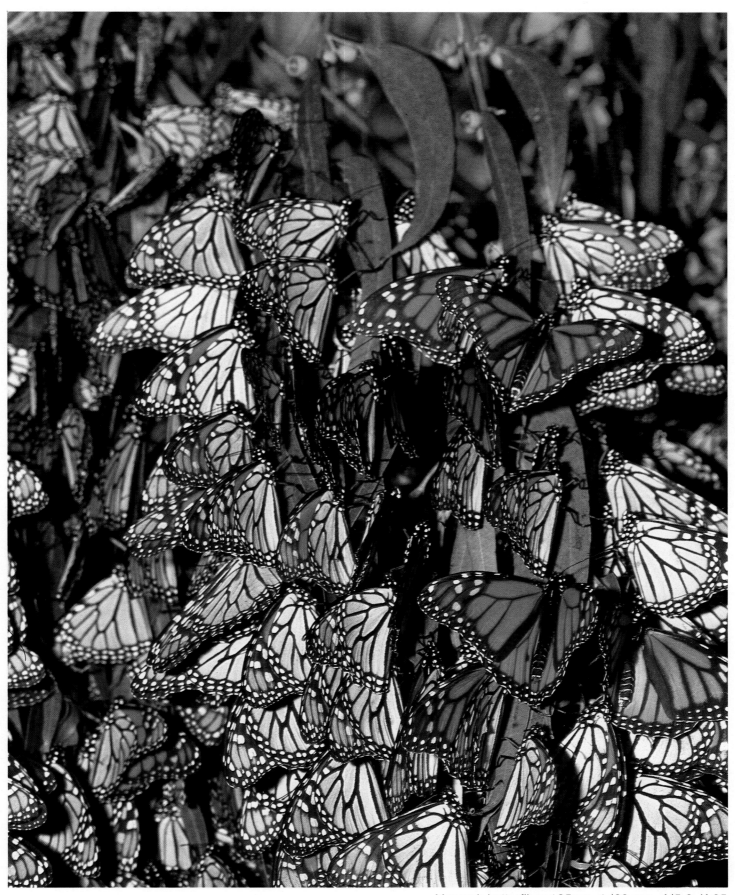

Monarch butterflies: 105mm, 1/60 sec., f/5.6, K 25

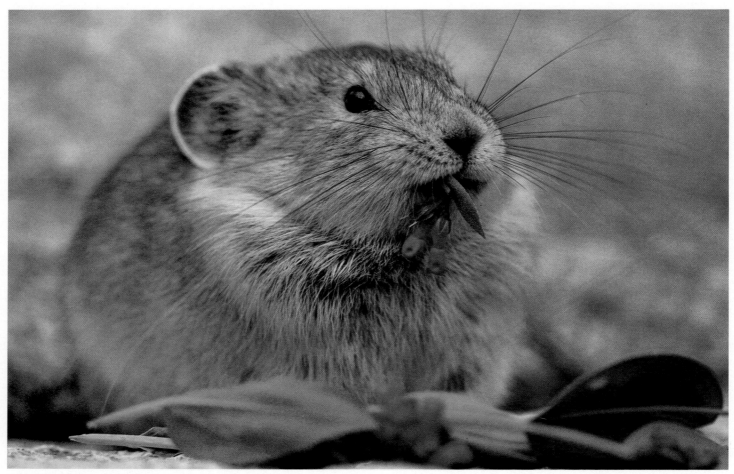

Pica: 105mm with extension tube, 1/250 sec., f/2.8, K 64

A colony of picas in the Rockies was found by locating their habitat—talus slopes surrounded by grassy meadows—then observing the animals until he spotted a den. He let them get used to his presence, enabling him to shoot this pica from just four feet away, with camera braced against a rock.

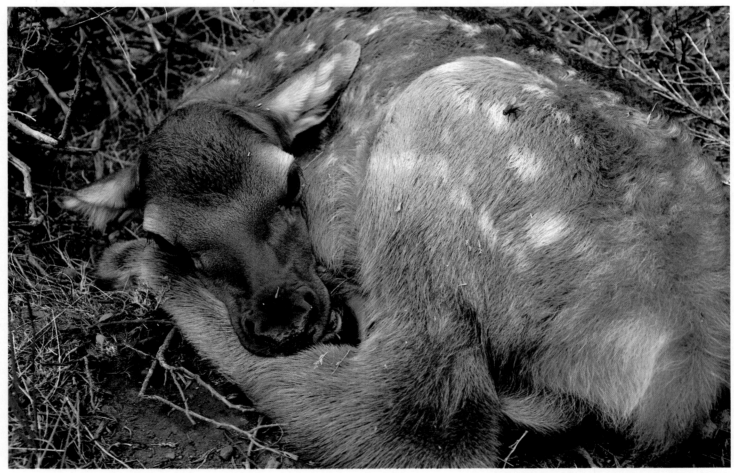

Newborn elk: 35mm, 1/30 sec., f/11, K 64

This newborn elk calf was sleeping on a ridge in Yellowstone, where elk traditionally come to give birth. Its mother was off feeding, certain that her motionless, camouflaged youngster would remain undiscovered.

DWIGHT R. KUHN
Studio Naturalist

Beyond the realm of the familiar lies a mysterious world of small and secretive creatures not often seen with the unaided eye. Many escape notice because they are miniscule, others are shy or active only at night. This vast, elusive population is the special province of the natural science photographer, who brings the subjects into his studio and waits behind the camera as their extraordinary lives unfold. With the aid of closeup lenses, he can magnify them, and capture the fleeting events in their life histories. It is not necessary to own an arsenal of equipment to become successful at macro photography; one just needs basic techniques, knowledge about animal behavior, curiosity and patience. Dwight Kuhn, one of America's most skilled and successful closeup photographers, brings these ingredients to his work.

Born in 1946, Kuhn grew up in Pennsylvania and graduated from Penn State, where he majored in zoology. Shortly thereafter, he and his wife moved to Maine in search of the country life, and he found a job teaching biology and chemistry at Guilford High School. Inspired by the work of Eliot Porter and Frederick Kent Truslow, whose astonishing portraits of birds in action have been regular features in *Audubon* and *National Geographic* magazines, Kuhn decided to try his luck with a nest of barn swallows he had discovered on a nearby farm. Using an old Pentax, 200mm lens, tripod, flash, and a 30-foot cable release, he set up his equipment and waited, triggering the flash each time an adult landed briefly at the nest to feed the young. Out of 30 rolls of film, he found just four or five satisfactory frames, yet they were enough to encourage his efforts. As he studied the techniques of other photographers, and began reading camera magazines, nature articles and scientific journals, Kuhn became increasingly interested in small subjects, a field not widely covered by other photographers. Within several years he began to get his own work published. Kuhn has documented the life in a pond, a meadow and on a fallen log, and photographed the life cycle of stickleback fish, aphids, lacewings, mosquitoes, the mice, flickers, praying mantises and star-nosed moles. He is currently working with bumblebees and water shrews.

Equipment

Kuhn uses Nikon equipment: two F2A camera bodies, 35mm, 55mm macro and 200mm lenses, motor drive, bellows and extension tubes. But the lens

A head-on view of a horsefly reveals hundreds of eye facets, each recording a separate image of what it sees. As with most of the pictures in this section, depth of field was obtained by reversing a 50mm lens and shooting very close to the subject, using a tripod and a flash.

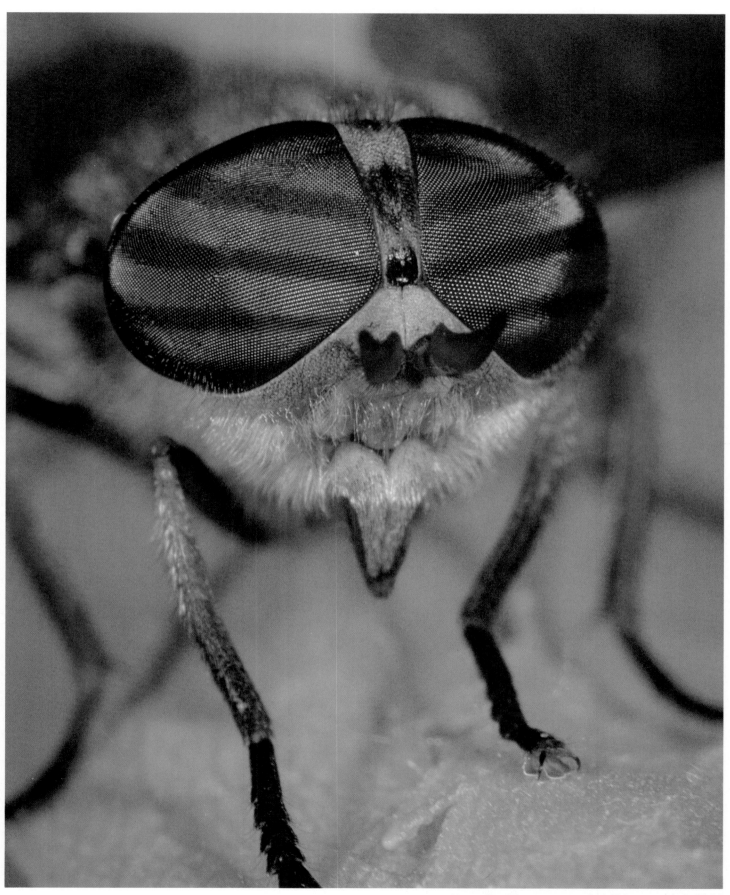

Horsefly: 50mm reversed, 1/60 sec., f/16, K 25

that he now uses most frequently for his closeup work is a 90mm Vivitar Series 1 macro. He also owns a 400mm Novoflex, a seven-pound Husky tripod, several Sunpack flash units and a Minolta II flash meter, which comes with a booster that makes it possible to take a flash reading directly through the camera. Kuhn prefers Kodachrome 25 film because he believes it has superior color saturation and fine grain, but uses the faster Kodachrome 64 in the field.

The Sticklebacks

One of the first subjects Kuhn photographed, stickleback fish, turned out to be among his most commercially successful. He had collected several of the small fish for his home aquarium, not knowing what they were or anything about their life history. When he noticed one building a nest, Kuhn did some research and found their behavior so interesting that he decided to shoot a story about them. "I started cleaning and preparing eight aquariums in April," he relates. "Then I collected some sticklebacks from a local stream and placed one or two males in each tank, adding the females later, when the males were ready to mate. I moved around, watching them and working with whatever aquarium provided a good picture situation. During the breeding season, the males develop orange-pink sides and a bright red throat, displaying their gaudy colors to challenge other males entering their territory and to attract females, which they court with a peculiar zigzag dance. The males are very maternal, actually. They make nests by gluing together a hollow sphere of aquatic plants with a mucus secretion from their kidneys. When one has lured a female to the nest he stimulates her to lay eggs by prodding her tail, then chases her away before she eats them. He also has to protect the newly hatched young from marauding unmated males, that try to steal the eggs away. Sometimes he will carry the young back to the safety of the nest in his mouth. I worked steadily on the story for over a month, sometimes six hours a day, until I got the entire stickleback life cycle on film. I shot 60 rolls and kept almost 1,000 frames, which means that I was pretty satisfied with the take."

Preparation

Because Kuhn likes to get involved with a subject and document it thoroughly, he only photographs two or three stories a year. Most of the actual shooting takes place during a relatively brief period in the summer, when the animals are active and living out their normal life cycles. The winter months are spent in painstaking research, a process that Kuhn feels is essential to the success of the project. "The most important part of my work is the preparation," he says. "I'm always looking for ideas. I read the scientific journals and pay attention to what's being published in the popular press. If I come across an animal whose behavior interests me, then my work starts in earnest. I have to think the behavior through in terms of photography, beginning by learning as much as possible about the animal. Is its life cycle compressed enough to allow me to document it in the relatively short time available for picture taking? Where can I get specimens? Since I'm interested in specific events and stages of development that will make good pictures, I need to know how often they occur and how much time will elapse between them in order to anticipate the photography. I must be able to recognize any behavioral or physical clues that will indicate that something 'big' is about to happen. I must know the exact size and color of the subject to be able to have my cameras and lighting ready ahead of time. Finally, I need to know something about the rate and scope of the animal's activity, so that I can build a habitat that will give it the room it needs, while still keeping its activity within camera range."

Part of Kuhn's initial research involves investigating the animal's physical requirements. He will not even set up a situation unless he feels that he can provide the proper conditions for its survival—his ultimate goal is always to return his captives safely to the wild. Will the creatures settle down or will it be constantly under strain? It is important that he be able to work with an animal without causing it undue stress, which invariably is reflected in the pictures. If its posture appears tense then it doesn't look natural, and fright shows up easily in the eyes. Laboratory reports on research animals are often available, containing facts about their care. If he still has questions, Kuhn contacts the researchers themselves, who are usually more than willing to help. When the animal requires live food Kuhn must be able to supply it and, since this can be time-consuming, he has to budget it into his schedule. It took him 45 minutes a day to catch enough flies for his praying mantises and as much time again to feed them, since every mantis had to be kept in a separate jar or they would eat each other. This went on for five months until Kuhn was satisfied with the story and set the insects free. Occasionally, despite careful research and preparation, a subject dies. The first time Kuhn attempted to photograph the sticklebacks, mold formed on the tanks and killed them. Before trying again, he sterilized everything that came in contact with the fish—aquariums, nets, sand—and the next time the original sticklebacks, as well as their hatchlings, were returned to the home stream when he finished the take.

The Setup

To recreate a setting that looks as much like the natural habitat as possible, Kuhn collects soil, dead leaves, moss, bark or stones from the same location where he found the subject. In the case of small aquatic creatures, which are virtually impossible to photograph in their natural surroundings, he builds a mini-version of their environment in an aquarium. Although many

photographers install an extra, movable piece of glass to keep the subject confined to the front of the tank and in one plane of focus, Kuhn does not, preferring that the animal move about freely in the setup. He uses a natural-looking and unobtrusive greenish background, although sometimes a dark field will make the subject stand out more distinctly. He places the background close enough to the subject to be illuminated by the flash (otherwise, it will fill in and turn black) and yet far enough away for it to be out of focus and not too distracting.

Lighting

Kuhn feels that the major problem encountered with closeup photography in a controlled setting is learning to judge the amount of light required for the proper exposure, and how to position the flash for the most natural results. The closer the subject is to the lens, the shallower the depth of field—that zone of the image in which objects appear in focus. Closing the aperture as far as possible increases the depth of field but cuts down on the amount of light reaching the film. Kuhn shoots most small animals with the aperture stopped down to f/8 or f/11, and very small ones at f/16 or even f/22, to gain sufficient depth of field for all or most of the animal to be in focus. With so little natural light coming through the lens, the picture must be taken at a very slow shutter speed or an additional light source in the form of a flash unit. The flash provides the necessary light and the brief duration of the flash (1/1000th of a second or faster) will stop most motion.

If the subject is as small as an insect, a single light source is usually sufficient. Larger subjects require two flashes, one on either side of the camera, to eliminate harsh shadows and give a natural modeling effect. With a translucent subject, it is often effective to position the flash behind the creature so that the light passes through its body. Pale-colored subjects reflect light, whereas dark ones absorb it and require a stronger source of illumination. If the flash is too close to a shiny object, such as a beetle, flare spots can occur that burn the film white. Aquatic and fast-moving animals are photographed through glass, and many of the best pictures have been ruined by having the flash, and the rest of the camera equipment, reflected in the surface. This can be avoided by masking the equipment with a wide piece of black cardboard, with a hole to accommodate the lens, and by positioning the flash at a 45° angle to the glass.

Kuhn is very critical about his exposures, feeling that a half stop either way may be too far off. Even after years of experience, he finds that the proper lighting and exposure can still be a guessing game, due to the many variables that come up with each new situation. He prefers to test a roll on the setup before starting the actual photography, and throughout the take will bracket one f-stop higher and lower, when in doubt.

Kuhn sets up his subjects to document fleeting moments in the animal's life cycle. Here (top to bottom) a male stickleback, unready to mate, chases a female from the nest, another prods a female's tail to stimulate egg laying, a third raids another male's nest for eggs.

The Mosquitoes

One of Kuhn's easiest and best-known projects was photographing the life cycle of the mosquito. "I had seen some pictures in a magazine that weren't so very good and felt that I could do better," he

Dwight Kuhn, a high school science teacher living in Dexter, Maine, has been a free-lance photographer since 1973. He is known for life sequence photography of small animals and insects with results that are both informative and strikingly beautiful. His work appears regularly in all of the major nature publications as well as encyclopedias and textbooks.

CLOSE UP

As a rule, the term closeup photography applies to shots where the subject is reproduced on the film at sizes ranging from about one-eighth life-size to life-size. Macro photography ranges roughly from images that are life-size to those magnified about 20 times. Beyond that, photography through a microcope takes over.

The 35mm single-lens reflex camera with through-the-lens metering is an almost ideal tool for closeup and macro photography. It makes calculating exposure a simple problem, and its interchangeable lenses allow a great deal of flexibility.

The simplest and cheapest way to take closeup photographs is with supplementary closeup lenses, which attach to the front of the prime camera lens. Extension tubes and rings are also simple to use and inexpensive. They fit between the lens and the body of the camera, and work by increasing the lens-to-film distance. Most are designed so that the camera's through-the-lens metering system works with them in place. The same concept of increasing the lens-to-film distance lies behind extension bellows, which are used chiefly for extreme closeup work. They are not quite as sturdy as extension tubes.

For macro work, although it is possible to reverse the lens on the camera by using a reversing mount, the best solution is a macro lens. Regular lenses are designed to perform best when focused at infinity; macro lenses are designed to be at their best at close range.

Regardless of the type of lens you use for closeups, support the camera firmly, and use a cable release to prevent camera shake when the shutter is released.

Even at the smallest apertures, depth of field is very shallow in closeup photography, often as little as a few millimeters. This means that accurate focusing is critical, and that exposure is best controlled by manipulating the shutter speed or the flash unit.

To determine flash exposure in closeup work, experiment. A rough guideline would be to position the flash anywhere from four to 20 inches from the subject, and diffuse the light with a layer of handkerchief over the flash unit. Bracket your shots, use test strips, and be thoroughly familiar with your equipment. Remember that getting exactly the right exposure takes trial and error, experience—and patience.

says. "I decided to film the *Culex* variety because it was the most common in the area and I could get eggs from a nearby biological supply house. The setup consisted of miniature aquariums made up of slide mounting glass of two different sizes: 2″ x 2″ and 3¼″ x 4″ pieces, sealed together with a nontoxic, silicon aquarium cement. I made these little glass boxes very compact to prevent the developing mosquitoes from floating out of the plane of focus in their aquatic environment. The aquariums were partially filled with water, to which I added an anti-chlorine solution. Pond water would have been too cloudy for my purposes. The egg rafts arrived in the mail smashed beyond use, so I put them in an aquarium, in water kept at 80° F., and waited a few days until the larvae, called wrigglers, popped the caps off the bottom of the egg cases and escaped into the water, hanging upside down at the surface. I fed them prepared baby fish food, available at pet stores, mixed with a few drops of water. Because they were so fragile, I transferred the tiny larvae from the tank to the setup with a medicine dropper."

For dramatic effect, Kuhn set up a flash approximately one foot behind the larvae, at a 45° angle to the glass to prevent reflection, and photographed them at f/11 and f/16 with a standard 50mm lens reversed at the end of a bellows. Eventually the larvae became pupae, with large, dark eyes and curved tails, and hung from the surface of the water like commas. He photographed the pupal stage the same way. When a pupa was ready to transform into an adult, its body darkened and tail straightened, and shortly the adult emerged from a slit along the top of the pupal case. He shot a sequence of adults emerging from their old skins with half of the photograph above the water line and half below, for a split-image effect. Kuhn completed shooting the mosquito life cycle by collecting eggs from a local pond, which he photographed in a petri dish from overhead. Photographing the adult mosquito was easy. "I just stepped outside and coaxed one of the many buzzing around me to bite my finger, which I held in front of the camera that was set up on a tripod on the lawn." Kuhn started photographing the mosquitoes in the middle of the winter, finishing the larvae and pupae in a few weeks. The egg rafts were shot the following summer, along with the biting adult. The entire project, from start to finish, took little more than a month, on and off. He sold the story to *Audubon* and *Ranger Rick* magazines and single pictures from the take have appeared in books, murals and filmstrips.

The Shrews

Kuhn is currently working with shrews, which he live-trapped in his backyard. Smaller than mice, shrews are rather common but are rarely seen because they spend much of their lives underground. Their energy level is so high that they have to eat more than twice their body weight every day, and so are active most of the time, nervously darting about in search of food. Kuhn found them to be active for an hour, then at rest for an hour and a half, round the clock. Their incredibly rapid movement and insatiable appetites were difficult problems. "I fed them dogfood and occasionally a live frog or worm," Kuhn says, "which they fought over savagely, or took turns stealing from one another and running to the other end of the enclosure."

He set up a ten-gallon terrarium that simulated their natural surroundings: soil covered with grass and moss. At first, he used a lot of soil but soon learned that the shrews would dig underneath the food and drag it down to them rather than eat on the surface, where they could easily be photographed. Eventually Kuhn kept the soil layer very thin to prevent them from burrowing out of sight entirely. During the shooting, he discovered that they had different personalities. Some would be quite shy and hardly ever come out; others would be almost fearless and remain in view for a long time. Kuhn used a 90mm Vivitar macro, which enabled him to photograph the shrews without being right on top of them. Most of the pictures he got were centered on eating and fighting. Next he plans to concentrate on care of the young. "Since shrews often eat their young, even in the wild, I suspect this won't be easy!" he says.

Patience

Expecting an animal to perform can often turn into a waiting game. Kuhn may have to sit behind the camera for hours, sometimes days at a time, but if the event is critical for the sequence that he is trying to capture, the reward is worth the wait. Occasionally the waiting process itself can be productive. It was during a lull while photographing flickers at their nest hole that Kuhn's attention shifted to a fallen log nearby, where parasitic wasps were drilling their holes. He began photographing the community of life living in the rotting wood, which developed into a fascinating story in itself. Kuhn feels that anyone who has the interest has the potential to be a good photographer. "The most important thing is to have a standard of excellence—an idea of what a good picture should be—and to keep trying until your work begins to match it. I require that my images be sharp, with bright, clear color and a background that doesn't distract from the animal. Because I am interested in capturing behavior, and know that an event can take place so quickly that I am hardly aware of it, I have to think through my photographic technique as much as possible before work actually begins. This is the major advantage of a setup. My subject's size is known to me. There is no wind or rain to contend with. I control the light and create the environment. I have my photographic logs for reference. To a very large degree, I am able to solve photographic problems before I begin."

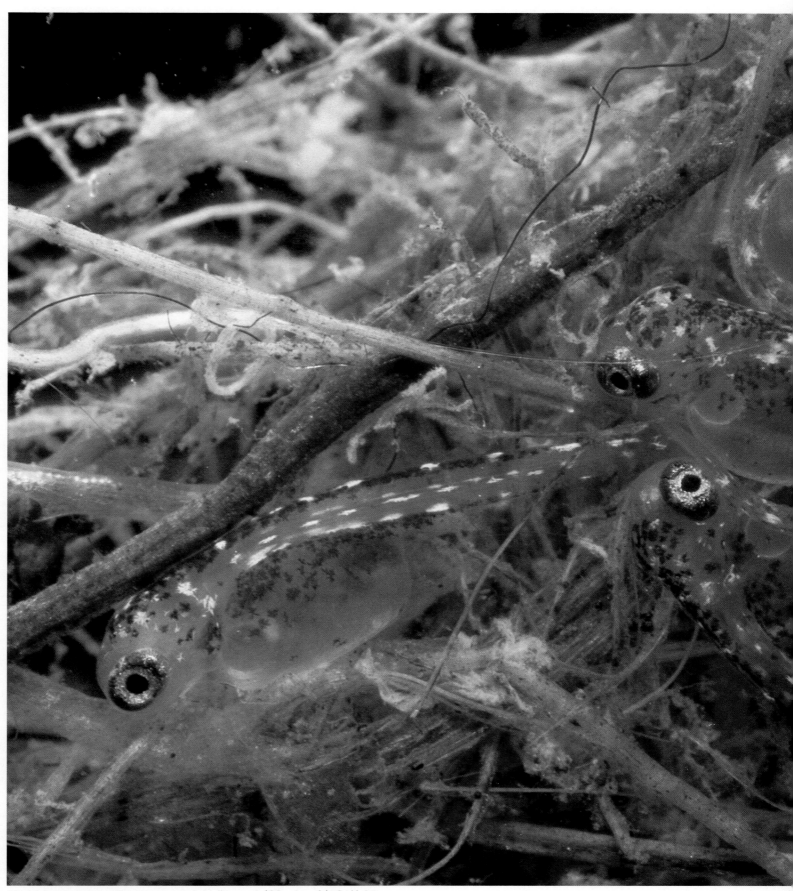

Stickleback eggs: 50mm reversed, bellows, 1/60 sec., f/16, K 25

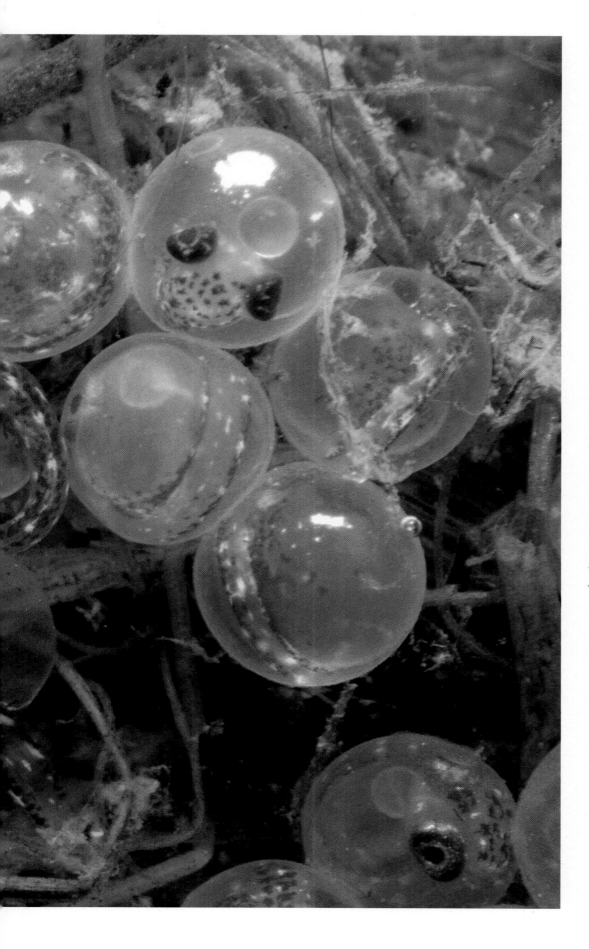

Stickleback eggs begin to hatch in an aquarium in Kuhn's studio. He collected the fish from local streams during the breeding season and photographed the entire life cycle. Each tank contained nesting weeds, stream plants and sand. For shots of the tiny eggs, Kuhn reversed a 50mm lens on a bellows and shot with two flashes, positioned on either side of the camera at a 45-degree angle to the glass to prevent reflections.

Aphids: 50mm reversed, bellows, 1/60 sec., f/16, K 25

Spittlebug: 50mm reversed, bellows, 1/60 sec., f/16, K 25

In summer, female aphids (top left) produce live young without being fertilized by a male. The all-female offspring in turn produce only females throughout the season, multiplying so rapidly that they become serious pests. To record a birth in progress, Kuhn brought infected plants indoors and shot the ⅛-inch insects with a flash, using out-of-focus leaves for a natural-looking background. He photographed the spittlebug nymph (bottom left) covering itself with a frothy mass of bubbles for protection against predators. The garden slug (right) was kept moist in a bed of moss, where he shot it laying eggs the size of a pinhead.

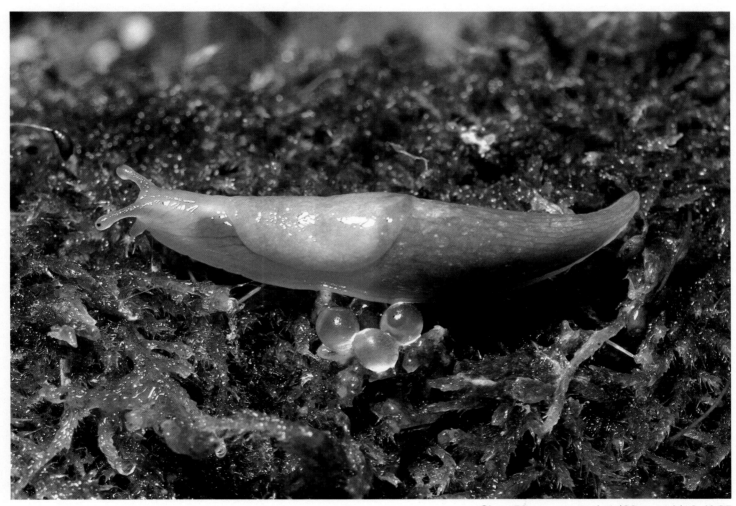

Slug: 50mm reversed, 1/60 sec., f/16, K 25

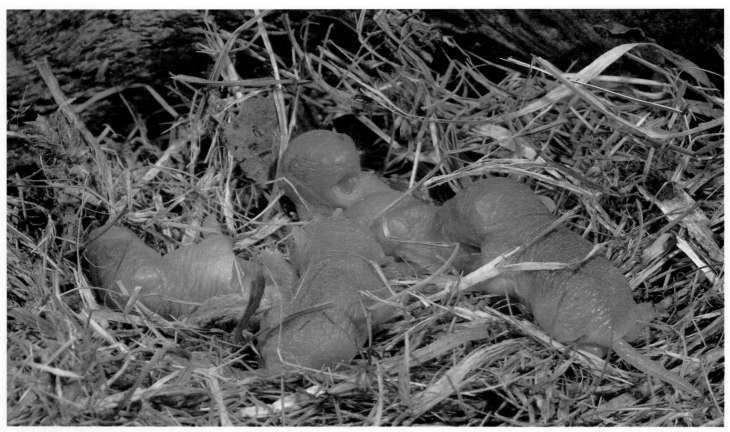

Newborn deer mice: 105mm with extension tube, 1/60 sec., f/11, K 25

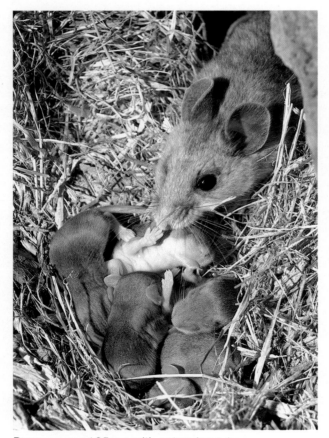

Deer mouse: 105mm with extension tube,
1/60 sec., f/11, K 25

Shortly after capture, a deer mouse (left) gave birth and Kuhn was able to separate the newborn mice from the mother for a short time to photograph them. The main problems were keeping the front of the glass clean and preventing the mouse from finding a more secretive location for her nest. It was difficult to prevent the short-tailed shrew (right) from burrowing out of sight completely. It ate constantly, and required a steady supply of live worms and dog meat. Since shrews do not see well, Kuhn was able to work without a blind, provided that he moved slowly.

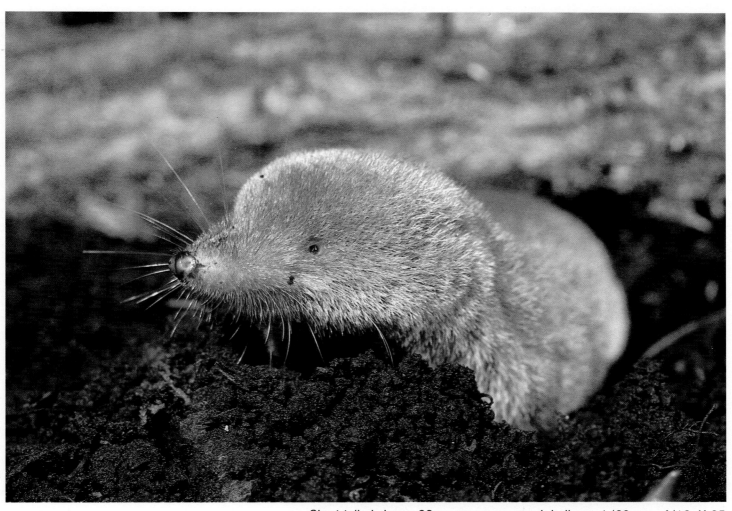

Short-tailed shrew: 90mm macro reversed, bellows, 1/60 sec., f/16, K 25

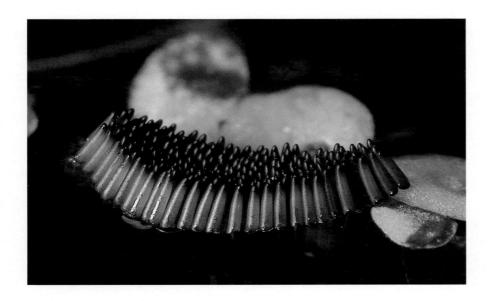

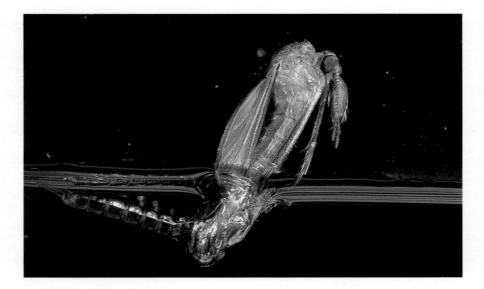

To record the emergence of a mosquito (left), Kuhn collected rafts of eggs from a local pond and placed them in a shallow glass dish, lighting it from above. The emerging adult was in a tiny box made of glass mounting slides glued together with aquarium cement. Kuhn shot it half above and half below the water line, for a split-image effect. It then rested on the water for a moment to dry off and harden. He enticed a female mosquito to land on his finger (right), which he placed in front of the camera setup and shot it before she flew off, engorged with enough blood to produce her eggs.

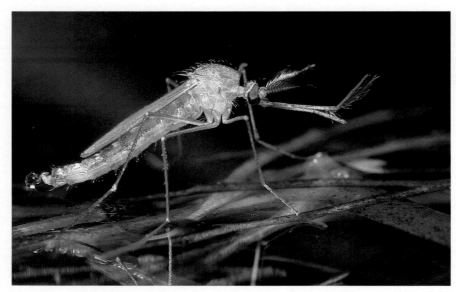

Mosquito emerging sequence: 50mm reversed, bellows, 1/60 sec., f/11, K 25

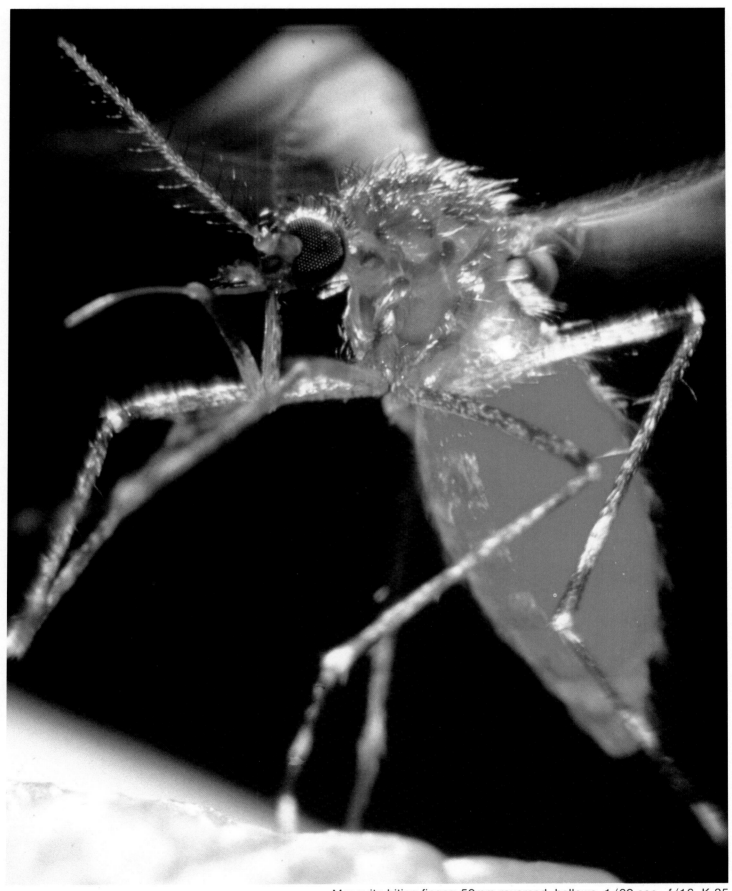

Mosquito biting finger: 50mm reversed, bellows, 1/60 sec., f/16, K 25

CAULION SINGLETARY
View from a Blind

It's two A.M. in the Everglades National Park and a park ranger is on patrol, alert for suspicious signs that might indicate alligator poachers at work. In the dark, he spots a bobbing mass of light etching a slow path through the dense vegetation. Without pause he continues on, the ranger aware that it's only Cal Singletary making his way back through the wilderness after a long night of photography—just as he has three nights a week for the past month. Laden down with camera equipment, his path lit by a headlamp and a hand-held flashlight, Singletary pays close attention to the water-covered trail, fearful of disturbing one of the deadly cottonmouth moccasins that abound in the area. It is a one-mile hike from the nest of the barred owl, subject of his recent photography, to his car. It will take the better part of an hour to reach it and another half hour to make the drive to his house in Homestead, Florida. At eight that same morning he will be up and en route to the small printing business that supports the Singletary obsession—photography of the rare and elusive creatures that find sanctuary in the tropical habitats of the Everglades.

Cal works with the full cooperation of park officials. In fact, virtually every subject he photographs is part of a research project done in close conjunction with park research biologists. Such trust, and with it the necessary permits to photograph endangered species in a national park, is not given lightly. It is a direct tribute to the diligent concern for the welfare of his subjects that Singletary has demonstrated for 15 years.

Singletary began shooting wildlife in 1965 as a respite from the pressures of running his own business. His first picture sequence, an anhinga (a large water bird) fishing, was sold to *Audubon* in 1967. Since then, he has become one of the magazine's leading photographers. Although he has filmed many kinds of animals, his favorite subjects are birds; he is determined to get closeups of all the rare species in the Everglades, capturing their private lives from the time of egglaying to the fledging of the young. With life histories of the roseate spoonbill, wood stork, barred owl, short-tailed hawk, southern bald eagle, swallow-tailed kite, great white heron, brown pelican and osprey already in his files, Singletary has made an impressive dent in his chosen subject matter. The photography will continue for as long as he can endure the painstaking hours spent in a sweatbox of a blind where temperatures can often exceed 110° and the mosquitoes can be so thick that they turn a white shirt black.

A great white heron with its young. Singletary is the first photographer to document the behavior of this shy, beautiful bird at the nest.

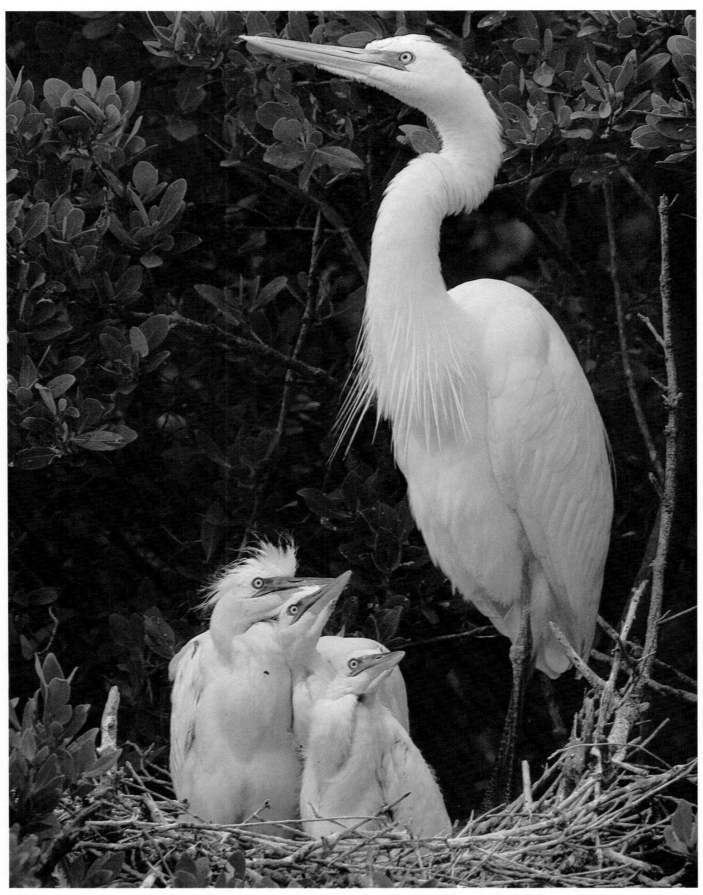

Great white herons: 300mm, 1/250 sec., f/6.5, K 25

Caution

Singletary gets near his sensitive subjects by working from a blind, often sitting in it nine hours a day, three or four times a week, for as long as 90 days, until a project is completed. Each photo sequence offers a new set of problems that must be solved before he can begin. It may take years of searching to find a nest that offers a good site to erect a blind that will allow him entry without disturbing the birds. Once found, he must then devise a blind that is appropriate both for the location and temperament of the species, and determine how to build and place it so that it will be accepted by the nesting birds. Once his plans are made, he presents them to park officials and applies for a permit to photograph. Only if they are satisfied will they allow him to proceed. By choosing to work with rare, often endangered, species, Singletary has set himself a stringent set of limitations. One false move could mean the loss of a nest, something that he has promised himself will never happen as the result of his carelessness—or ignorance. Singletary knows his animals, their territorial requirements and the alarm signals that, if triggered, could cause panic and the loss of the season's young. It takes much homework, money and time to create his photographic setups, but no matter how much has gone into a project, should his subject show any signs of spooking, Singletary is prepared to walk away.

Wood Storks

The wood stork is a large white bird with black flight feathers and tail, and a naked gray head that has earned it the nickname "flinthead." It is a colony nester and once more than 300,000 of them nested in the Everglades. However, in recent years their population has dropped precipitously due to the fluctuating water table, which has prevented them from gathering enough food to feed their young.

In 1972, Singletary photographed one of the only remaining breeding colonies. It was the first time since 1968 that the birds had nested successfully. The colony was located in one of the most inaccessible areas of the park and he had to travel four hours to reach it, using a combination of car, park boat and canoe. Visiting the site three times a week, he worked several nests at the same time, from a blind placed six feet above the water line and only 15 feet from the birds. It was on the outer rim of the colony, so that if the wood storks became disturbed he could pull away quickly without creating a "domino" effect, a fright reaction in which one bird after another leaves its nest until the entire colony is deserted. This is a common phenomenon among the larger waders, and Singletary had seen its devastating effects at a spoonbill colony, where all 600 nests, each with several chicks, had been abandoned when a predator got into a rookery. Fortu-

nately, the wood storks not only accepted his presence but continued to build their nests. Singletary set up two tripods in the blind, using a 400mm lens for head shots and 200mm and 135mm lenses for portraits of adults and young at the nest. In the three months he spent with the wood storks, he photographed all aspects of parental care and development of the young. He was the only photographer that the park service allowed near the rookery. In the tragic event that the wood storks are not again able to breed in their normal fashion, Singletary's pictures and notes will be available to aid the scientists who will try to save the species from extinction.

Hawks and Eagles

Singletary has photographed a number of raptors in the park, including several whose life history had never been known before, such as the short-tailed hawk, only five pairs of which are known to be breeding in south Florida. He recalls, "After years of searching, I found a nest high in a pine and built a 50-foot Rohn tower, 35 feet away, consisting of 12-inch steel triangles in 10-foot sections that drop one inside of the other. We guyed the tower at the 30- and 50-foot level, tying branches to the wires so that the birds could see and avoid them when in flight. The hawks accepted the blind, and I was able to get a remarkable story. But I never did get used to working at that height, watching the hawks flying beneath the platform, or the wind blowing the nest tree out of view. Looking through the 400mm lens, with all the blind openings closed, it felt as though the tower itself was falling whenever the nest tree disappeared from my sight." Reviewing his take, Singletary discovered that, in addition to the snakes and rodents believed to be their only fare, these hawks fed the young small birds, including seaside sparrows. This discovery led to the locating of a hitherto unknown concentration of the rare sparrows in the park.

Singletary's take on bald eagles revealed similar surprises. For years, biologists were convinced that eagles fed more than just fish to their chicks. Singletary's photographs showed the parents bringing in dead spoonbills and grebes, as well as diamondback terrapin turtles. He photographed the eagles in Florida Bay, nesting just nine feet off the ground in a clump of mangroves. He constructed a three-foot-square wooden platform with a canvas enclosure, on 13-foot-high legs, allowing for several feet to be lost in the mud. It was 33 feet away from the nest, positioned to face the open side. Although the eagles accepted the blind, they were always aware of the photographer's presence, even though he took advantage of the adage that birds can't count and brought along a friend who would leave as soon as Singletary had set up his equipment and was ready to work. "The eagles were so alert that, even though they were a quarter of a mile off, it took me 45 minutes to move a 400mm lens three inches to the left

without being noticed," Singletary remembers. "But after a few weeks, I could extend a camera outside the zippered opening and photograph the female preening just eight feet in front of the blind. She knew I was there but as long as she didn't see me, she accepted my presence."

American Crocodile

The possibility of being the first to film an American crocodile on its nest intrigued Singletary, who became interested when John C. Ogden, Audubon research biologist, discovered a nest and decided to study it. These rare animals, which range in size from 5 to 14 feet in length, are best distinguished from alligators by their narrow, tapered snout. Never numerous, there are now less than 500 and most of them are found only in the remote mangrove islands of Florida Bay. Crocodiles bury their clutch of some 40 eggs in low, 8- to 25-feet-wide, mounds of sand or marle. Until Ogden and Singletary began their three-year study, almost nothing was known of the secretive creatures' nesting activity, especially as they only visit the nest in the dark of night.

The first discovery was that it would be impossible to photograph the crocodile using normal techniques. Its sense of smell is so keen that it would not approach the nest at all if there are humans anywhere in the vicinity, so working from a blind was out of the question. Singletary and Ogden enlisted enough financial support for the project to create an elaborate rig, including two Nikon cameras with special backs that could hold 250 pictures. Knowing that a crocodile will not tolerate any foreign object in its nest, they developed an egg-shaped mercury switch, wired to a timing device that would be triggered by the animal's attempts to remove the switch, and would then take a picture every few seconds until all the frames were fired. Two of these switches were placed in the nest. One activated a camera with a 105mm lens for closeups and the other a 35mm camera with a wide-angle. Five Braun RL515 strobes, which contain portable battery packs that can keep a charge for 10 days, were used. The strobes were activated to fire micro-seconds apart by Weine micro-slaves—small, light-sensitive units—one attached to each strobe, that, when struck by light, triggered the next strobe to fire and so on down the line. The micro-slaves were activated by the first strobe going off when the crocodile triggered the mercury switch. Cal figured out the correct exposure by photographing his son, dressed in drab-colored clothes, sitting on a sandpile at night. The equipment, which cost $5,000, was insured with Lloyds of London against damage or theft.

Singletary's only opportunity to see a crocodile at night occurred by accident several years later, when he came upon one lying on a bank as he was returning from another project. But even without seeing the animal, he was able to produce a remarkable photo sequence of its behavior. His pictures revealed that the mother crocodile returned to the nest every night as hatching neared, apparently to listen for the sounds of emerging young. When hatching occurred, she dug up the young and actually assisted them as they struggled out of their eggs, dropping any unopened ones into the salt water, which acts as a hatching catalyst. Knowledge of this behavior was unknown before the research.

Equipment

Singletary uses two Nikon cameras—an old F and an F2—with motor drives. After years of photographing wildlife without a motor drive, he rarely uses it for bursts of 10 or 15 shots at a time, but just taps the button when action is intense. "Anticipating behavior only happens after careful observation over a long period of time," he says. "If the subject does something interesting once, it will do it again, provided that it is at ease with your intrusions into its territory. Birds are always aware of your presence, but they will accept you if they think you pose no danger to them or their young."

He owns a combination of Leica lenses (400mm and 200mm) and Nikkor lenses (300mm, 200mm, 135mm, 105mm, 55mm macro, 25mm and 20mm wide-angle), and advises "Buy the sharpest lens you can, that's what makes the picture." He relies most heavily on the two Leica lenses and his 300mm Nikkor telephoto. Singletary uses heavy Tiltall tripods, Braun strobes, and no filters. He prefers Kodachrome 25 because he feels that it gives the most natural color, but shoots with Kodachrome 64 for landscapes, and when the light is poor.

He feels that every camera and lens should be a hard-working tool that pays for itself, not just a status symbol. "My cameras look absolutely terrible," says Singletary. "None of the original paint is left on the lenses. Lenses have floated past me and I rinsed them off and worked with them again, providing I was working in fresh water. I must have very sturdy equipment because it is always falling out of boats, canoes, or blinds—along with me." Despite an occasional accident, the only broken bones Singletary has sustained came when he met his wife Sharon, slipped and fell on her patio, and broke four ribs.

Advice to Beginners

Singletary learned to photograph by using the public trails of the Everglades National Park. His first published pictures, including the anhinga sequence that began his association with *Audubon* magazine, were made from a public boardwalk, often at the peak of the tourist season. "There is no variety or concentration of birds in all the world like we've got in the Everglades," he brags. "During the winter dry season when the water levels are down, the birds concentrate close to the trails because that's where the food and water are. The shows are fantastic! In some ponds, spoonbills will be feeding

Caulion Singletary began taking nature photographs in 1965 and since 1967 has been a regular contributor to Audubon magazine. A dedicated and knowledgeable field photographer, whose backyard is the Everglades, Singletary has contributed invaluable insight into the private lives of rare and endangered species.

THE LIFE CYCLE OF THE ROSEATE SPOONBILL

It took five years to find a spoonbill nest close enough to shore to allow the blind material to be transported, one with a good angle of sun available all day, and adults that did not spook easily. Singletary assembled all the parts for the blind ahead of time, using bolts and wing nuts instead of nails to avoid making too much noise at the rookery, which might cause the birds to desert their nests at the most crucial stage.

The legs of the blind were made of 2 x 2s that supported a plywood platform with a one-inch dowel at each corner to which he attached a 3 x 3′ aluminum frame. Over this he pulled a water repellent canvas cover, made to order at a local upholstery shop. The enclosure had an opening for lenses but, fearful that constant lens changing might scare the birds, Singletary inserted an open-ended coffee can painted black, zippered it into place, and interchanged his lenses through that instead.

He waited until the spoonbill chicks were about a week old and had gained some strength before putting the blind in place, concerned that if the adults were disturbed earlier they might abandon the nest. With most of the work done beforehand, it took a crew of four just 20 minutes to set the blind up, placing it 13 feet in front of the nest, which was six feet up in a black mangrove tree.

On the first day of shooting, Singletary tried out several lenses for composition, selecting a 105mm for the nest and tree, a 200mm for family portraits and a 300mm for tight closeups. He bracketed each shot in thirds of an f-stop, making notes on each exposure. The film was processed in three days, and his best speed and aperture proved to be 250th of a second at f/6.3. The camera's light meter would have failed him in this case, reading the dark green foliage and overexposing the light-colored subject. Exposure was especially critical, as these pink birds, with spatulate-shaped bills, nest under a dense canopy that is penetrated by occasional patches of bright sun; the extreme contrast makes getting an accurate reading difficult.

Singletary photographed the nest from mid-December to early February, visiting it several times a week. Toward the end of the nesting cycle, when he could risk extending his body out of the blind, he photographed the parents as they made their fly-over, using a 300mm lens with a motor drive. When the young had fledged Singletary dismantled the blind and restored the area to its original condition.

just four feet away from your camera. A visitor can easily see bald eagles, limpkins, herons, Everglade kites, wood storks, pelicans and alligators. In a good year you can wind up with pictures of just about everything shown in the guidebooks. This is a great place to begin if you are serious about wildlife photography.

"But even in the Everglades," he warns, "you've got to do your homework if you're going to get good pictures. Practice with your equipment so that you never have to think about it, so that it's automatic to grab for the right lens and make quick camera adjustments. Read up on the animals you want to photograph. Learn as much as you can about their behavior. Even then, more often than not, you'll find out you're wrong about what you've learned. You're just going to have to put in your time if you want to work nature.

"To get into the restricted areas of the park you must prove yourself to park personnel, who tend to feel that wildlife photographers are almost as dangerous to their charges as wildlife poachers. A case-in-point involves a well-known filmmaker who had a permit to photograph eagles until a ranger found him throwing rocks at one to force it to land at a more photogenic spot. That kind of indifference to the rules makes it just plain hard for all the rest of us." As it was, it took Singletary five years of walking the public trails before his respect for wildlife and habitat was acknowledged by park officials.

Help from Others

Singletary gives much credit for the success of his projects to the people he works with, including rangers, biologists and even some former poachers, who used to hunt endangered species for a living. He also gets help from engineers and other experts to solve some of the more technical problems. "I am fortunate," says Singletary. "I guess the adrenalin that I get pumping in myself transfers to other people. Anytime I talk about my work with wildlife, I always use the term 'we' because it is impossible to do these projects alone. It's too much physical labor for one person. I can't do it by myself, I need others to get involved. My friends will see an interesting subject and they'll say 'God, Cal, wouldn't it be fantastic to do something on that!' And then we start thinking about it and looking for it and we find a nest. While working on that project, I'll see something even more fascinating than the first idea, and it just keeps snowballing."

Perhaps Singletary's greatest satisfaction occurs when a project is over and he views his slides with the park biologists. Watching the daily life of a rare creature unfold on the screen often reveals aspects of its behavior never seen before, and provides a unique research tool for future work on the species. Singletary is proud to have made a contribution toward a better understanding of the wildlife in Everglades National Park, one that may well help save it for generations.

Almost all of Singletary's photography is done from a blind. Here, he climbs a 50-foot tower that he constructed in order to place himself within camera range of the elusive swallow-tailed kite. Temperatures rose to as high as 110°F inside the canvas blind.

A bald eagle feeds her 29-day-old chick. At her feet, the carapace of a diamondback terrapin can be seen, conclusive evidence that these raptors feed their young a more varied diet than had previously been known. In photographing a life cycle, Singletary concentrates his attention on the small details of nest life and the gradual changes in behavior that take place as the young mature.

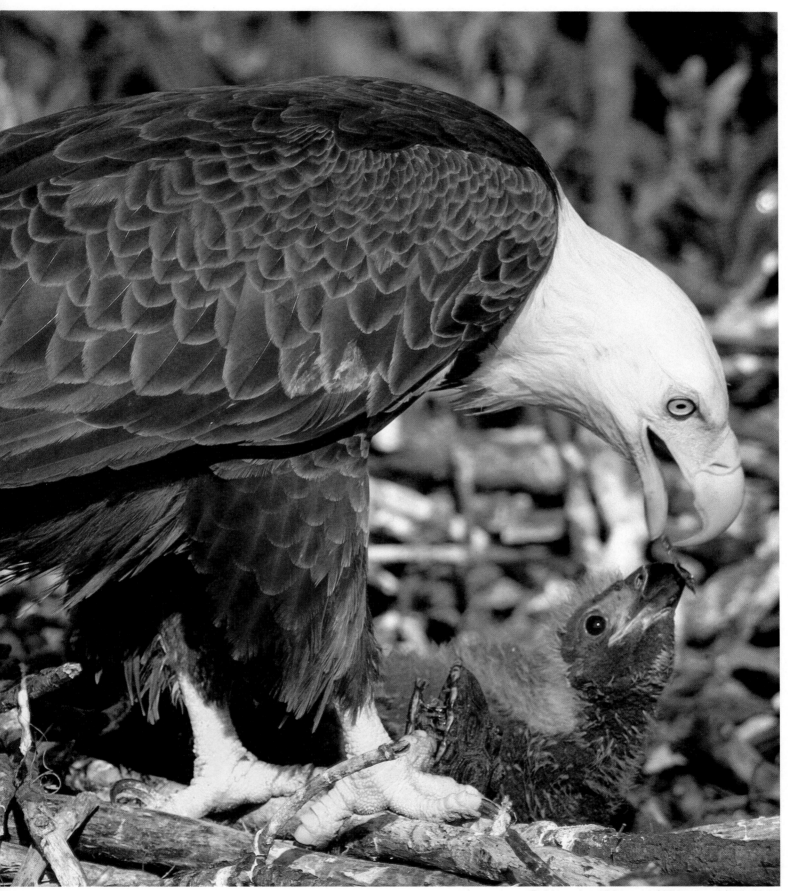

Bald eagle: 400mm, 1/250 sec., f/5.6, K 25

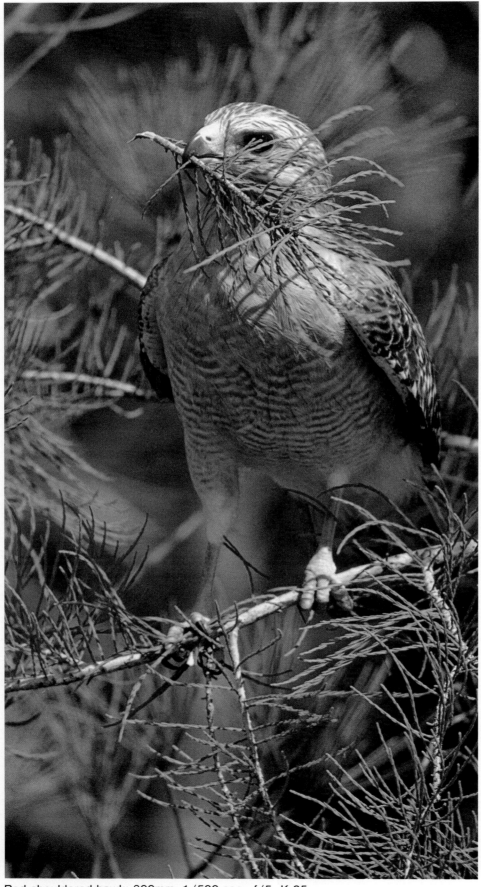

Red-shouldered hawk: 300mm, 1/500 sec., f/5, K 25

The stories of the red-shouldered hawk (left) and the barred owl (right) were shot at the same time, Singletary working with the hawk during the daytime and the owl after dusk. The nests were just a half mile apart, convenient for the photographer but apparently even more handy for the owl, which eventually ate the hawk chicks. The adult owls would only come to the nest in complete darkness and, because their flight is silent, he had to preset his cameras and listen for sounds of the feeding chicks before firing his flash so as not to scare the parents away.

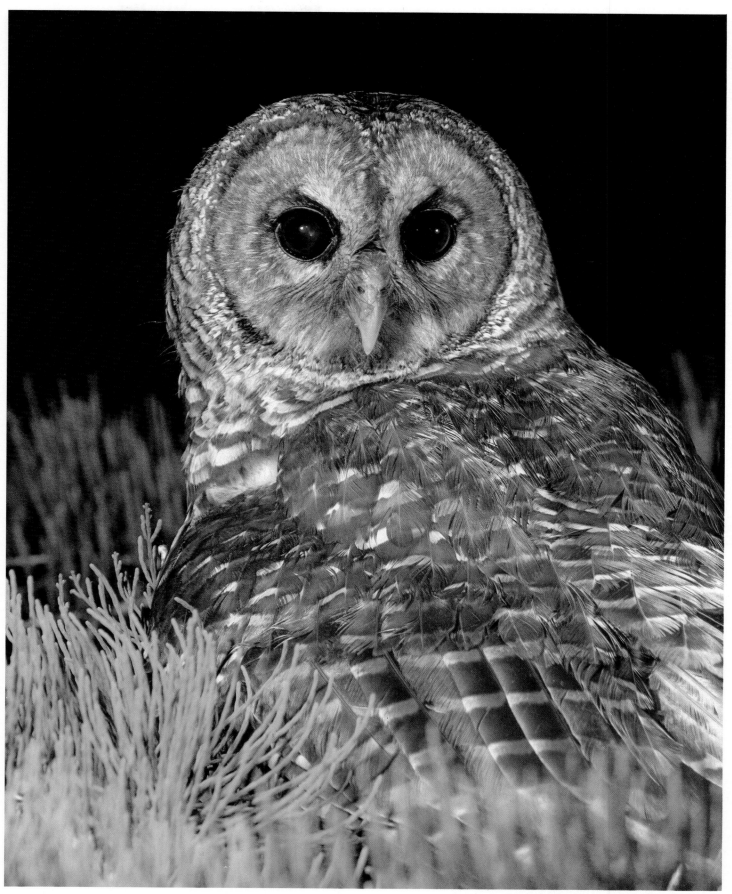

Barred owl: 400mm, 1/60 sec., f/12.5, K 25

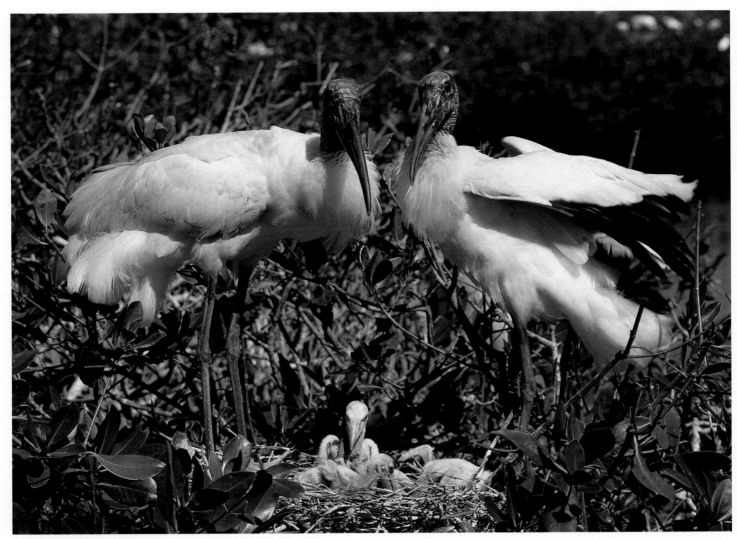

Wood stork family: 135mm, 1/250 sec., f/9.3, K 25

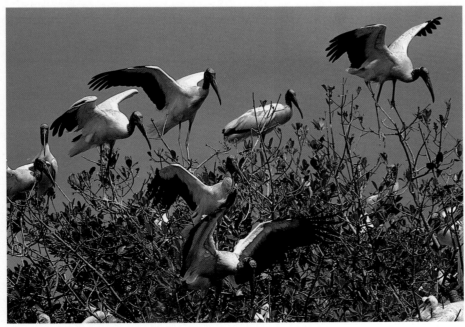

Wood stork rookery: 400mm, 1/5000 sec., f/6.3, K 25

Singletary's work with sensitive, often endangered, species in Everglades National Park requires extreme caution. One wrong move may mean the loss of a nest. The wood storks (left) and roseate spoonbills (right) were shot from blinds set up just a few feet away. It took months to complete each story, but despite the time and research put into each project, Singletary would have pulled out immediately if the birds had shown any signs of spooking.

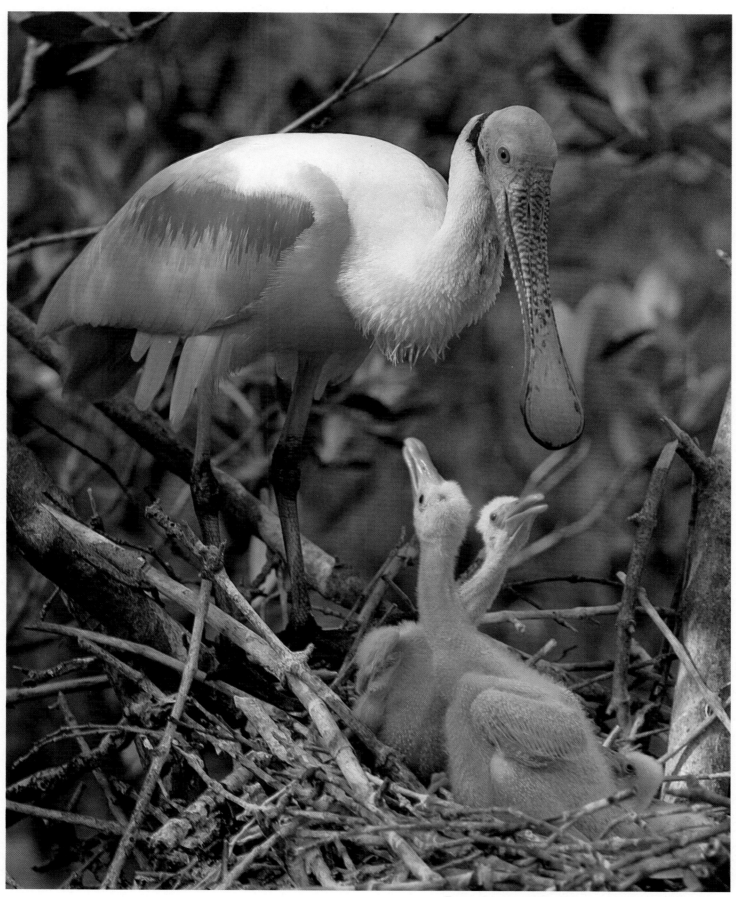

Roseate spoonbills: 200mm, 1/250 sec., f/5, K 25

To get the first photographs ever taken of the rare American crocodile on its nest at night (right), Singletary rigged an egg-shaped mercury switch, wired to a timing device, which when disturbed by the crocodile would take a picture every few seconds until all the frames were fired. Four strobes were placed around the nest, each activated by a small, light-sensitive, microslave unit that fired the strobes microseconds apart. In the hatching sequence (left), a nine-inch crocodile emerges from a three-inch shell. These photographs were made under controlled conditions in a laboratory. The eggs were taken from a nest disturbed by local construction; all the hatchlings were returned to the wild.

Crocodile hatching sequence: 200mm, f/22, K 64

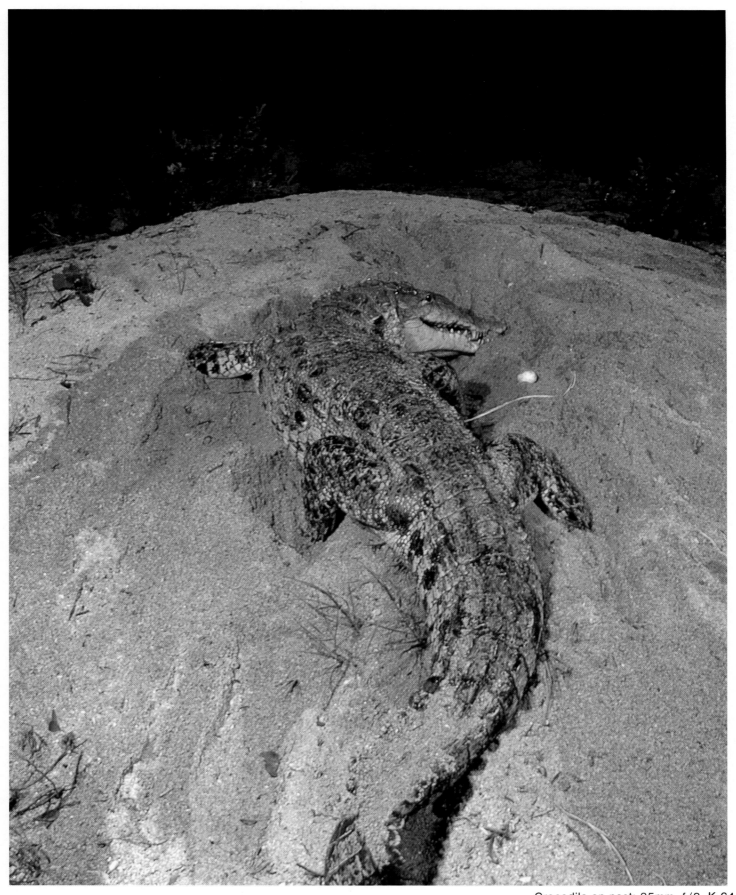

Crocodile on nest: 35mm, f/8, **K 64**

JOHN SHAW
Master of Closeup

It is not necessary to travel to exotic places to discover the natural world. Its magic is available to anyone who has access to nearby woods, a bog, meadow, beach, or even a backyard. For John Shaw, the local landscape and its wildlife is ever changing and always new. His sensitive observation of life around him yields a fresh view of familiar subjects, and transforms the common into the uncommon. A fallen leaf glows on the surface of a pond, asters sparkle in autumn frost, pale woods soften with spring rain, a dragonfly appears as an iridescent jewel. Always Shaw is aware of the changing light, seasons, patterns, shadows and reflections that alter what he sees from moment to moment and hour to hour, creating infinite variety. To Shaw, equipment is not as important as the seeing, slowing down, and distilling the essence of what is before him, enabling him to capture the experience of wildness in images of extraordinary beauty.

Shaw lives in central Michigan, in the transition zone between farm country and the North Woods. His home, 15 miles from the nearest village, is surrounded by wilderness, allowing him the close contact with nature that he enjoys. "The natural world is very important to me," says Shaw, "it's probably the most important thing in my life. I spend a lot of time in the field, some of it with cameras and a lot of it without cameras. In fact, sometimes I think that photography is just an excuse to make a living while being outdoors."

Born in Tulsa, Oklahoma in 1944, Shaw developed a strong interest in nature and photography early on. After college, he taught American literature for several years at the University of Wisconsin and Western Michigan University, but devoted his summers entirely to photography and as he saw his work improve, felt increasingly frustrated with the time spent in the classroom. The sale of some pictures to *National Wildlife* magazine in 1969 provided the incentive to give up his academic career and try freelance photography full time. "I guess you could say that I'm either a teacher who went bad, or one who went good, depending on how you look at it," he says, and has never regretted the decision. Since 1975, Shaw and fellow photographer Larry West have run week-long summer workshops on field photography as well as day seminars and programs for colleges, camera clubs and nature centers across the country. Ironically, Shaw now seems to be teaching more than he did before, but this time

A sleeping butterfly, covered with dew, is a favorite subject of Shaw's. He shot this European skipper at dawn, in dead calm, moving his tripod carefully into place so as not to disturb the vegetation. He prefers not to use flash in this situation, as it creates artificial-looking highlights in the surrounding droplets.

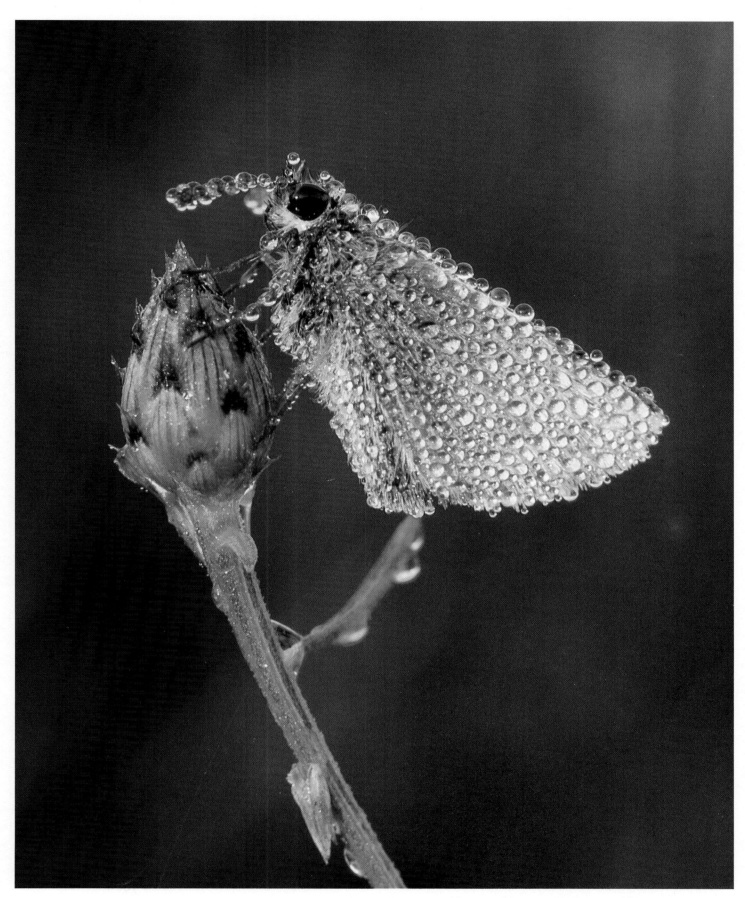

European skipper: 105 macro, bellows, 1/60 sec., f/11, K 25

he enjoys it—his classroom is the outdoors and the subject is his favorite: photography.

Shaw's appreciation of the subject matter can be mystical and emotional at times, such as when he is shooting a particularly beautiful scene at twilight, but the technological aspect of photography also fascinates him. "Working with the camera is entirely mechanical and rather ritualistic," he says. "I remember that Hemingway, in the Nick Adams stories, described trout fishing in terms of ritual. Nick, coming back from World War I, had to order his world again, to give it meaning by the ritual of tying on a fly and casting it a certain way. A ritual is also involved in setting up a tripod, mounting the lens on the camera, selecting the shutter speed, f-stop, and so on. There is a certain beauty to this, a Zen, if you will. I think that's what I like most about the combination of natural history and photography. You must have both the mysticism and the technology, the Orient and the West, coming together to produce a good picture."

A sense of spontaneity is important to Shaw. "My photography goes well when the experience of being outside really excites me and a picture taken during that time reflects what I saw and felt. There are other times when I should just put the camera down and forget it, because I simply can't capture what I want on film. There are some things you just have to experience, you can't photograph. I try to photograph things as naturally as I can. Many photographers chill insects before shooting them but I am absolutely against controlling subjects this way. What you end up with is a picture of a chilled insect, and once you know the subject matter, you can easily spot this type of shot. I try not to be an intruder. I want the photograph to look like the animal was accepting of me, that it wasn't scared. As much as possible, I want it to treat me as just another animal passing through, which is why I always work alone. The few times I have tried shooting with people around, I have been unhappy with the results."

Tripods

As far as Shaw is concerned, the best accessory that a photographer can have is a good tripod. "The type of work I do requires a lot of low level work, often at very slow shutter speeds, so I shoot every picture I possibly can off a tripod. Unfortunately, most of the tripods on the market are poorly designed—they're either too short, too flimsy, or they cut your hands when you try to carry them. The French-made Gitzo tripods are wonderful, however. By just changing the leg locks, in seconds they go from absolutely flat on the ground to above eye level, with no center post extension. I avoid using the center post as much as possible, otherwise, I feel that I no longer have a tripod but a monopod with a three-legged base. When it's necessary to use the center post, though, I don't have to invert it; everything works right side up. I do carry a long-extension center

post that enables me to get four feet higher for shooting down on a landscape for a different perspective, but it's a little unstable and I wouldn't use anything longer than a 50mm from that height. Although they make a good tripod, Gitzo tripod heads are poorly designed, so I use a Husky quick set, which I have adapted to the Gitzo. Bogen tripod heads are also good."

Flash

Shaw prefers working in the marginal light of early morning, late afternoon or in moody weather conditions, when the light is softer and more defining. "I use flash only for night photography or to stop the

Typical of the small "backyard" animals that are Shaw's specialty, a black-capped chickadee approaches its nest with food.

action of small mammals, insects and birds," he says. "My flashes are the very small Vivitar 102s, about the size of a cigarette pack. I prefer to place them within one or two feet of the subject, which gives me good light, with nice, open shadows. At such a close distance, the reflector of even a small flash becomes large in comparison to the size of the subject, and the effect is the same as that of a bare tube flash, bounced off an umbrella. A large flash, positioned farther away, gives a point source of light that creates black shadows and harsh lighting. Traditionally, nature photographers tend to use a lot of flashes, and you'll see bird photo-

graphs with three, four, or even five catch lights in the eyes. This doesn't look natural. After all, we live on a planet with only one light source, and so there should be only one catch light." Shaw has designed a special flash bracket that is attached directly to the camera, creating a self-contained, flash-camera-lens unit that leaves him free to pursue butterflies and other active small subjects across fields and through woods, shooting them hand-held, without a tripod, for more spontaneous results.

Accessories

Although he relies on his through-the-lens meter for closeup work, he also owns a hand-held Lunapro, which he uses to read incident light—the light falling on the subject. When photographing active subjects, he uses a motor drive, which automatically winds the film and keeps the camera always cocked and ready for action. Shaw uses a Nikon 2X tele extender whenever he needs to turn his 300mm into a 600mm lens to bring distant subjects closer. Occasionally, he uses a polarizing filter to intensify blue sky or reduce glare on shiny foliage or water. 81A and 81C warming filters cut the bluish cast on gray days, and bring up the colors in yellow, orange and red subjects, particularly in the early morning when they are not in full sun. Despite the advice of camera salesmen, Shaw advocates removing the skylight filter from a lens when it is not needed, as he feels it can degrade the image. "After all," says Shaw, "if the lens designer had wanted a permanent filter on the lens, he would have built one onto it."

Blinds

Shaw rarely uses a blind unless photographing small birds or working in an area where mammals are expected to come in. "I used to really curse blinds when I owned one that had to be guyed out with ropes," he laughs. "I always seemed to put it in the wrong spot, and as soon as I got it set up I would discover that I was two feet over from where I wanted to be, and I'd have to tear it down and move it again. Finally, out of sheer frustration, I built my own, which is the best design I've ever come up with and makes working with blinds a pleasure. It's based on a projection stand, with legs that are adjustable for height. It has a plywood base with a cotton cover that has a sleeve for the lens; the aluminum legs detach for easy carrying. I have cut a handle hole in the plywood and the legs secure flat to the plywood so I can pick the whole thing up in one hand. It weighs around ten pounds and is as easily portable as any blind I have ever had. It can adjust to as low as three feet off the ground or high enough so that I can stand up inside it and shoot over cattails, for example. Before, if I left a blind up for a few days, too often I'd come back to find it vandalized or stolen. Now I can set up the blind, shoot for an hour, tear it down and leave within a matter of minutes."

Film

The only film Shaw uses is Kodachrome He selects K 25 whenever he can, because he likes it color saturation and feels that it is the sharpest, finest grained film available today. "I prefer to work in natural light, particularly early or late in the day, wher there's just an edge of light, and so I get into very long exposures. I've shot K 25 up to four minutes, and as fa as I'm concerned it doesn't color shift. There's a reci procity change; in other words, at long shutter speed the film slows down and the usual relationship between the shutter speed and aperture changes, but once you correct for the loss of speed, it is not necessary to filter for color. If I need faster film, I use Kodachrome 64. don't care for Ektachrome; it's very grainy, I don' think it's sharp and don't like the colors."

Travel

His home base is the Midwest, but Shav has worked throughout much of North America, as wel as Costa Rica. When traveling by air, he asks for a hand search at the inspection station and carries three thing with him on the plane; an aluminum Halliburton case for his cameras, lenses and accessories, a shoulder ba for his tripod, and another containing lead-foil Film Shield bags, each of which holds about 25 rolls of film "Because I work off a tripod," he says, "I tend to stud the setup very carefully before actually pressing th shutter, and so I don't take a lot of film. For two week in Yellowstone, I would take a maximum of 60 to 8 rolls and I doubt I would shoot it all unless somethin really spectacular happened."

When he goes on a field trip, he carries backpack made by Focus Inc., in Montana, which unzips and opens like a Halliburton case. The inside i lined with foam cut to conform to the shape of eacl piece of equipment. With this system, if Shaw sees a empty space in the pack at the end of the day, he know that he will not leave a lens lying out in a field.

Insects

Shaw is particularly fascinated with in sects, calling them the dragons of our age because the remind him, in miniature, of those colorful, bizarr creatures of myth. Dew-covered subjects are his favor ite. "If I had to pick what I would call paradise," say Shaw, "I'd probably choose a summer morning at sun rise, with a dead calm and a very heavy dew. I reall enjoy the morning, when everything is absolutely fres and new. At that time nobody else is out and I own th world. I know that if I go to a certain habitat I'll fin butterflies and dragonflies so drenched with dew tha they can't fly. There is one small section of a catta marsh about five minutes from my house where I kno that I can always find them. I've seen times when sleep ing dragonflies actually define this area and when

*Much of **John Shaw's** photography is done close
[to] home in the woodlots and wetlands of rural Michigan where
[h]is love of the common subject results in uncommonly beautiful
[im]ages. Shaw's photographs have appeared on the covers of
[A]udubon and National Wildlife and he, with Larry West, is
[co]author of Visions of the Wild. Nature photographers travel
[to] Mason, Michigan from all over the United States to attend the
[p]hotography workshops given by Shaw and West each summer.*

Larry West

THE IDEAL FIELD CAMERA: THE 35mm SLR

Shaw is strictly a 35mm single-lens reflex [SLR] photographer, believing that it is the most suit[a]ble system for his type of work because it allows direct, [th]rough-the-lens focusing and framing, and has a ver[sa]tile, interchangeable series of lenses. He owns several [N]ikon F2 camera bodies, a 24mm, 55mm macro, [1]05mm macro, 200mm and 300mm Nikon lens, Novo[fl]ex auto bellows and 105mm short-mount bellows lens, [a]s well as a Nikon 2X tele extender, motor drive, Gitzo [tr]ipod (model 320), Lunapro meter, several Vivitar 102 [fl]ash units, polarizing and warming filters, cable re[le]ases, a specially built flash bracket, and a blind that [h]e designed himself.

Although most cameras today come with a [sp]lit-image rangefinder viewing screen, Shaw suggests [re]placing it with a clear matte screen (B or E in the [N]ikon line); otherwise half the image blacks out when [sh]ooting closeups or using long lenses. Another current [tr]end is to leave the depth of field preview button off [th]e camera body. For field work, however, Shaw feels [th]at it is essential to be able to stop the lens down and check the depth of field before shooting, so the preview button is an important feature to consider.

Shaw tends to use the longer lenses because they allow more working distance between lens and subject, and include less background in the photograph, which is particularly important for closeup work. He explains, "The 105mm macro Nikkor is my bread-and-butter lens,which I use for just about everything. I also own the 300mm Nikon ED (extra low dispersion glass), which has internal focusing—a feature I would urge photographers to look for when buying longer lenses. Unlike the standard lens, which gets longer as you focus closer and so you have to slow down the shutter speed to compensate for light loss, internal focusing lenses stay the same size all the time; since they don't get longer, there is no light loss. This means that once I take a meter reading, I'm shooting at the same exposure whether I'm eight or 100 feet from the subject, saving a lot of time. Also, these lenses seem to focus very rapidly, which makes them a joy to work with."

walk just a few feet beyond, I can't find another one. I've never quite understood why this is; perhaps it's a micro-climate, with a temperature range that's slightly different from the rest of the area.

"I shoot dew-covered subjects with either a 105mm or 200mm lens on a bellows. If I'm shooting with a 55mm lens, I'm simply too close physically and there's a good chance that I'll knock the insect off its perch or hit it with the tripod legs. With a 105mm or 200mm, I can back off a couple of feet and, because of the narrow angle of view, can eliminate a lot of distracting details behind it. Since the 55mm macro has too short a focal length for the type of work I do, I treat it as another wide-angle lens, like my 24mm. My Novoflex bellows has two rails: the top one is for focusing and the bottom rail acts as a rack and pinion, so that I can move the whole assembly back and forth, without changing magnification. Working off a tripod, using Kodachrome 25 film, my exposures commonly run into the seconds. My normal shutter speed range is anywhere from a 15th of a second to four seconds. I would probably take ten or fifteen frames of it, to make sure that I get a few sharp ones, as the slightest breeze will move the subject. The hardest part is to position the tripod and frame the subject. I have to shoot flat into it, so that the film plane and the subject plane match. The closer I get, the more depth of field I lose, and I have to line up film and subject very carefully, even with the aperture down to f/11 or f/16, to get all of the subject in focus. Then I sit there, with cable release in hand, waiting for dead calm to try to get a frame off. Most of my time is spent waiting for the wind to die down and so I tend not to shoot many different subjects in one morning."

Birds

During the nesting season Shaw spends a lot of time in the field with binoculars, searching areas that he thinks would be likely sites, finding and marking the nests that look workable. Once he locates a nest and decides when the light is best to shoot it, he views it through the lens that he wants to use, generally his 300mm, to determine where he wants to set up the blind. "I tend to use my 300mm because usually that is the closest that I can get to the bird without disturbing it. The safety of the bird always comes first. I'll put up the blind and back off quite a ways and use my binoculars to see if the bird accepts it. If it doesn't come back soon, and I really want to work that nest, I'll set up the blind much farther away and move it in slowly, usually over a period of several days. Birds are strange. Some species are very accepting and will perch on the equipment and swing from the light cords. Others are extremely wary. If there's any problem at all, I would rather pull my equipment, tear the blind down and get out of there entirely.

"I photograph most birds with my 300mm, usually at 250th or 500th of a second. The longer lenses seem to be shutter-speed critical, and so I use them at the fastest speed possible, otherwise there's a lot of vibration and the image isn't sharp. I avoid the shutter speeds below a 60th of a second until they get down to half a second, when there's enough time after the shutter opens for vibrations to dampen out. I use what, for me, is high-speed film—K 64, always working off a tripod, of course.

"A lot of my bird photography depends on whether I'm using natural light or flash. Large birds tend to nest in the open and so I can usually shoot them in natural light quite easily. To effectively stop the motion of small species, however, I need artificial light. I use several of my tiny Vivitar 102s. The main light, placed about two feet from the bird, is positioned at a 45° angle above and to the side of the lens. The fill light is six feet back and positioned alongside the lens, pointing almost directly at the subject. I often use a backlight as well, placed on the same side as the main light, to illuminate the area behind the subject and avoid an unnatural-looking black background. Nowadays I'm not photographing birds at the nest as often as I used to. The situation has been done so often that it's hard to get something fresh. And I'm increasingly concerned that, with so many bird photographers around, too many species are being stressed. My current goal is to develop a good technique to photograph smaller birds in natural light away from the nest. I'm quite encouraged with the results I've gotten so far."

The Rewards

Shaw finds photography rewarding in many ways. He explains, "I like the idea that, by choosing certain vantage points and lenses, I can frame the world. By selecting one part of the landscape and not another, I am saying *this* is important. Also, I would like to think of myself as preserving bits of time and space. When I look at one of my photographs, I can recall everything associated with being outside and taking it. I remember the exact time of day, my feelings, the fact that my feet were wet, or that it was hot. In this way, photographs are little memory triggers. Although my experience of being outside is uniquely my own, photographing it can freeze the experience into a piece of film and I can share it with other people. This has a lot of meaning for me.

"In the long run, I hope that my photographs will inspire people to care about nature and work to preserve the environment, including the smallest backyard woodlot. I think we need the idea of wildness—not wilderness, just wildness. Knowing that something is untamed and has an existence of its own completely independent of ours is very important. Through my cameras, I can find these wild things, capture them on film, and show others how interesting and beautiful they are."

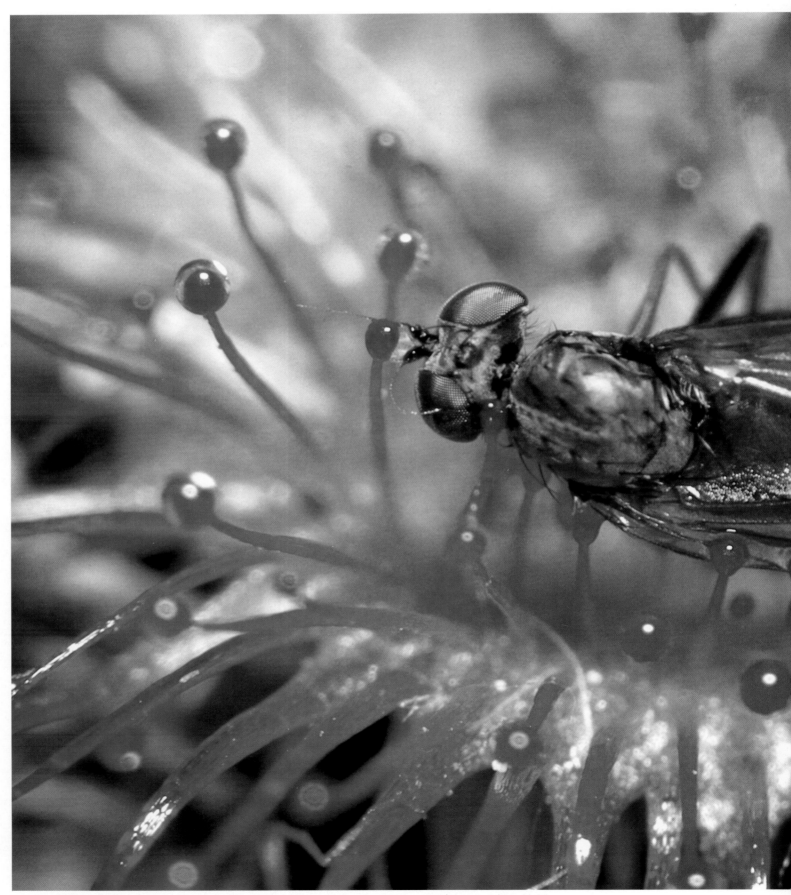

Fly on sundew: 105mm short mount used as a supplementary on a 200mm, 1/60 sec., f/22, K 25

Attracted by the sparkling lights, a fly lands on a sundew and becomes ensnared by dozens of sticky globules. The tentacles will slowly fold over the victim, which will be digested by the carnivorous plant over a period of several days. Because of the extreme magnification and stationary nature of the subject, Shaw used a tripod; ordinarily he follows insects around, shooting them with a hand-held camera. A single flash stopped the motion of the fly's wings and the plant, which swayed slightly in the wind.

Band-wing grasshopper: 105mm macro with extension tube, 1/60 sec., f/16, K 25

Black-and-yellow argiope: 105mm macro, 1/60 sec., f/16, K 25

Many normally wary insects can be approached when they are pre-occupied with something. The band-wing grasshopper (top left) was involved with egg laying, enabling Shaw to work for 15 minutes at close range without disturbing it. Attracted by a blossom's nectar, the coral hairstreak (right) was photographed in Michigan. The black-and-yellow argiope, or garden spider (bottom left), is 2½ inches long, slow moving, and builds a new web in the same area each morning, giving the photographer a chance to practice different techniques and correct mistakes.

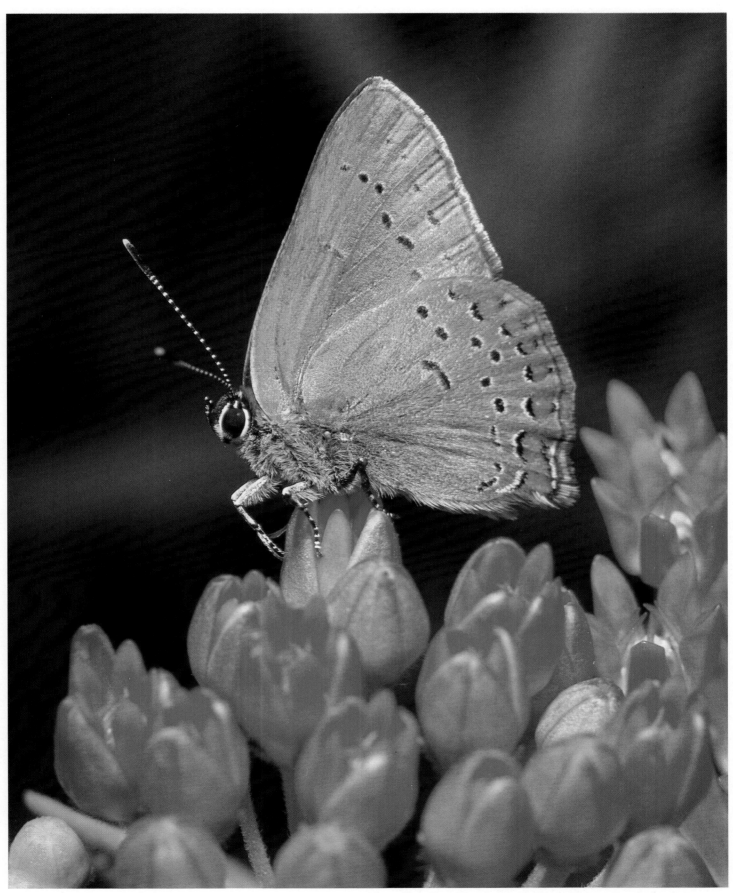

Coral hairstreak: 105mm macro, bellows, 1/60 sec., f/16, K 25

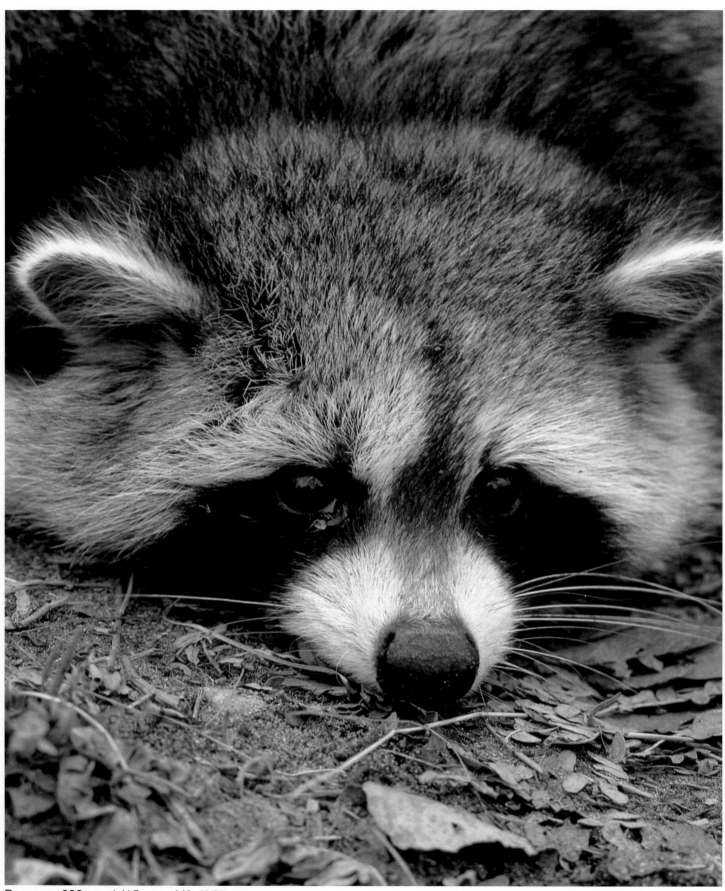

Raccoon: 200mm, 1/15 sec., f/8, K 25

Even "backyard" wild mammals are cautious, and best photographed from a blind or with patient stalking. Squirrels make good subjects for the novice because they are common, tend to stay in one area, and lose some of their wariness. Shaw shot this red squirrel (top right) from a permanent blind behind his house, baiting it close with corn and seed. Its curiosity overcoming fear, this wild raccoon (left) approached within five feet of Shaw, who was working in a low level blind beside a stream. Shaw spotted the woodchuck (bottom right) from his car and stalked it for an hour, crawling through the grass to within 15 feet. He got its attention by whistling.

Red Squirrel: 300mm, 1/60 sec., f/16, K 25

Woodchuck: 400mm, 1/125 sec., f/5.6, K 25

Cottontail rabbit: 300mm, 1/60 sec., f/5.6, K 64

After years of shooting birds with flash and a fixed setup, Shaw now prefers to use natural light, which allows him to follow the subject and photograph it in a wider range of activities. Since without flash he must use a faster shutter speed to stop movement, depth of field is limited and focus becomes critical, a particularly difficult problem with small, active birds such as the cardinal (right). The hungry rabbit (left) was photographed in the early spring, from 10 feet away, with natural light.

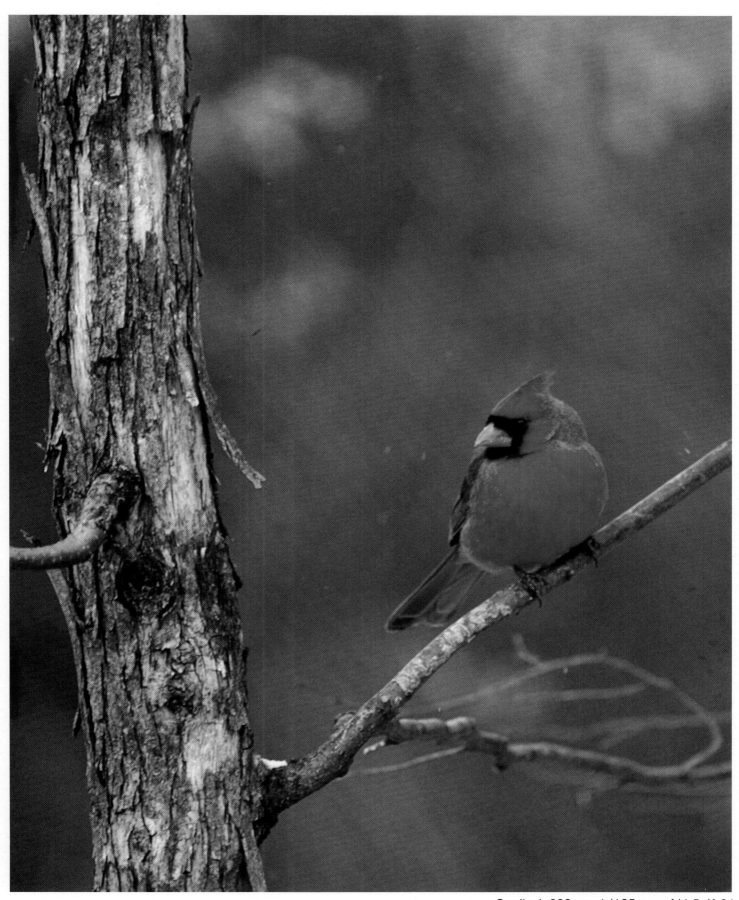

Cardinal: 300mm, 1/125 sec., f/4.5, K 64

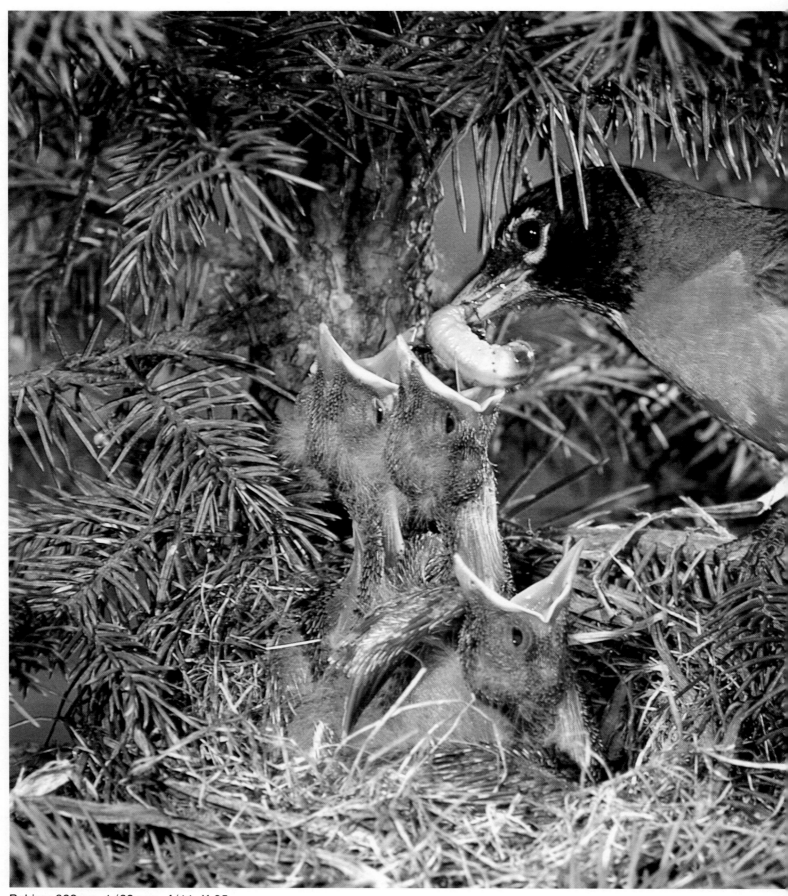

Robins: 300mm, 1/60 sec., f/11, K 25

For every photogenic nest, such as this robin's, there are 10 unsuitable ones. Shaw looks for one that is at the right height, has a natural opening through the branches for easy accessibility, and has a good location nearby for a blind. Nesting situations are very delicate; if disturbed the parents are easily frightened into deserting the eggs or chicks. Shaw puts his blind no closer than eight feet and never ties back branches, which might reveal the nest to a predator or expose the young to the deadly heat of the sun. With Shaw, the safety of the bird comes first.

ED BRY
Animals in Black and White

The art of black and white requires a special way of seeing. The photographer must interpret the range of colors before him in terms of brightness and contrast, highlights and shadows, texture and shape. When a subject is thus reduced to its purest elements, without the distraction of color, it becomes graphic and can make a statement that can be more personal and powerful than a color image

Among the handful of professional nature photographers working in black-and-white today, Ed Bry is one of the finest craftsmen in the medium. He combines an uncanny ability to capture animals in the act of doing something unusual, with a remarkable simplicity that gives his pictures impact and drama.

Born in 1924, Bry was raised in the small town of Manvel, North Dakota, which had a population of less than 200. As a boy, he helped his father in the family grocery store, but spent most of his time hunting and trapping in the nearby woods. Later, Bry worked for the North Dakota Fish and Game Department, first as a game warden, then as an editor for the state publication *North Dakota Outdoors,* a position he has held since 1963. He supplies most of the pictures for the magazine, and has also sold his work to *Audubon, National Wildlife* and *Field and Stream.*

Early Interest

Bry became interested in photography in grade school, shooting birds at a feeder with an old Ansco 620 camera, which had just three shutter speeds and f-stops. Among the first subjects he tried to portray in their natural habitats were ruffed grouse, snowshoe hares and deer. At that time Bry had no telephoto, relying on his stalking skills to get him close enough to the subjects, then either tripping the camera with a string himself or letting the animal take its own picture.

Bry has spent all of his life in his home state of North Dakota, finding pleasure in its changing seasons and the variety of its hills, woods, rivers, wetlands and prairies. Most of his photographic work is done within a few hours' drive of his home in Bismarck, usually in refuges or national parks where the wildlife is more tolerant of people than on private land. When after waterfowl, Bry looks for loafing or resting areas, such as sandbars, where they like to sit and preen. He usually finds larger animals early in the morning, or where they feed or bed down. When he isn't working from a blind, Bry shoots from a car or stalks on foot, luring foxes, raccoons, coyotes and magpies by making

A mule deer doe bounds away across the North Dakota Badlands. Bry approached slowly in his car, getting as close as 100 feet before she spooked and ran.

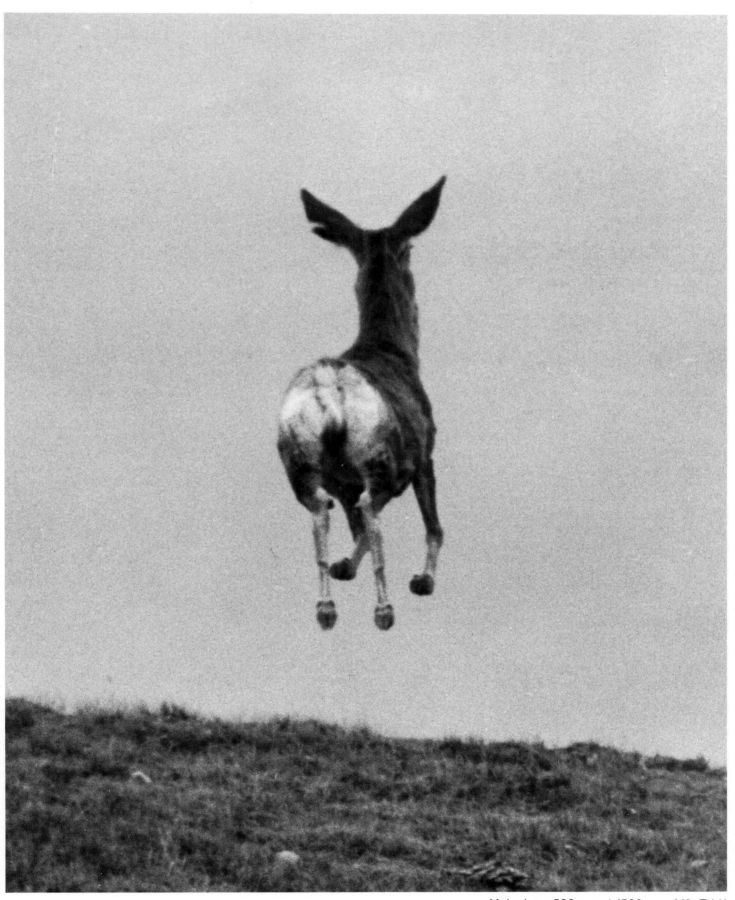

Mule deer: 500 mm, 1/500 sec, f/8, Tri-X

a squeaking sound against the back of his hand, or using a mechanical predator call, which imitates the sound of an injured rabbit. He works into the wind so the animals can't catch his scent, and either photographs with a friend, who spooks the animals toward him, or works alone, waiting for wildlife to come to him. A basic method for finding subjects is simply to stop and listen, particularly in areas where grouse strut on their dancing grounds. Sage grouse make a soft plopping noise by inflating and deflating air sacs on their chests, and sharp-tailed grouse and prairie chickens make a booming sound that can be heard more than a mile away.

Behavior

Although Bry has been observing and photographing wildlife for the last 40 years, he is still learning about their behavior. He has studied prairie chickens on their dancing grounds for many years but only recently saw a pair of the birds mate. Bry is always on the lookout for an unusual picture situation, and often his curiosity has resulted in unique photographs—and unnerving adventures.

"To me, half the success of a photograph is that it tells a story or is interesting," he says. "For many years I had been aware of a large sharp-tailed grouse dancing-ground located on the site of a prairie dog town in Theodore Roosevelt National Memorial Park. I thought this would be a good chance to photograph two wildlife species together. In late May, I set up a small pup-tent blind on the spot that would get me the grouse/prairie dog photos that I wanted. As I carried in the blind in the late afternoon, prairie dogs were everywhere, and even a few grouse flew off.

"Before dawn the next morning, I crawled into my blind and began to wait. Almost immediately, sharp-tails flocked around me but kept an unusually respectable distance from the blind. The morning was cool, damp, and partly cloudy. I lay and waited for the prairie dogs—apparently they don't like cool mornings—when suddenly I was jolted into full awareness by a strange sound behind me. I twisted around to peer through a small peekhole at the rear of the tent, and saw a huge buffalo rolling just a few feet away. I reached for a camera but before I could focus, the animal stood up and shook itself—hair and dust erupted in a cloud, all silhouetted against the rising sun. The big bull walked off behind me where I couldn't see him but I kept hearing him as he breathed heavily and fed on the short grass. I was concerned that he might investigate my blind.

"I decided to wait it out. The prairie dogs weren't up yet and I didn't have my pictures. Soon the buffalo wandered into view again, almost up to the blind. As I watched out the rear peekhole, I saw a beautiful scene—the sun was reflecting off thousands of dew drops that clung to the grass, and steam was issu-

ing from the bull's nostrils.

"Eventually two buffalo were feeding behind my blind, not so close now, but I kept a wary eye on them as I waited for the prairie dogs and took a few grouse photos. As the sun rose higher, the grouse were losing interest in their morning dance and about 25 suddenly flew away, leaving a half-dozen scattered over the area. Now a few sleepy prairie dogs began to show but none appeared in my preferred picture-taking area in front of the blind.

"Well, the buffalo stayed around, all the grouse left, the prairie dogs became more active—and I was cramped and stiff. Then another picture developed—a bull was feeding next to a prairie dog. This time I needed my biggest lens, a 500mm telephoto. I couldn't maneuver it to the peekhole behind me because of lack of room in the blind, so I crawled out and took a quick photo of a remarkable sight—a tiny prairie dog and a big buffalo together. Then I pulled up stakes, rolled up my blind, packed everything into my car and drove away, very happy with the day."

Equipment

Bry keeps his equipment and technique simple. He uses 35mm single-lens reflex cameras, Plus-X and Tri-X film, and 200 and 500mm telephoto lenses primarily, often shooting at a 500th of a second, hand-held, while sitting in a blind.

He has picked up a variety of cameras over the years, including two Nikon Fs, three Minoltas (an XG-1, XG-7, and SR-T 201) and a Fujica ST-701. His lenses include a 500mm Pentax Takumar, 200mm Vivitar Series 1, Soligor 35–70mm and 70–210 zooms, and a 135mm Komura. He keeps the 500mm on the Fujica body, mounting both on a homemade gunstock, for a combined weight of 11 pounds. Bry uses extension rings to bring the close-focusing range of the 500mm lens from 35 to 18 feet.

Bry no longer uses a separate light meter, preferring to work with the camera's built-in meter instead. When he uses his telephoto, he reads the automatic meter right through the lens. There are times, however, when the meter is misleading. Early in the morning, when available light is low, it tends to underexpose the subject, so Bry opens the lens one to two f-stops to compensate. He also does not use the built-in meter when photographing birds in flight. "I want to take them as fast as I can to stop the action," he says. "I'll go to a thousandth of a second and guess at the light reading, playing with the f-stops until I get the right one." Bry has a natural feel for lighting conditions, and usually can "eyeball" the correct available light under difficult conditions. If he is photographing a bird flying against the sky, he takes a reading from a nearby rock that has the same general color as the bird. The sky would be too bright and give a false reading, underexposing or silhouetting the bird. Bry doesn't feel

that the distance from the subject matters much; the bird will be exposed the same whether close up or far away. Bry uses a polarizing filter to darken the sky, provide more contrast and cut down on reflections. He has a Minolta 200 SX flash, which adjusts the light automatically once the f-stop is selected.

He works mostly with Plus-X film. He uses the faster but grainier Tri-X when he is using his telephoto under poor light conditions, and needs the faster film so that he can use a faster shutter speed to slow down the action, and a smaller f-stop to give greater depth of field.

Blinds

Bry does most of his work from a blind, using small pup-tents and a 4′ x 4′ x 3′ structure that he built himself out of plywood and canvas. He uses the pup-tents for shooting grouse and waterfowl, usually lying down to get a low angle. The larger blind is used when longer periods of waiting time are required, and then he often sits on a small folding chair.

If possible, he photographs in the early morning, with the blind facing west to catch the east light. He finds a place that the animals use for feeding or loafing and sets up the blind in the middle of the day, when they aren't very active. Occasionally he lures waterfowl closer with grain, but most often he likes to find a spot where they feed naturally. When photographing western grebes, for example, he found that they gathered near a small dam at the edge of a lake where the water flow attracted many minnows. He set up his blind on the shore and shot them feeding and diving, and eventually got pictures of them performing their remarkable courtship dance. A pair would suddenly stand up in the water and, necks arched, race across the surface for 10 to 40 feet, with legs churning.

Most animals adapt to the blind's presence, but there have been some notable exceptions. Bry recalls, "I wanted to photograph a lone whooping crane that was hanging out in a cattle watering-hole, so I got permission from the rancher and set up a pup-tent nearby. When I came back the next day to begin work, I found that the blind had been knocked down and completely flattened by the cattle. I managed to straighten it out enough so that I could get in it and I had started to photograph the crane when the herd of cattle came back. There was just something about the blind that they didn't like. They milled around and kept getting closer and I finally stuck my hand out and hollered at them to go away. All it did was make them angry, and they acted like they were ready to jump on the blind again. Of course, by then the crane had flown off, so I had to give up on that picture."

Darkroom Technique

Bry's darkroom is organized so that all the "wet" procedures are carried out along one side, and the "dry" ones on the other side, to avoid contaminating paper and chemicals.

Developing. Bry usually develops four rolls at the same time, loading them in total darkness onto the wire reels, which he places in a small, stainless-steel cylindrical tank, and fills the tank completely with about a quart of the fine-grain Kodak developer Microdol-X. A cover is placed on the tank which makes it lightproof so processing can be done with the lights on. Bry mixes a gallon of the fluid at a time, adding some replenisher every time he uses it, and storing it in an airtight brown plastic jug, where it keeps for up to five months. He knows that it needs to be replaced when the negatives are less contrasty than normal or the developer appears to be discolored. All of his darkroom chemicals are kept between 68 and 70° F. After adding the developing solution he taps the tank to dislodge any air bubbles that might be caught in the film, sets a timer for 10 minutes, and gently agitates the cylinder by turning it over and back once every minute. Too much motion will cause streaks on the film.

After 10 minutes, he replaces the developer fluid with a stop bath, a 28 percent acetic acid solution that halts the development process by neutralizing the alkalinity of the developer. Bry leaves the stop bath in the tank for 15 seconds before replacing it with Kodak Rapid Fix, which clears the negative by dissolving any undeveloped emulsion particles that would darken with age and eventually obscure the picture. Once again, he taps the sides of the tank to release any bubbles trapped in the coils of the film, and agitates it twice as often as before, for four to five minutes.

With the faucets adjusted to provide running water at about 68° F., Bry washes the film for about 15 minutes, using a round plastic tray with holes to let the water drain out the bottom. He then takes the film off the wire reels, carefully holding it by the edges, wipes it on both sides with a damp sponge to remove any excess water and particles that might have adhered, and hangs it to dry in a homemade cabinet—an enclosed box with rows of heavy string and clips—that can hold up to 15 rolls of film.

Printing. When the negatives have dried, Bry cuts them into strips of six and runs them through his Leitz enlarger to see if they are good enough to print. If the negative seems sharp enough, with balanced contrast, and the subject matter is interesting, he makes at least one 8x10-inch print of each. Bry prints his negatives on high-speed Kodabromide paper, selecting the grade best suited to the contrast of the negative. The softest gradation (grade one) would be used to tone down a high-contrast negative, the hardest (grade five) to improve a soft, low-contrast negative. Grade two is considered the best grade for a "normal" negative but Bry prefers to use grade three, particularly for his telephoto work. Occasionally, when he is shooting

*Except for a brief stint during World War II, **Ed Bry** has lived his entire life in North Dakota. The editor-photographer of* North Dakota Outdoors, *a magazine published by the state fish and game department, Bry devotes his photographic energies to documenting the behavior of prairie wildlife. His work has appeared in* Audubon, Field and Stream, National Wildlife *and the books of Chanticleer Press.*

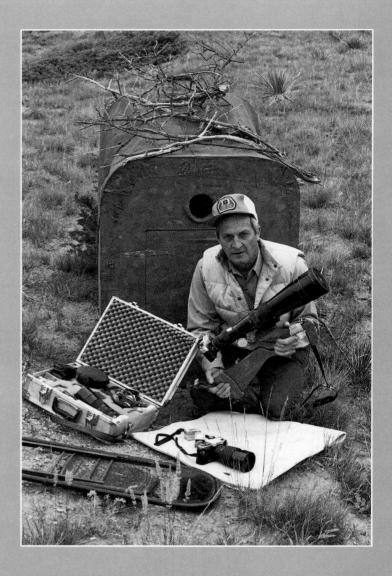

USING TELEPHOTO LENSES

Ed Bry does most of his work using his two favorite lenses, an old Takumar (Pentax) 500mm telephoto and a Vivitar Series 1 200mm telephoto. Although he emphasizes that the photographer should still try to get as close to his subjects as possible, Bry's telephotos are invaluable to him.

The most important use of a telephoto lens, of course, is that it magnifies the image and brings the subject closer. But just as useful as the magnification are two other characteristics of telephoto lenses: a narrow angle of view and shallow depth of field. These two factors become particularly valuable when the subject must be isolated from cluttered surroundings. A small animal in a large patch of tangled brush, for example, will stand out when photographed with a telephoto because the distracting brush behind and in front of it will be out of focus, and brush on either side will not be in the frame at all. An additional advantage of the shallow depth of field of a telephoto lens is that it becomes possible for the photographer to shoot *through* nearby vegetation to a distant subject. If the lens is set at its widest aperture, the vegetation will be recorded as an out-of-focus blur, or may not register at all. By using this technique, the wildlife photographer can stalk his subject from behind a screen of grass or bushes and still get a good shot without revealing his presence.

Bry cautions that a good deal of practice is needed to use long telephoto lenses well. Because they have small apertures, they are often not very useful in marginal light conditions. The magnification provided by a telephoto lens also magnifies camera motion, so it is important to hold the camera as steadily as possible. Bry rarely uses a tripod, instead bracing the camera against a tree, his knee, the outside of the blind, or his car window. He has devised a strip of narrow rubber tubing, slit down the center, that fits tightly over the edge of the window glass and provides a nonskid brace. To further cut down on camera shake, he tries always to use the fastest shutter speed possible. He suggests using a speed that is close to the numerical value of the focal length of the lens; for a 500mm lens, try to use a shutter speed of a 500th of a second, and for a 200mm, a 250th of a second.

early in the morning and the light is low, he will punch up the contrast of the film by using grade four paper. Bry is now switching over to polycontrast paper, however, where the contrast of the negative is corrected with filters on the enlarger, rather than with various grades of paper.

Like film, photographic paper is coated with a light-sensitive emulsion. When an enlargement is made, light is passed through the negative onto the paper, with the aid of a lens. Bry uses a Leitz enlarger, which is mounted vertically on a column and can be raised and lowered to regulate the distance from the lens to the paper, thus controlling the sharpness and size of the image. He crops the picture at this stage, eliminating extraneous detail and composing it for maximum impact.

In the printing process, exposing, developing, the stop bath and fixing are all carried out under an amber safelight—a special work light that will not affect photographic paper. Bry cleans the film of lint, puts it in the enlarger emulsion (dull) side down, places paper on an easel at the base of the enlarger, turns the enlarger light on, and makes the exposure. Using his hands under the light, he remedies any deficiencies in the negative by dodging: holding back light from the shadow areas to prevent overprinting, and burning extra light into areas of the negative that are too dense.

When he thinks he has a satisfactory image, Bry immerses the print, emulsion side up, in an 8x10-inch tray containing Kodak Dektol developer for about one-and-a-half minutes, judging the time more by appearance of the print than by the clock, although if it is left in the fluid too long, the print will stain. Holding it by the edges with a pair of tongs, he drains off excess fluid and slides it successively into a tray containing the stop bath, which he agitates for 15 seconds, then into the acid fixer, agitating it for 10 seconds, and continuing to move it about occasionally for another five minutes. He is careful not to let the developer tongs come in contact with the solution. He then transfers the print to the washing tray for 30 minutes or longer, until all traces of the fixing solution are removed. Otherwise, the print will eventually turn yellow. Finally, he feeds it into an electric drying drum for five minutes.

Printing his own work is the most rewarding part of black-and-white photography for Bry. He can heighten or reduce the contrast, warm or cool the tones, soften or sharpen details—in short, he can actually improve on the image that the camera recorded. "I can print them the way I want to," he says, "and I think I do a better job than a commercial printer because I'm more careful. They're my work and I worry about them looking good. They don't have any blemishes if I can help it. People send me pictures that they want me to use in the magazine and often the quality is bad. Recently I received six prints, three of which had no contrast and the other three were covered with white spots from dust on the negatives. I couldn't believe how awful they were."

Advice for Beginners

Bry discourages new wildlife photographers from buying a big telephoto lens, such as a 500mm, which is hard to master. He suggests beginning with a 200 or 300mm lens, and learning the use and advantages of the different f-stops and shutter speeds of the camera without relying blindly on the automatic meter. Bry feels that it is important for photographers starting out with black and white to do their own developing and printing. That way, they will carry the process through from beginning to end, and have more control over the final product. As they learn how to improve the negative and make better prints, they will develop a keener eye and a better way of seeing things.

"I believe we are missing out on much if we do not develop the knack to really see," says Bry. "Having the ability to spot wildlife quickly is really more the result of experience and training than having good eyesight. Naturally, those who spend more time out-of-doors looking at nature, whether hunters, photographers, or ranchers, have the greatest chance to develop eyes that are quick to see things."

"Last winter I traveled across the state in a caravan of five carloads of people, all of whom do not spend much time outside. Upon arriving at our destination, I remarked about the unusual sight of four snowy owls perched on highline poles near the highway. Only one person in the other four cars had spotted them. Here were birds that few of these people had ever seen and would like to see but even the out-of-place whiteness on top of the poles wasn't noticed.

"We should all practice being more observant. Learn to look for the unusual, for what doesn't appear to be in place. Maybe that spot on the hill is a sleeping fox, that dark patch in the marsh might be the ears of a deer, a swatch of color could be litter or it might be an uncommon wildflower, maybe that little bit of white far out in the field is a rare whooping crane. The beautiful outdoors is there for everyone to see—if you really look."

Whooping cranes: 200mm, 1/500 sec., f/11, Tri-X

A trio of whooping cranes flying over a deserted farmstead near Goodrich, North Dakota, evokes a feeling of nostalgia. Small groups of these endangered birds migrate through the center of the state every spring and fall, en route from their breeding grounds in Canada to Aransas National Wildlife Refuge on the Texas coast, where they winter. The cranes were more than 400 yards off, almost beyond range, when Bry saw them approaching the abandoned building, and quickly grabbed his camera to capture the scene.

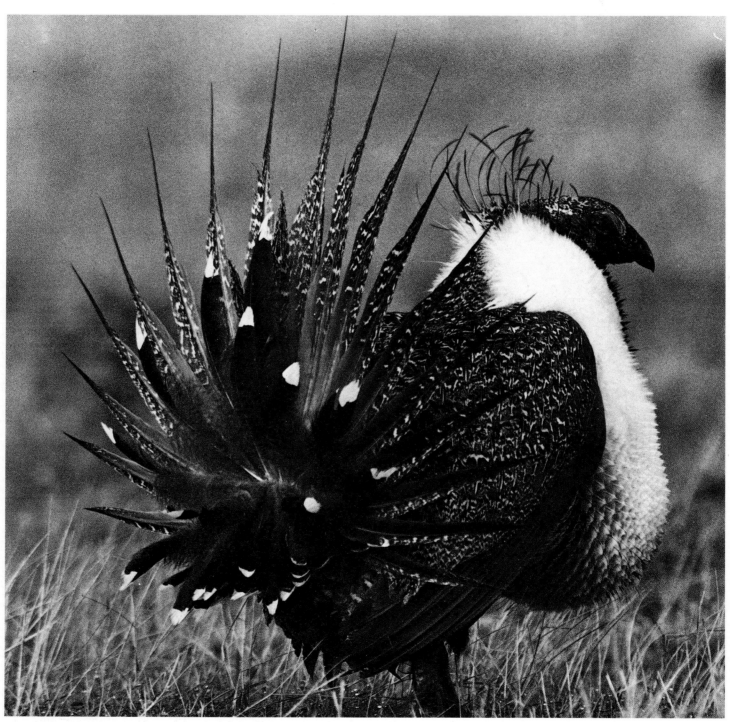

Sage grouse: 500mm, 1/250 sec., f/5.6, Tri-X

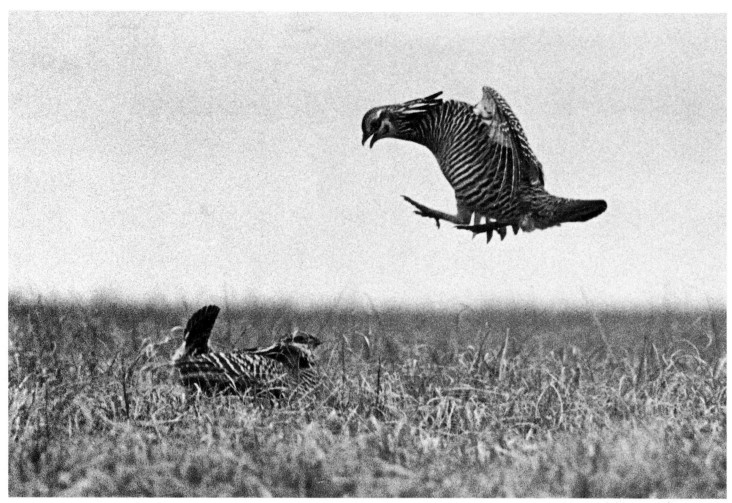

Greater prairie chickens: 500mm, 1/500 sec., f/8, Tri-X

North Dakota is home to several species of prairie grouse, which gather in groups on dancing grounds where the males bow and strut for the attention of the females. A displaying sage grouse (left) has two air sacs on its chest that deflate with a popping sound. Leaping into the air, male greater prairie chickens (top right) fight for boundary rights where their territories meet. Serious damage rarely results; the only losses are feathers and pride. Unlike its relatives, the male ruffed grouse (lower right) displays alone, drumming on a log or rock in the woods. Bry photographed this one from a blind 15 feet away, waiting for its wings to slow at the end of a roll.

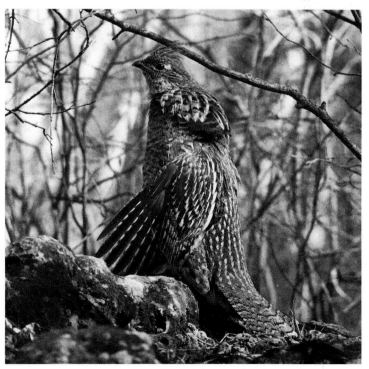

Ruffed grouse: 200mm, 1/250 sec., f/5.6, Tri-X

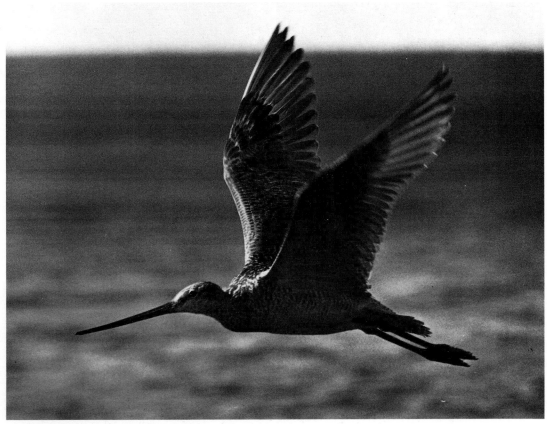

Marbled godwit: 200mm, 1/1000 sec., f/16, Plus-X

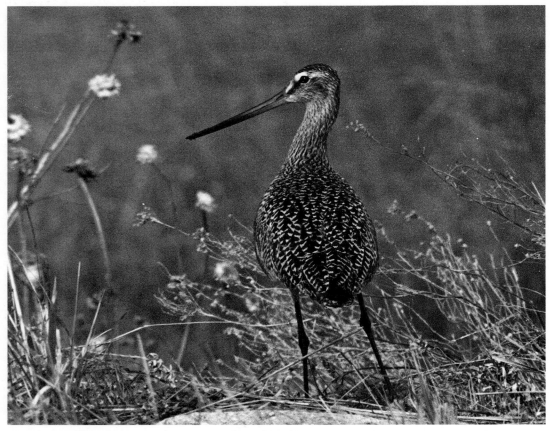

Marbled godwit: 200mm, 1/250 sec., f/5.6, Plus-X

Prairie wetlands are Bry's favorite habitat. He approached within 15 feet of a marbled godwit (bottom left) by shooting from his car window as he drove along a road at the edge of a slough. The godwit in flight (top left) was attempting to chase the photographer away from its nest. Bry guessed the distance between them, prefocused his lens and panned with the bird as it flew past 20 feet away. The 13-lined ground squirrel (right) was eating grass along a lake shore. When Bry squeaked his finger against his lips, it paused long enough for him to get this closeup photograph.

13-lined ground squirrel: 200mm, 1/500 sec., f/11, Plus-X

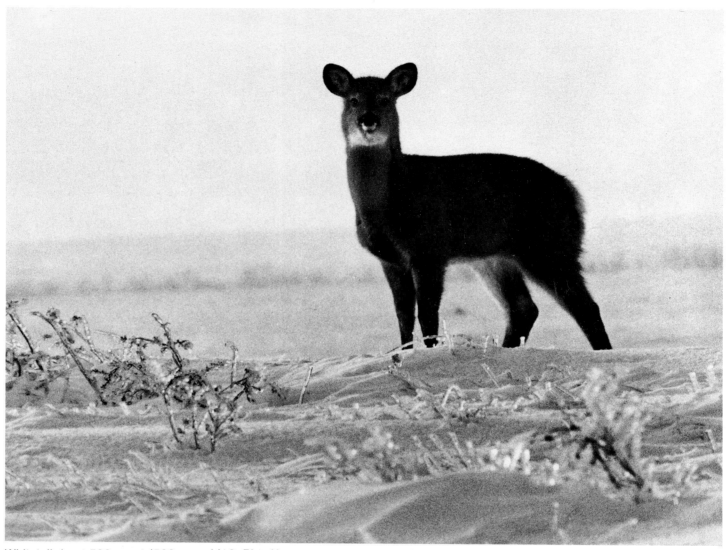

Whitetail deer: 500mm, 1/500 sec., f/16, Plus-X

Cottontail rabbit: 200mm, 1/500 sec., f/16, Tri-X

Animals become less wary in winter, when shelter is hard to come by and food is scarce. After a snowstorm Bry was able to get within 50 feet of a white-tailed doe (above) as she foraged in an open field. The mourning dove (right), its feathers ruffled in an attempt to stay warm, was rescued during an unexpected May blizzard, in which thousands of creatures perished. In spring, when the river bottoms flood, slushy conditions force many animals from their natural habitats. Bry surprised a cottontail rabbit (bottom left) far from its home base in brushy thicket. He focused quickly and snapped the picture from just 15 feet away.

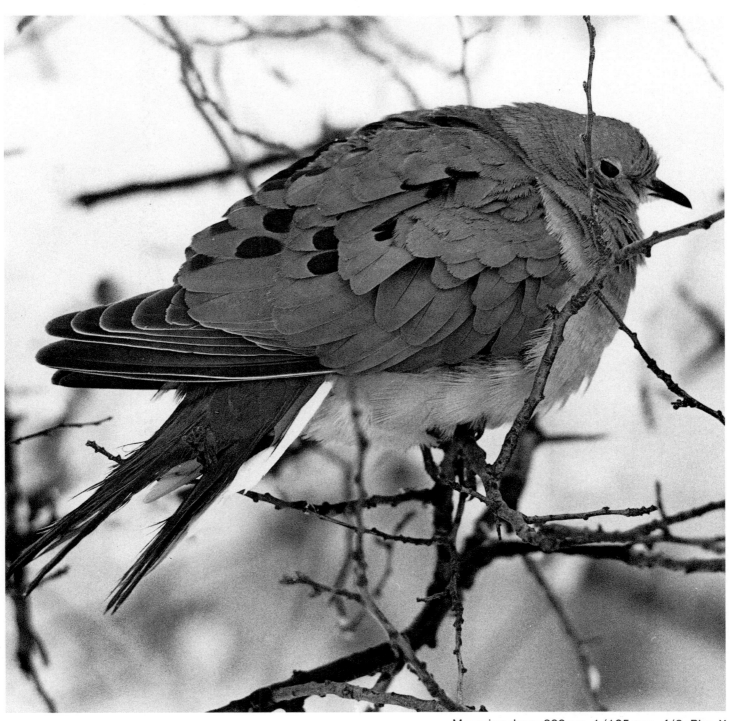

Mourning dove: 200mm, 1/125 sec., f/8, Plus-X

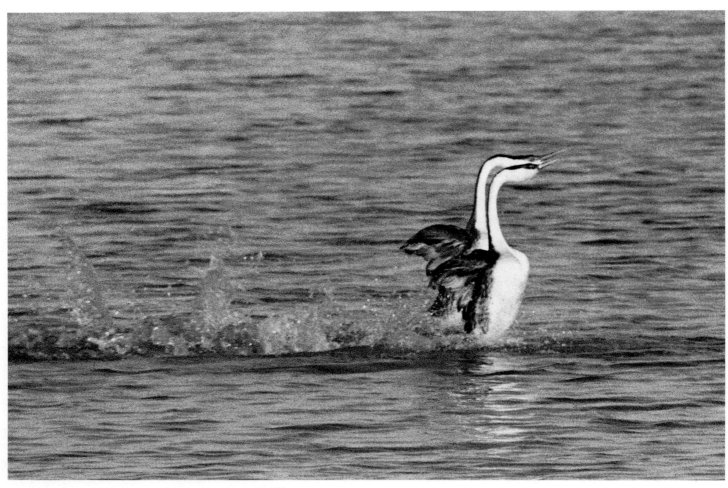

Western grebes: 500mm, 1/500 sec., f/16, Tri-X

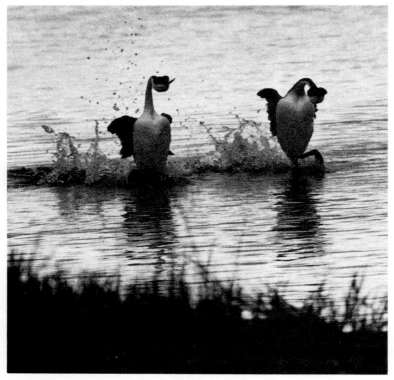

Western grebes: 500mm, 1/500 sec., f/16, Tri-X

Bry photographs most wildlife from a blind, and hours of patient watching have rewarded him with some remarkable behavior sequences. He captured the rarely seen courtship dance of the western grebe (top and bottom left) at Long Lake National Wildlife Refuge near Moffit, North Dakota. Since each dance lasts just 10 seconds, Bry had to guess which of 30 pairs were about to perform by observing their elaborate bows and curtsies, and other pre-dance signals. The avocets (right) were courting at Rice Lake. He photographed them from a blind 30 feet away, as the female postured before the male.

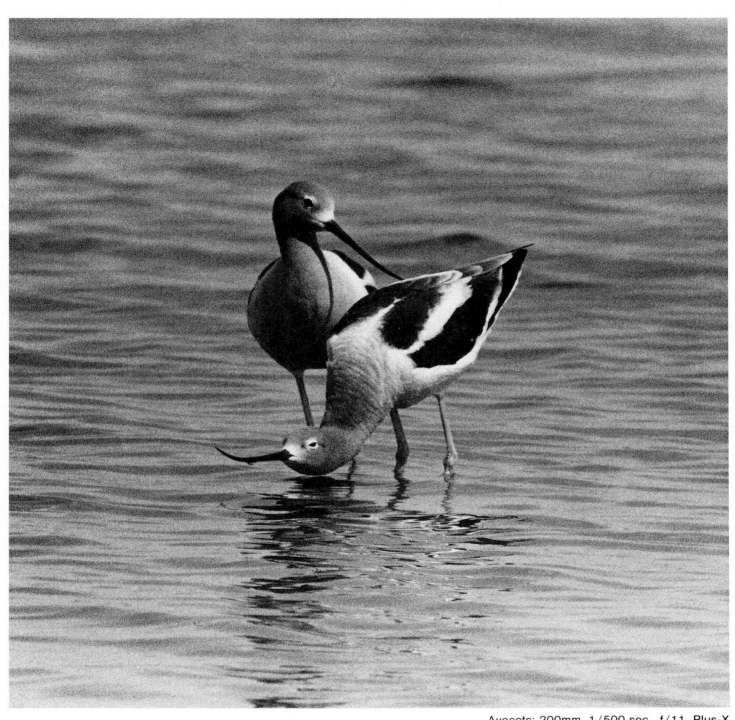

Avocets: 200mm, 1/500 sec., f/11, Plus-X

GARY R. ZAHM
Purveyor of Mood

A flock of pintails feeding and preening in a prairie marsh at dawn are suddenly alert. Heads turn nervously, necks shoot up, and bodies tense as they prepare for flight. Easing quietly into the water behind them, a hunter has been steadily moving closer, screened by cattails, until he is only 25 feet away. As the ducks explode out of the water he swings his gunstock and fires, catching one of them just as it hits the top of its climb. Timing is everything in shooting, whether the hunter has a gun or a camera.

Gary Zahm, an accomplished sportsman most of his life, has found that his background in hunting has served him well as a wildlife photographer. "I can still go out any time of the year when waterfowl are around and set out decoys and hunt with a camera," he says. "In essence I'm still doing the hunting except for the shooting. My training as a hunter has taught me the subtleties of animal behavior and sharpened my eye. I wear clothing that blends in with the landscape, move through shadows to minimize sun reflection, and always approach downwind, hiding in natural cover to get close to the subject. I think these stalking skills are part of my success."

Born in Rockford, Illinois in 1942, Zahm received a degree in wildlife biology from the University of New Mexico at Albuquerque, and became a field biologist with the U.S. Fish and Wildlife Service. He worked at Bosque del Apache National Wildlife Refugee, 100 miles south of Albuquerque in the Rio Grande Valley, then spent four years at the Lake Andes National Wildlife Refuge complex in South Dakota, where he came to appreciate the remoteness, open spaces and spectacular light of the prairies. He is currently refuge manager at the San Luis National Wildlife Refuge complex at Los Banos, California, where he administers three local refuges: San Luis, Merced and Kesterson.

Zahm became interested in photography as part of his work, and soon began to look critically at wildlife pictures published in the sports and hunting magazines. He thought that many seemed to be posed and fake, and decided to try to photograph wildlife as he had seen it all his life—through the eyes of a hunter. He has shot mainly in color, but Zahm was influenced, in part, by the black-and-white work of H. K. Job, who photographed waterfowl in flight in the 1940s. Zahm's first work was sold in 1974, and he has since published 500 photographs in such magazines as *Audubon, National*

Wildlife becomes less wary in storms and can be approached more readily. A blizzard drove this hungry western meadowlark to some exposed wild sunflower heads filled with seeds. Zahm eased his truck to within 35 feet, shooting from the window to get an unusual closeup portrait.

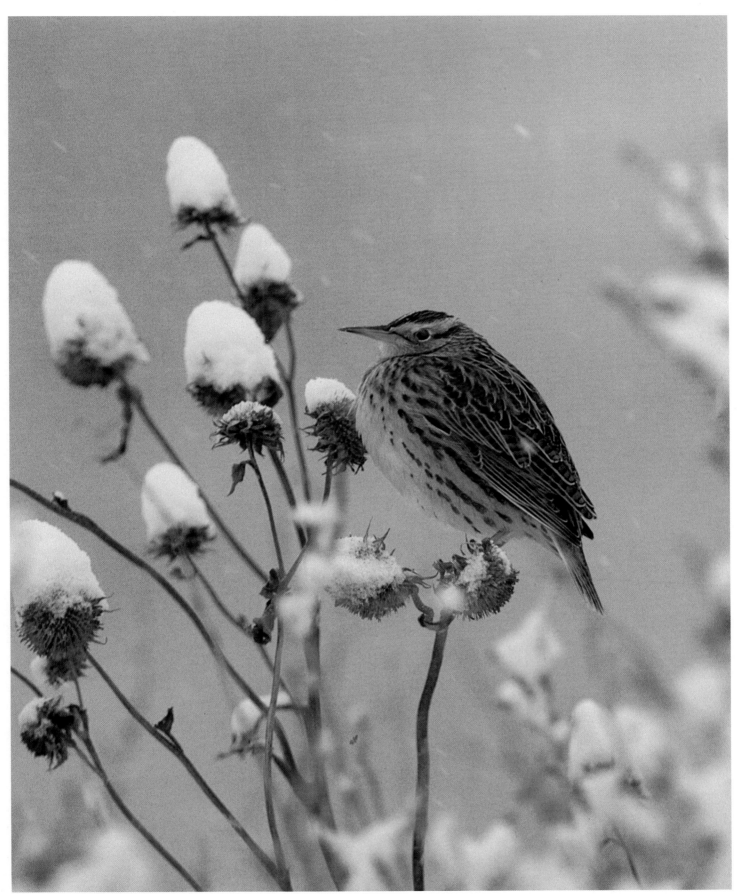

Western meadowlark: 500mm, 1/125 sec., f/8, K 64

Wildlife, Reader's Digest, Sports Afield, Outdoor Life, Field & Stream, The American Hunter and *Das Tier*. He has also had pictures in Sierra Club and Audubon calendars as well as many books.

Waterfowl

Snow geese are Zahm's favorite subject and, over the years, he has portrayed them in every conceivable manner: flight and behavior shots, habitat photographs, closeups and portraits, at all times of the day, in all types of weather, and throughout most of the year. Almost two million snow geese winter in the United States, migrating south from their nesting grounds in the Arctic, along the Atlantic, Central and Pacific flyways. Many thousands move into the prairie "staging areas" to graze in marshes and stubble fields before continuing the journey south. Zahm photographs them there in the late fall and again in the early spring, as they make their way back to the tundra to breed. "Snow geese are very noisy and showy, with their white and black coloration," says Zahm. "They are up and moving around at dawn, and there is a lot of commotion in the roosting marsh before they move out to feed. The geese usually take off in large flocks that stretch out for about an hour as they leave the roost, so I get many chances for flight shots. When they move into the fields to feed there is a lot of swirling. Around midday, they come back to the marshlands to drink water and pick up some grit, which aids digestion. They'll loaf and preen until two or three o'clock, then move back out to the feeding areas, giving me another chance to photograph them leaving the roost."

Bait

Zahm lures gamebirds, such as wild turkeys and quail, with food that the species would be eating naturally at that season of the year. He concentrates his photography in areas where the birds are feeding, whether it's a cornfield during a snowstorm or a wild smartweed patch at the edge of a marsh. He scouts the location ahead of time, noting tracks and places of heavy activity. Rather than pile the food in unnatural-looking mounds, Zahm scatters two or three gunny sacks over a wide area in front of the blind, so that the birds will find it in the normal course of their feeding activities.

Small Birds

Because of their size and because they are rarely found in flocks, small birds are harder to get close to than waterfowl or gamebirds. Zahm finds the meadowlark particularly difficult to photograph, although it is one of the most common birds in North America. Since it is small, he must get within 35 feet of it with his 500mm lens to almost fill the frame, but meadowlarks will rarely allow a vehicle to approach closer than 50 feet. Often, the only way to get near such species is to come upon them during adverse weather conditions, such as a blizzard, when their main source of food is covered up and they are hungry enough to lose some of their caution.

By comparison, redwing blackbirds are easy to photograph. They associate in noisy and active territorial groups and will tolerate quite a bit of human disturbance. Each male stakes out a small area in the cattails to attract a female, defending it vigorously against all rivals. Redwings are so named because the males have bright red shoulder patches, or epaulets, which they fluff up during courtship display. From years of observing them, Zahm knows that when he sees a male begin to bob its head and spread its wings and tail, he has about two seconds to get ready before the bird's epaulets are raised and it begins to sing.

Zahm likes to get as close to his subject as possible. Since his 500mm telephoto lens will only focus as close as 33 feet, he inserts an extension tube between the lens and the camera, which allows focusing to 15 feet. He gets his reading from the camera's meter, preferring to shoot at a 250th of a second to stop most of the action. He tries to use as small an f-stop as possible, such as f/11 or f/16, which assures a good depth of field so that most of the picture will be in focus. The overall sharpness also improves the color quality of the image. Zahm will always sacrifice shutter speed to maintain depth of field.

Blinds

Zahm often uses his vehicle as a blind, and recommends the car routes that have been established in many of the state and federal refuges and parks. These wind through a diversity of habitats, among animals that have become used to such disturbances and so are less wary and easier to approach.

Zahm prefers to go after his subjects rather than wait for them, and so rarely uses blinds. However, he owns two portable blinds—one made of burlap and another made of nylon, with permanent funnels through which lenses can be interchanged without upsetting the subject. He sets up a blind in natural cover, with the opening at the back in dense vegetation so that he can crawl into it unseen. He has found that normal camera noises in a blind do not disturb wildlife. They may raise their heads and look around, but as long as they don't see movement they think of it as a strange sound, not danger.

When a blind is left up overnight or longer, it can become a temporary haven for various forms of wildlife, not all of them welcome. Zahm always checks for snakes when he first enters in the early morning, and once he glanced up to find 15 wasps hanging overhead. Stinging insects pose a major problem with blind work. Zahm doesn't want to swat them and scare his subject, so he tries to work them into a

corner and pinch them with a soft hat, or coax them out of one of the blind openings. Once, when he returned to a blind after a week away, he found that a black phoebe had built its nest inside. Zahm abandoned the blind to the bird.

In summer on the prairies, the temperature inside a blind can reach 120°, and with the high humidity around the marshes, when the wind blows, the blind becomes an oven. In winter, Zahm has worked in bone-chilling blizzards, when the temperature often drops to −20° and the wind sweeps across the open fields at 50 miles an hour. He relies on down clothing and insulated boots for warmth, but has found that his equipment still functions without special winterization if the batteries are fresh.

Equipment

Zahm uses Canon equipment, including two F-1 camera bodies, an MF motor drive, and nine lenses: a 28mm, 35mm, 50mm, 50mm macro, 100mm, 135mm, 200mm, 300mm and a 500mm fluorite telephoto, which contains fluorite crystals that intensify the light and eliminate most of the color distortion, giving as true a color as the eye sees. He has received many comments from editors on the color quality of his pictures, which he attributes in large part to the properties of this lens. Zahm also owns a Vivitar 283 flash unit, cable releases, and two tripods: a heavy-duty Leitz Tiltall and a small Vivitar tripod that collapses to 12 inches, for flower photography.

Zahm uses Kodachrome 64 exclusively, which he rates as ASA 80 on the camera's meter. At ASA 80, the meter tells him that more light is available than it does at ASA 64, and so he tends to shoot at either a higher f-stop or faster shutter speed. Zahm feels that he gets a better picture by deliberate underexposure.

Lighting

Like most wildlife photographers, Zahm prefers to shoot early in the morning and late in the day, when the light is softest and the animals are most active. He feels that the best lighting of all is during the last two hours of the day, but now that he is away from the pure air of the prairies, and has to contend with dirt, dust and chemicals from California farm operations and industrial haze and smoke, he finds that the quality of light deteriorates rapidly, and he loses two f-stops as soon as the sun begins to set. Now he has to start three and a half hours before sundown to get what he wants.

"Lighting changes so much that you just have to experiment," says Zahm. "You can do whatever you want with it. If you planned to shoot with front light but the sun is setting, go around to the other side and use the back light to get some silhouettes."

When shooting directly into the sun, Zahm often tries to include the little starbursts that come through flooded marsh vegetation and other foliage at that time of the day. He often backlights his subjects during the middle of the day, when the light is harsh. Zahm prefers to shoot at very small apertures, f/16 or f/22, which give him good depth of field, and also to use a fast shutter speed, up to 1/1000 of a second, which stops the action to the point where he can catch the light coming through the wing feathers of a duck in flight. He tries to include some green foliage in the picture, which helps absorb some of the light's harshness.

Zahm also finds side-lighting an interesting technique. It gives modeling to the subject, revealing the musculature of a deer or the depth of a duck's body. Since there is less available light in this situation, he usually shoots at a 250th of a second at f/8.

One of the most difficult lighting problems is shooting into a blue sky, when camera meters usually give a false reading, since they are designed to average the light. To compensate for this, Zahm exposes for the subject, not the sky. Although he generally uses the built-in camera meter, quite often he will under or overexpose a subject. When shooting a white bird against the sky, he compensates for the additional brightness by closing down at least one f-stop, so that the meter reads f/8 he will shoot at f/11 or f/16. On the other hand, when photographing flight shots of dark ducks, he opens up one f-stop (sometimes two), shooting at f/5.6 instead of the f/8 indicated by the meter. This may wash out the sky somewhat by gives good light on the subject.

Since he photographs waterfowl most of the time, Zahm has learned to work with the natural glare off the water rather than compensate for it. He feels that exposing for the actual light conditions rather than trying to get feather details will usually result in a more dramatic picture. He uses the highest f-stop possible to get some unusual effects. A haze filter, along with the built-in coating on the lens, cuts down on flare. Zahm takes into account the reflection of the bird on the water as well as subject itself. A picture of a horizontal duck can be greatly enhanced by shooting it vertically to include its reflection, which often transforms a documentary picture into an art image.

To capture the iridescent color of a duck head or wing patch, called the speculum, Zahm waits patiently until the bird's feathers catch the light at the right angle. A mallard's head can be bright green or dull black, depending on how it turns in the light from one minute to the next, and Zahm always takes several shots to make certain that the camera has recorded what his eye has seen.

Often, the difference between an average wildlife shot and an excellent one is whether or not the animal's eye has a highlight. Otherwise, the eye blends in with the head and the subject appears lifeless. Zahm approaches an animal with that in mind, composing

STALKING WATERFOWL

Gary R. Zahm, *a refuge manager for the U.S. Fish and Wildlife Service, has been photographing and writing about wildlife on a freelance basis for ten years, with more than 450 photographs published to date. While his pictures cover all aspects of the natural world, he is best known for his images of waterfowl in action.*

Although he has photographed a variety of animals, Zahm tends to concentrate on the many species of waterfowl because of his long association with them. He is most interested in action and behavior, and specializes in flight and courtship photographs. "Seasonal timing influences my choice of subject," says Zahm. "Fall and winter bring migrant waterfowl and other birds in large concentrations, spring offers subjects in good breeding plumage, while summer is the time to photograph new families."

Most waterfowl behave in basically the same way, but mallards and some of the other ducks that Zahm photographs, including pintails and teal, are found in smaller numbers and tend to be more wary. Zahm either stalks them through the wetlands or brings the ducks to him, using traditional hunting techniques. When stalking birds, Zahm makes use of natural cover, such as clumps of cattails, shrubs and other vegetation. To lure waterfowl close enough to where they are circling or actually cupping their wings and getting ready to sit down, Zahm sets out decoys. Ducks are gregarious, associating with their own kind, and when they see decoys riding quietly on a lake or river they assume that it is safe to land. However, Zahm has found that once they settle among the decoys, the ducks are rarely fooled by them. When a friend moved an electronic decoy, which quacked and swam by remote control, into a flock of wild mallards, the ducks did a double-take and promptly took off. "Decoys may not always be accepted by the birds, but they sure can fool other hunters," says Zahm with a laugh. He recalls that one winter, while he was patiently waiting for some Canada geese to come into range, he was startled to hear a gunshot just behind him and looked around to see a hunter shooting into the decoys that he had carefully positioned in the field.

Zahm mounts a camera body, motor drive, and his 500mm lens, which together weigh 10 pounds, on a gunstock, and uses this combination for virtually all his wildlife photography, usually shooting at a 250th of a second, between f/5.6 and f/11. "It's a throwback to my hunting days," he says. "Shooting a picture of a flying duck is about the same as shooting the bird with a gun. There is a certain point in time when the bird's action is just about stopped, such as when it's coming in to land, or starting to take off. That's the time to shoot it. I think my training as a hunter helped me understand the importance of timing."

the picture long before he shoots it. He looks for good front or side lighting to pick up the eye highlight and feels that it makes or breaks the picture. "Either I get the highlight or I don't take the photograph," says Zahm.

Mammals

Because they have dark coats and tend to stay in the shade, mammals are more difficult to photograph than birds. Zahm feels that the only time one can really get good closeups of the big animals is during the breeding season in the late fall when they lose some of their caution. He works in refuges and parks, such as Yellowstone and Glacier, where the animals are never hunted and so are less likely to spook—and where he is more likely to find trophy-size specimens.

Most people do not have enough respect for wild animals, which can get them into trouble. Zahm has seen tourists getting between females and their young, or walking right up to have their pictures taken alongside a wild bull moose. Although he thinks ahead when photographing big mammals, and tries never to corner them or allow them to corner him, Zahm had an unnerving experience while photographing pronghorn antelope in Custer State Park in South Dakota. "I was following two big bucks over a ridge and as I crawled to the top, I looked down and counted 300 bison trotting rapidly up the hill. When you're out in the open far from your car, with a herd of bison coming right at you, including some 1,000-pound old bulls, it can scare the hell out of you. I plastered myself to a nearby pine tree and held my breath as the animals lumbered by. Needless to say, I left the antelope for another time."

Although he has never been treed by an animal, Zahm once was forced out of a tree by one. He was photographing a fishing scene in Oklahoma and thought he smelled a water snake nearby. He looked and looked around his feet and then just happened to turn his head. Water snakes can climb trees and there it was, just eight inches from his face. Zahm left in a hurry.

Advice for Beginners

When he was starting out, Zahm feels that he failed to scrutinize his pictures carefully enough before submitting them to magazine editors. "They weren't sharp," he says, "and the subjects didn't fill the frame the way they should. I failed to get close enough and didn't have adequate lenses. Not everybody can own the most expensive equipment, but you should try to get the best lens you can afford. I've taken out a lot of newspaper people and photographers during my work, and I notice how they see a mammal coming toward them and just snap the picture, without thinking about how far away they are or whether the lighting conditions are acceptable. Often they just have a 200mm lens and are using inferior types of film, so naturally they are going to be disappointed with the images they get."

Zahm recommends that beginners carefully study wildlife pictures in magazines to become familiar with the quality expected of published work and to learn the habitat in which the animal was photographed, so that they can look for the species when they walk around in a similar area. Most of the hunting magazines publish information on tracking and animal behavior—tips equally useful for the photographer as well as the hunter. State travel and fish and game publications give local information indicating which lands are open to the public and when waterfowl are most likely to arrive and depart from the area.

"Action, composition, color and sharpness are the keys to getting a good photograph. I also look for mood, like a thunderstorm or an eerie fog bank, to give my pictures a surrealistic quality," says Zahm.

"The best thing is just to get out as much as possible, to a refuge or city park, and observe the animals. Every day that you're out, you learn something. Notice what the animals are doing, what time of day it is, what time of year. Knowledge of the subject is the most important aspect of good wildlife photography."

Zahm feels a deep responsibility to portray the country's wildlife in its natural habitat, with all its color and exciting behavior. "Through my photography I hope to gain public support for the perpetuation of wildlife," he says, "so that future generations can continue to enjoy what we presently take for granted. I shoot a lot of film, but I spend a lot of time not even photographing, just observing. I'll usually have some binoculars with me, a small pair of Bushnell 7 x 26 custom compacts that I keep in my pocket, and I'll look at different birds while I'm out shooting. Many times I'll just sit and watch waterfowl swirl around. That's really part of it for me. I enjoy being outdoors during all seasons and in all weather conditions, and I like the solitude of being alone with wildlife. Since I love being out in the field, photography makes it all the better."

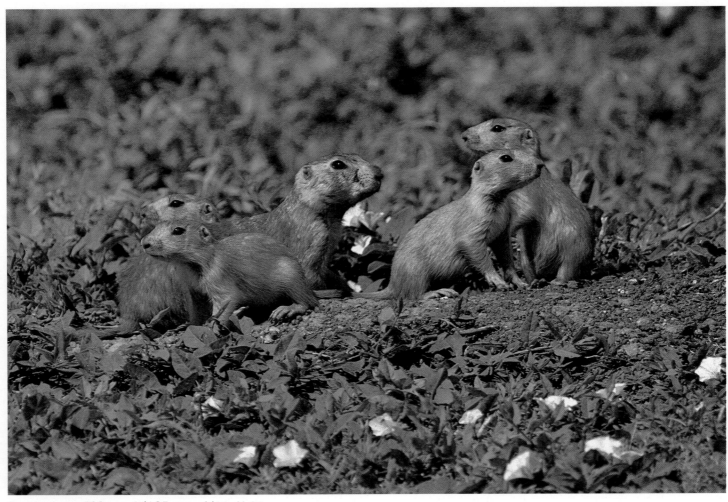

Prairie dogs: 500mm, 1/125 sec., f/11, K 64

Often light sets the mood for a photograph. More curious than fearful, a family of prairie dogs (left) was photographed at midday, from a blind placed in the center of a prairie dog town in South Dakota. Zahm underexposed one f-stop to get the correct exposure for the animals and compensate for the dark tones of the background. To capture the bull elk (right), soaked with heavy dew, Zahm crawled downwind a hundred yards through deep grass. The early morning light softens the portrait.

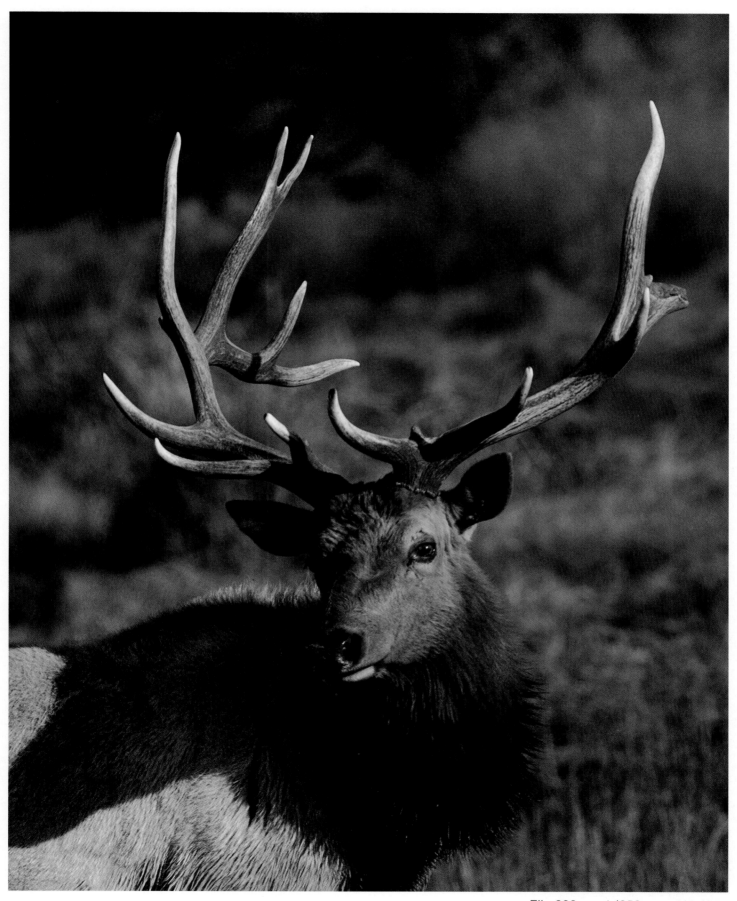

Elk: 300mm, 1/250 sec., f/8, K 64

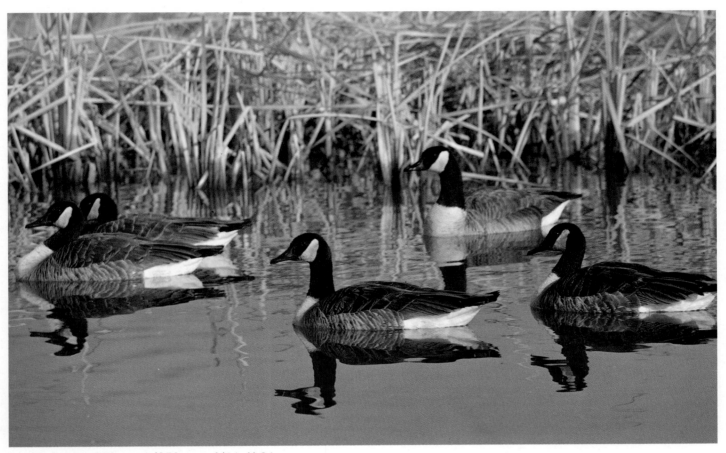

Canada geese: 300mm, 1/250 sec., f/11, K 64

Long-billed dowitchers: 500mm, 1/60 sec., f/16, K 64

Sometimes, including the reflections will turn an ordinary photograph into a work of art. Waiting in a blind at the edge of a marsh in New Mexico's Rio Grande Valley, Zahm heard the gabble of approaching Canada geese (top left) and swung his tripod to pan with the swimming birds. He carefully framed the picture of the long-billed dowitchers (bottom left) to include their reflections as well. The snow geese (right) were wading in shallow water near their evening roost at Bosque del Apache National Wildlife Refuge, New Mexico. Zahm underexposed the picture one and a half f-stops to allow for the birds' reflective surfaces, and chose a vertical format to accentuate the flock's natural composition.

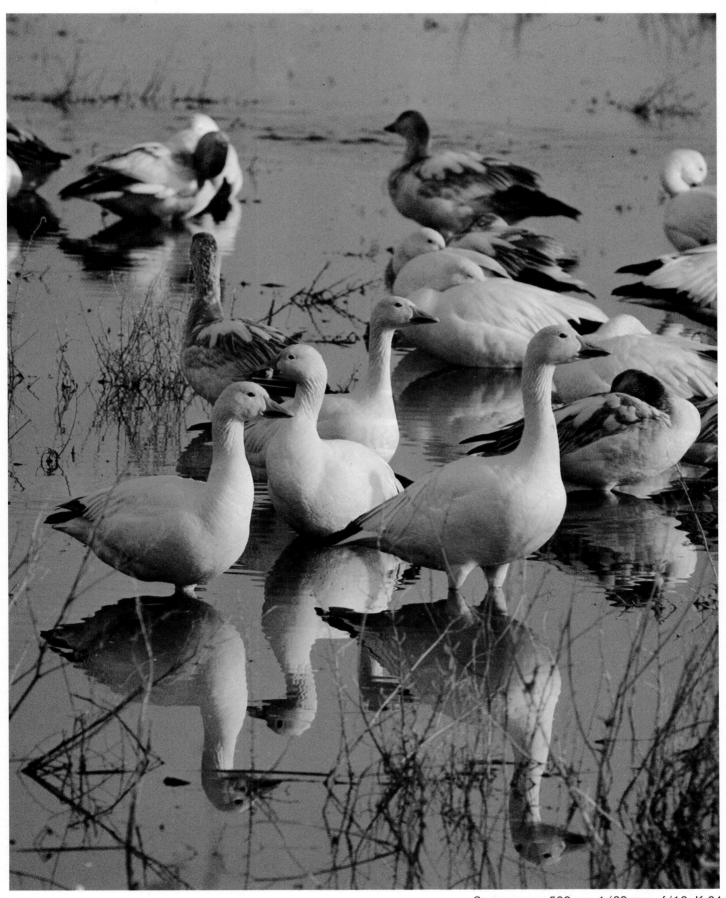

Snow geese: 500mm, 1/60 sec., f/16, K 64

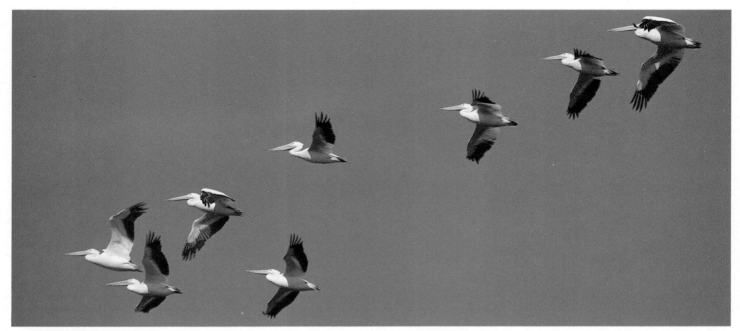

White pelicans: 500mm, 1/500 sec., f/8, K 64

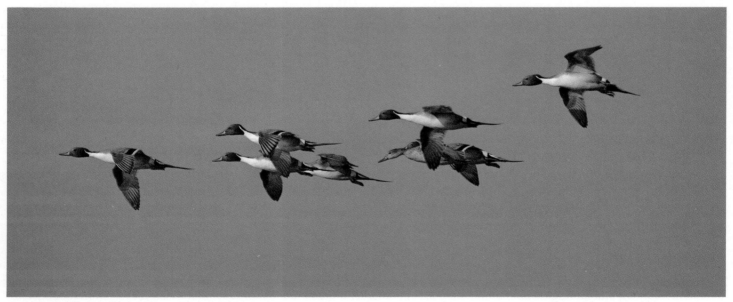

Pintails: 500mm, 1/250 sec., f/11, K 64

Estimating the correct exposure for birds in flight can be tricky. Camera mounted on a gunstock, Zahm followed a flock of white pelicans (top left) across the sky. Since white birds are lighter than the sky, he underexposed by one or two f-stops. The swift flight of pintail ducks (bottom left), 60 feet away, was captured from a hunter's blind—a concrete pit set into the marsh—with Zahm overexposing by a half to a full f-stop to compensate for the birds' dark coloring. Lured close together with scattered corn, a flock of mallards (right) exploded out of the water when the photographer yelled. He set his blind facing west to backlight the ducks against the early morning sun.

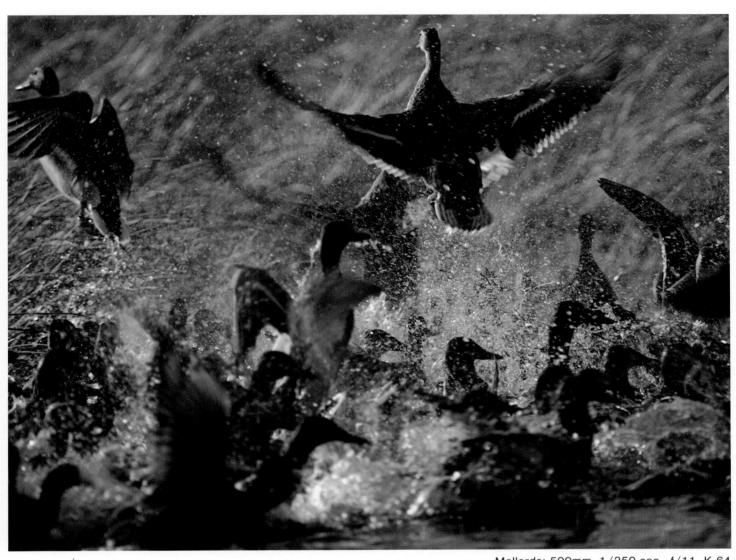

Mallards: 500mm, 1/250 sec., f/11, K 64

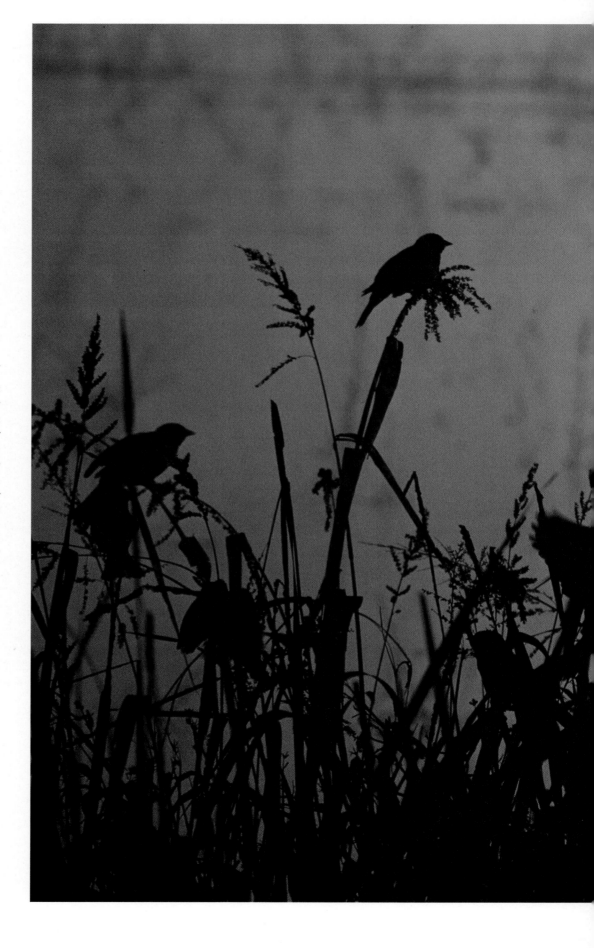

Out before dawn, Zahm saw a flock of red-winged blackbirds leave their cattail roost to feed on wild millet. He moved his car slowly into range, 100 feet away, and shot them in the morning's first light. Exposing for the backlight allowed for a fast shutter speed and good depth of field, resulting in a favorite photograph.

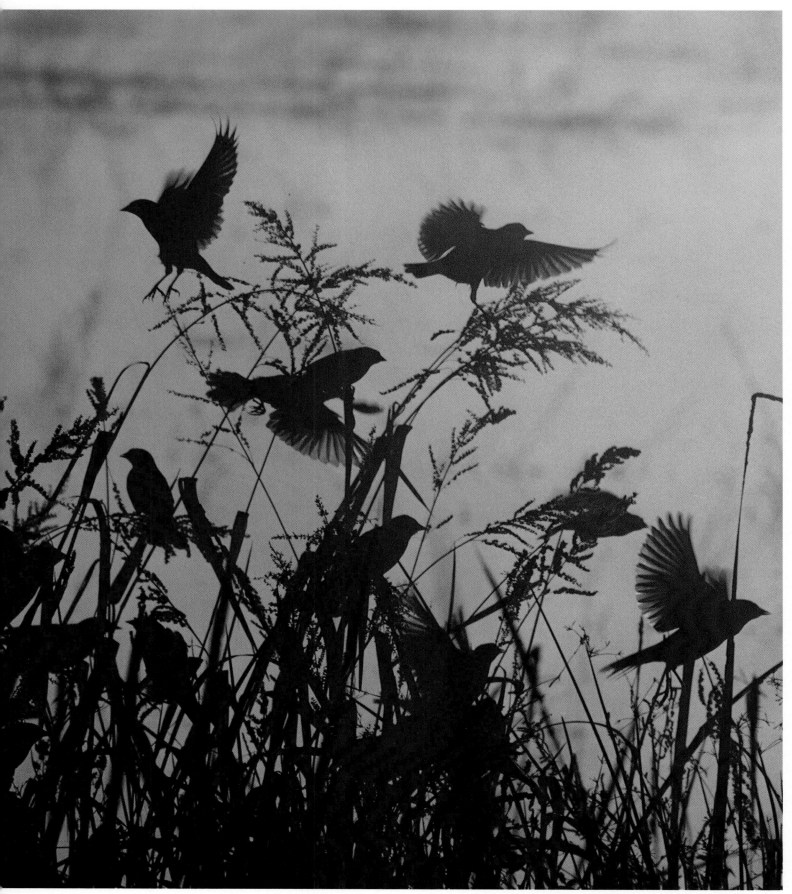

Red-winged blackbirds: 500mm, 1/1000 sec., f/16, K 64

THASE DANIEL
Expedition Photographer

"It's a competitive business and the best man wins," says Thase Daniel with a smile. She is one of the very few women who are commercially successful wildlife photographers, and she runs her business with a determination and unflagging energy that have made her a tough competitor indeed. Over the past twenty years, Daniel has sold thousands of images from her stock of more than 40,000 slides, has been published in the leading natural history magazines and books. She has framed prints of her most popular subjects—waterfowl, deer, and big game—hanging in the offices and homes of private collectors across the country.

Learning about wild animals and wilderness conditions did not come easily. A native of Pine Bluff, Arkansas, Daniel studied music, earning a graduate degree in piano and organ. Her interest in nature photography was sparked by a chance encounter with a Steller's jay, while vacationing at Estes Park, Colorado. "I saw this gorgeous blue and black bird and took a snapshot of it, from about 20 feet away. When the prints came back, I looked and looked for it, and finally saw this little black bug-looking thing way off in the distance. Right then I decided to learn how to take good pictures and never be that disappointed again." Her husband gave her a 35mm camera, a 200mm lens, and a trip to the vast Navajo Indian country of Arizona and New Mexico. After that, Thase was on her own. She looked through camera magazines, studied pictures made by famous wildlife photographers, and learned by trial and error, beginning with the birds in her backyard.

Thase feels that her unusual first name has helped her overcome some of the prejudice against women in the field. "People are surprised when they meet me," she says, "they expect me to be a man. I remember when my husband and I were going to South Dakota to hunt pheasant, and I suggested that we stop by the Swan Lake Refuge in Missouri, where thousands of migrating Canada geese pause to feed. I wrote for permission and enclosed my card, 'Thase Daniel, Wildlife Photographer.' When we arrived, the manager greeted my husband and began to explain the procedure, but John T. said 'Don't tell me, my wife is the photographer.' Well, the man's face kind of fell but he didn't have the nerve to say no, and the next morning I was in there shooting. This happens quite often. I sort of slip up on their blind side."

An alligator suns itself in Georgia's Okeefenokee swamp. The camera's meter gave an overall reading, but Daniel overexposed by about a stop and a half to compensate for the contrast between the dark subject and the surrounding bright vegetation.

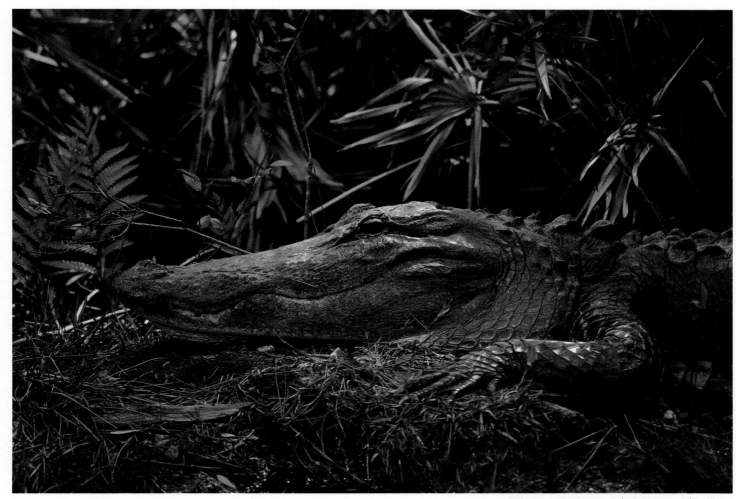

Alligator: 300mm, 1/125 sec., f/9, K 64

Far-Away Places

Although she has worked extensively in wild areas throughout North America, Daniel is best known as an expedition photographer. Her search for unusual subjects has taken her to many of the world's most remote and exotic places, including Alaska, Africa, Antarctica, the Galápagos Islands, Greenland, Hawaii, India, Nepal, New Zealand, Sri Lanka and South America. She usually makes a first visit to a new area as part of a tour group booked through a good travel agent; if the area is productive and she wishes to return at a later date she will make her own arrangements and work with local guides. Although some

Daniel established her early reputation with pictures of songbirds, such as this mockingbird, baited with discreetly placed food and photographed from a blind set up in her backyard.

agencies promote tours exclusively for photographers, most do not, and to avoid the possibility of joining a group geared for binoculars rather than cameras, she works closely with the tour leaders, explaining her needs in detail and carefully checking itineraries and credentials.

"It usually works out all right if you ask ahead of time," she says, "but I didn't do this for a trip to Churchill, in Canada's Northwest Territories. When I got there I saw that none of the other people had cameras, and realized they were all lookers, not photographers. This set the pace, of course. Finally, I told the leaders about my situation, that I had been holding back and not standing in front of other people but that I could not continue to do that. They allowed me to step in front and from then on I got some pictures."

Sometimes the location itself is not good for wildlife photography, such as Daniel's trip up the Amazon, 100 miles from the mouth of the river at Belim. "Every day for three weeks, we left the ship in rubber rafts and traveled up creeks and inlets to find wildlife," she recalls. "We passed native huts on stilts, but not much else. The Indians have to eat, and I think they must have killed every bird and monkey within miles of their homes. The trip proved very expensive and quite disappointing."

Some of Daniel's adventures have taken place in the coldest regions of the globe. In 1968, she joined Lindblad on his first tour to the Antarctic by chartered icebreaker through the Ross Sea. It was a difficult voyage; at one point the ship ran aground and it took three days for another icebreaker to free it. Thase recalls having to hike miles over a rugged terrain of snow and ice, carrying 30 pounds of equipment, to photograph penguins and Weddell seals. Several times she was close to exhaustion. "Years ago I decided that if I wanted a picture badly enough I would have to accept the hardships to get it," she says, and that same determination got her through the hardest trip she ever made—crossing the frozen fjords of Greenland with sledges and huskies. "I traveled with eight other people and some natives who could not speak English, and so we had to communicate by sign language. For two weeks we slept in small tunnel tents on the ice, and endured blizzard conditions. During the day, I tucked my camera into my down jacket to keep the shutter from freezing, and at night it stayed with me in my sleeping bag, jabbed into my ribs. It was uncomfortable, but at the end of the trip I was the only one whose camera was still working."

Wetlands

Daniel's favorite habitat for photography is wetlands. She has made several trips to the Coroni Swamp in Trinidad and has been visiting an egret rookery in southern Louisiana every April for the past two decades. The rookery is dark, swampy, and a haven for alligators, whose courtship roars can be heard for miles at that time of the year. While a friend watches for 'gators and water snakes, Thase goes after the courting birds, whose exquisite breeding plumes were used to decorate hats at the turn of the century, almost resulting in the snowy egret's extinction. When she first became interested in the Louisiana marshes, Thase read every book she could find that explained the behavior of local wildlife. She came to know what to expect at the rookery and the nearby feeding grounds, where the egrets waded for fish. This knowledge helped her

anticipate their actions and obtain many remarkable images.

Much of Thase's wetland photography is done near her home in Arkansas, at a hunting and fishing preserve with large stands of virgin bald cypress. She works from a boat to get as close as possible to her subjects—mostly ducks, herons and egrets. With both ends of the boat tied up and camera ready, she sits quietly beneath a camouflage of mosquito netting, a pistol on the seat beside her for protection, waiting for the action to start. She says, "My favorite and most productive time is very early morning, when the sun is at a low slant and the light is soft, when the spider webs haven't blown and the birds and marsh rabbits are in active pursuit of breakfast. I guess I love the outdoors so much because I stayed inside for so many years to practice my music. So I'm just catching up on my childhood, playing around in the open. I love it."

Animal Sense/Common Sense

Over the years, Daniel's way with animals, and courage in dangerous situations, have earned her the respect of every professional in the business. "You have to know your animal and what to expect. If you study the subject and get to know its habits, you can often outguess what it will do, and be prepared for any action. I always wear clothing that blends with the background, khaki or brown, never bright colors. I walk slowly toward a mammal, and when I see that it is becoming nervous, I stop and don't crowd it. I never look straight at the animal's face, but glance at it from the corner of my eye. Above all, I always try to keep in mind that I'm working with a wild creature, and if I push it too far, I'm going to get into trouble."

Thase learned her lesson the hard way, while photographing sea lions in the Galápagos. She watched a bull go out to sea and, thinking she was safe, turned to photograph his harem of cows. But the bull came back and slipped up quietly behind her; by the time she heard him it was too late to get out of the way. He pushed her down and she fell on the rocks, breaking her ankle. She feels certain that had a companion not shouted to distract the animal, allowing her to crawl 30 feet over the boulders to safety, the 600-pound bull would have mauled her badly.

Photographing large mammals is always potentially dangerous, but Daniel has gotten some of her most spectacular pictures by trusting her instincts and taking a chance. Recently, she traveled deep into the Alaskan wilderness to photograph brown bears fishing for salmon in a shallow stream. She arranged the trip herself, hiring a guide, and reached the area by a combination of commercial jetliner, chartered sea plane and small boat, hiking the remaining 10 miles on foot. "As we approached the area," she recalls, "my guide warned, 'If we meet any bears on the trail, back off and let them go by. Don't you dare fall down or turn and run because that makes them chase you, and if they catch you, they'll kill you. I'll be nearby with a loaded gun, just in case.' When we got there, we saw many bears competing for fish in a small area. There was much fighting and growling, with water splashing in all directions. I realized that instead of my 400mm lens, I wanted the 80–200 zoom, which is lighter and easier to handle, but requires you to be nearer to the subject than a 400. I changed lenses and told the guide that I wished to get closer. Since the bears had just come out of hibernation and their minds seemed to be on salmon, not us, we moved to within 20 feet. I had begun to work when suddenly one of them started toward me and didn't seem about to stop. I stood my ground and kept on shooting until it got so close that I was just getting head shots. About that time, I heard a click behind me and, since I hunt myself, I knew what the sound meant—the guide had taken the safety off his gun and was getting ready to fire. Just then the bear turned and ran away. I knew that I was taking a risk, but I had a gut feeling about it and it paid off in good pictures."

An experience that occurred on a trip to East Africa in 1965 convinced Daniel to temper courage with caution, and she advises other wildlife photographers never to work alone in an isolated place. A friend had dropped her off at Lake Nakuru, promising to return later that day, after Thase had photographed the vast colony of flamingos that gathers there each year to breed. The water was shallow for quite a distance and Thase, now on her own, rolled up her pants and waded out closer to the birds. After several hours she started back, but suddenly stepped into a hole and disappeared from sight. She recalls, "The alkaline water choked me and burned my eyes, but all I could think of was keeping my 400mm lens dry. I held the heavy gunstock straight over my head and used my left arm to try to get myself up. I finally managed to scramble out of the hole, but I was badly shaken. I realized that there was nobody within miles of me; I could have easily drowned in that place."

Equipment and Technique

Daniel uses Nikon equipment, including seven lenses: 24mm, 28mm, 55mm macro, 80–200mm zoom, 300mm, 400mm and 600mm. She used to own a 500mm mirror lens, but found that, although it was light and easy to handle, it gave a very shallow depth of field, and although a small bird would be entirely in focus, a larger animal, such as a deer, would not. In the States, Daniel usually travels by camper, often shooting from the vehicle to avoid spooking the subject. When she uses her 600mm lens, she rests it on the rolled-down window supported by a large, loosely filled beanbag that she made herself. When shooting hand-held, she uses a pistol grip to keep longer lenses steady, attaching it to the tripod screw at the base of the camera. The trigger and shutter release are connected by a cord,

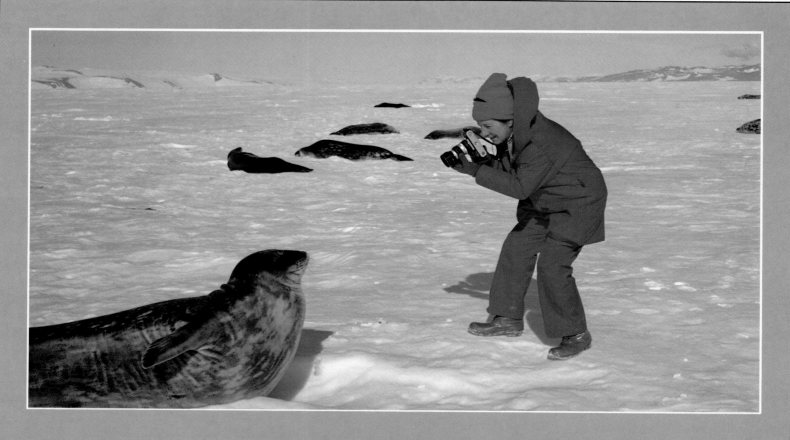

ADVERSE CONDITIONS

Thase Daniel makes her home in Arkansas but spends several months of every year traveling the world to photograph its wildlife. Her beautiful pictures are much in demand among picture editors. Between trips she focuses her lenses on the wetlands of the American South and is currently compiling these images into a book.

Thase Daniel is uniquely qualified to advise photographers on how to shoot under adverse conditions—she's experienced them all, from arctic cold to desert heat to jungle humidity.

Arctic conditions. To prevent your camera from freezing, keep it warm by carrying it under your clothing, taking it out only to shoot. Since film becomes brittle at low temperatures, advance and rewind slowly and gently. This will prevent both breakage and static marks. Battery power may drop off in extreme cold; always use fresh batteries, and try to keep them warm. The most serious danger is condensation in the lens and in the camera. Warm the camera gradually after coming in from the cold, and use a soft cloth or lens tissue to remove moisture.

Shooting snow is one of the trickier photographic challenges.Use a skylight filter to reduce glare and eliminate the bluish color cast. Take meter readings from your hand or a gray card to get the correct exposure. Snow texture shows up best if you face the sun so that the snow is lighted from the back.

Desert conditions. Heat and dust are the photographer's chief problems in the desert. *Never* leave film or equipment in direct sun, and try to find a relatively cool place for them. A skylight or polarizing filter should be on the lens at all times to avoid sand or dust scratching the surface of the lens, and to reduce glare and overexposure. Wrap a plastic bag around the camera to keep out dust. Fasten the mouth of the bag around the lens, and use one large enough to allow you to work the camera through it. Despite this precaution, some dust may still filter through so always clean the camera with a blower brush or compressed air at the end of each day's shooting. Advance and rewind the film carefully to avoid scratches from trapped dust.

Tropical conditions. The heat and humidity of the tropics can be incredibly destructive to camera gear in a short time. Film,in particular,will deteriorate rapidly. Open it only as needed and try to store in a cool, dry place. Use packages of silica gel in your cases to absorb moisture. If the gel becomes saturated, it can be dried out in an oven. Check your cameras and lenses often for condensation and corrosion, and for that special and incurable problem of tropical photography, fungus.

wrapped with friction tape to prevent the fragile wires inside from breaking. Daniel balances and focuses with her left hand, squeezing the trigger with her right hand. She can hold a 400mm with this setup to follow a flying bird or running mammal, using a motor drive to advance the film at three frames a second. Daniel considers the motor drive her most valuable piece of equipment for shooting wildlife.

Kodachrome 64 film is preferred most of the time, but she switches to Ektachrome 200 for fast-moving subjects, otherwise avoiding the high-speed film because of its bluish cast. When traveling by air, Daniel carries her film in Film Shield bags that are laminated with lead to protect it from X-ray damage. The effects of exposure are cumulative and, if the film has to pass through three or four different inspection devices in one trip, the build up of X rays can alter the emulsion and cause undesirable color changes or fogging.

Daniel's techniques for photographing wildlife are straightforward. When she wants a subject in sharp focus, against a blurred background, she uses a fast shutter speed and a wide lens opening, such as 500th of a second at f/5.6. If she wants more of the background in focus, she stops the aperture down to f/11 or f/16. Slow-flying birds can be stopped at 250th of a second; faster flyers require 500th. If she is slipping up on a duck, for example, she presets the shutter speed at a 500th of a second so that she is prepared to take the picture quickly, without having to fumble with the settings should the duck move.

Daniel carries two Gossen Superpilot meters with her in case one of the delicate instruments breaks down. Once she takes a reading she does not check the meter again, unless the light changes. If she is shooting a very dark subject, such as a moose, she takes a reading off a rock that is the same color as the animal. To get the correct exposure for photographing white birds, such as egrets, in bright sunlight, she takes a meter reading off a piece of white cardboard. Daniel has learned that the proper exposure for this situation, using Kodachrome 64 film, is 250th of a second at f/11, which stops all action and brings out every feather detail.

Blinds

Small birds are photographed from a blind that Daniel made herself, using aluminum tubing and burlap. "I never photograph a nest at the egg stage, as some birds will abandon their eggs if disturbed at this time," she explains. "When the nestlings are a few days old, and strong enough to hold up their heads for food, I put my blind about 20 feet from the nest. Each day I move it closer until I get to the spot where I want to photograph. Meanwhile, I position the strobe about 10 feet from the nest, and five feet high, substituting a broom handle and tin lid for the actual light until the birds get used to it. By using this procedure, I have never had a bird desert the nest."

In the field, Daniel uses a lightweight blind made of four strips of camouflage mosquito netting, each piece 3 feet wide and 12 feet long, which are sewn together, leaving a slit in the seam for the lens. When she drapes the net over her head, its pattern blends with the landscape and, although she can see out, animals cannot see her. She anchors the bottom of the net with her foot to prevent it from blowing in the wind and scaring the subject. She also uses this type of blind when working from a boat, and finds that wildlife seem to accept it quickly.

Advice for Beginners

Remembering her own start in the business, Daniel would tell beginning photographers to keep it simple. "Decide what aspect of nature photography you want to get into," she advises. "Scenics and wildflowers can be shot with a 50mm lens, but wildlife photography requires longer lenses and is more expensive. I suggest buying a 35mm single lens reflex camera that accepts a wide variety of lenses. As you learn more about the subject, you can add more lenses. At some point you may want to buy a second camera body that uses the same lenses. If one camera breaks down, you will have a spare. Never take a new camera or lens on a trip without using it first. Expose and process a few rolls of film and study the results. Become familiar with your camera. Take the instruction manual with you on a trip so that if something goes wrong with the camera, you or another photographer can try to fix it.

"When framing a picture, avoid putting the subject directly in the center. Never divide a picture in half unless you are striving for a closeup cover, which is best when centered, with space left at the top for the name of the magazine or book. Shoot verticals as well as horizontals and don't take every picture from eye level as this gets monotonous. If you are photographing a scene, decide what you want to play up, the sky or the ground. If the landscape is more interesting, then just include a 'pinch' of sky. If the sky has beautiful or dramatic clouds, use mostly sky and little land. Sometimes a tree limb or a colorful field of flowers can make an interesting foreground subject. Let your eye lead you to the focal point.

"Patience and perseverence will help you secure good pictures. I have waited quietly for long periods of time for action, and it almost always pays off. Remember that the location of the photograph is not as important as how you interpret what you see. People say to me 'If I could go to Alaska or the Galápagos, I could make pretty pictures too.' I tell them that you don't have to travel to exotic places to find beautiful pictures. The first pictures that I sold were of songbirds photographed right in my own backyard. Just open up your eyes and look."

This fast-moving black crake, a small African water bird, was difficult to photograph as it darted among the lilies in Lake Naivasha, Kenya. Daniel hand-held a camera, with a pistol grip and motor drive, following the actions of the bird as it moved from pad to pad. She stayed with it for more than two hours, shooting from 30 feet away. "If you can, take your time and wait until it looks good to you," she advises.

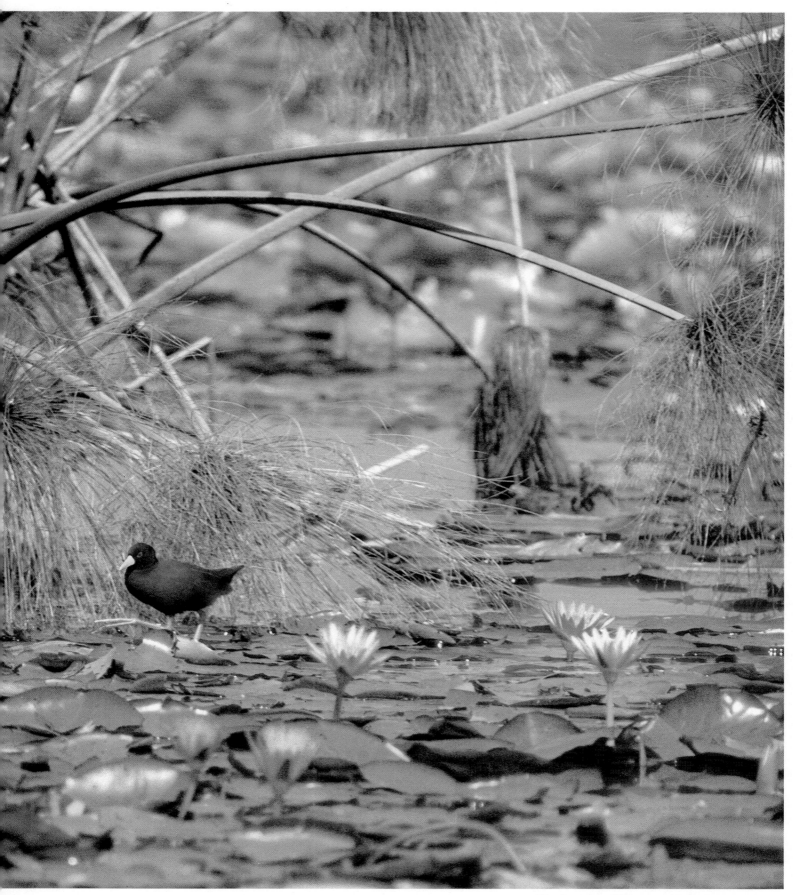

Black crake: 400mm, 1/250 sec., f/8, K 64

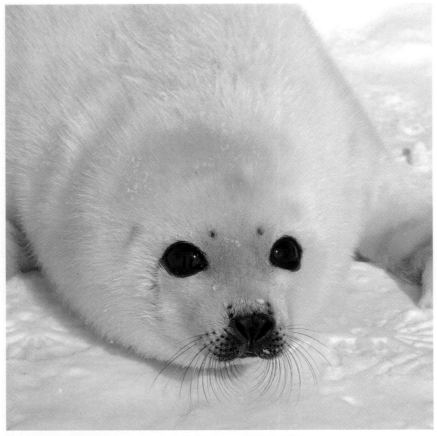

Harp seal: 80–200mm zoom, 1/125 sec., f/11, K 64

When Daniel goes after a portrait she tries to capture unusual behavior or a quality that key-notes the animal. The vulnerable-looking baby harp seal (top left) was shot in the Canadian Arctic. She came upon the Himalayan bear (bottom left) while hiking in the woods in Nepal and grabbed a picture as it passed quickly in front of her. The lion (right) continued to lick its paw, totally unconcerned with the approaching jeep, and Daniel was able to get close enough to show the taste buds on its tongue.

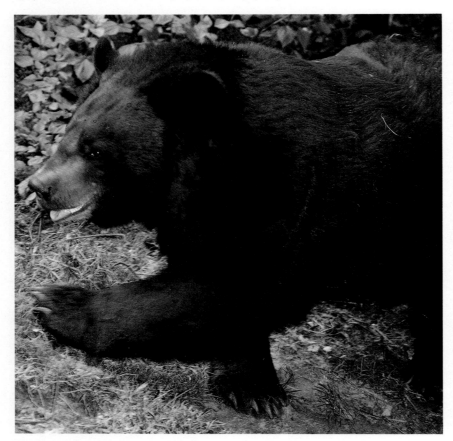

Himalayan bear: 300mm, 1/250 sec., f/6.3, K 64

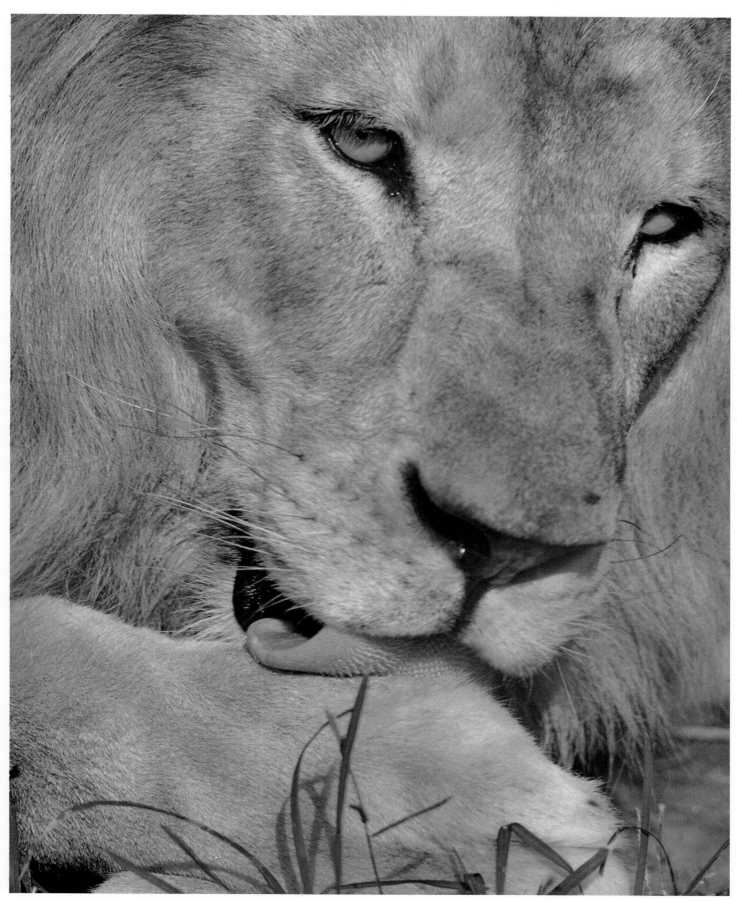

Lion: 400mm, with extension tube, 1/125 sec., f/8, K 64

Although Daniel has visited every continent in search of the world's wildlife, she finds many of her subjects close to home. The jaguar (below) a native of South America, was photographed at the Sonoran Desert Museum in Tucson, Arizona. Daniel eliminated the bars of its cage by placing her camera close to them and shooting with the aperture as wide open as possible. She photographed the snowy owl (right) in the province of Alberta, approaching the wary bird from the water. Her trip to Canada was first prize in a Ducks Unlimited photography contest.

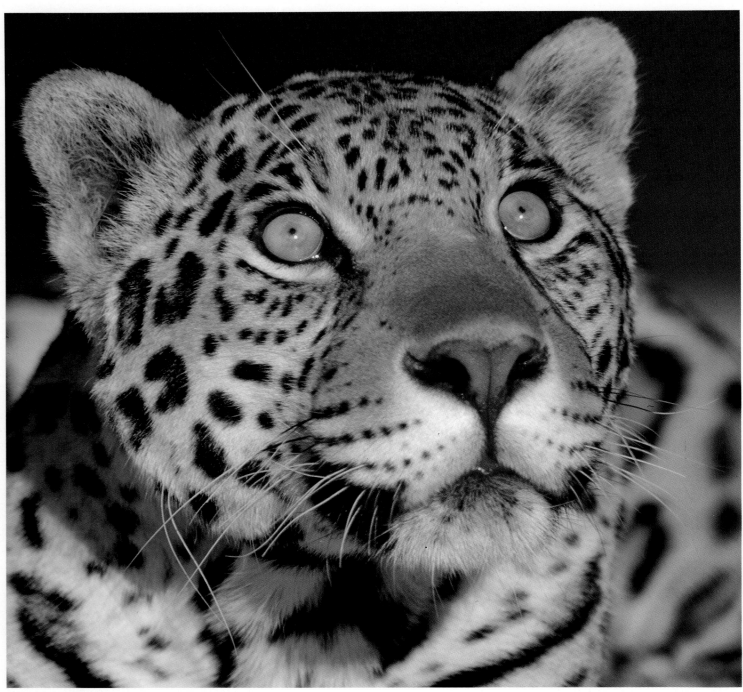

Jaguar: 200mm, 1/250 sec., f/5.6, K 64

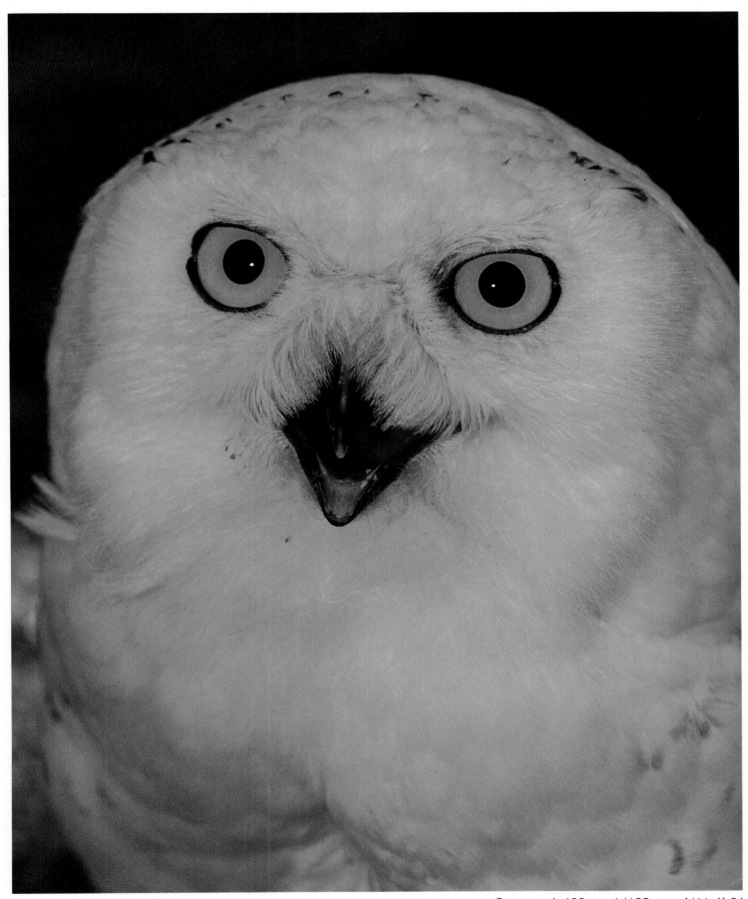

Snowy owl: 400mm, 1/125 sec., f/11, K 64

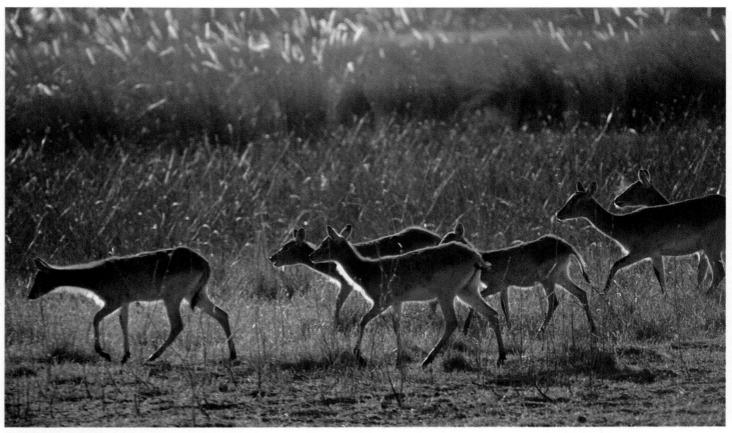

Red lechwe: 300mm, 1/125 sec., f/11, K 64

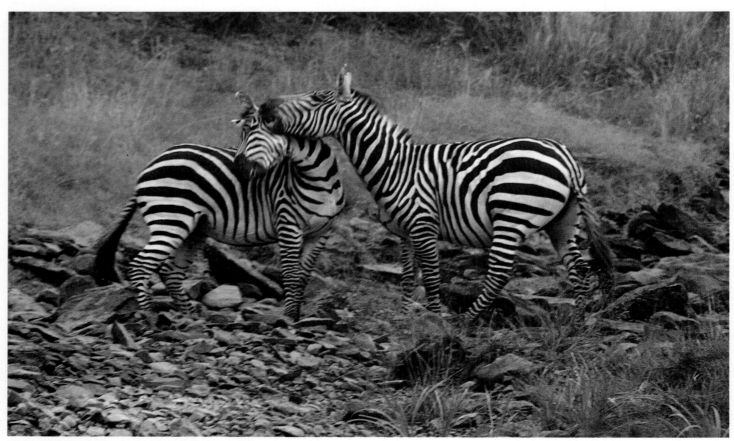

Zebras: 80–200mm zoom, 1/250 sec., f/8, K 64

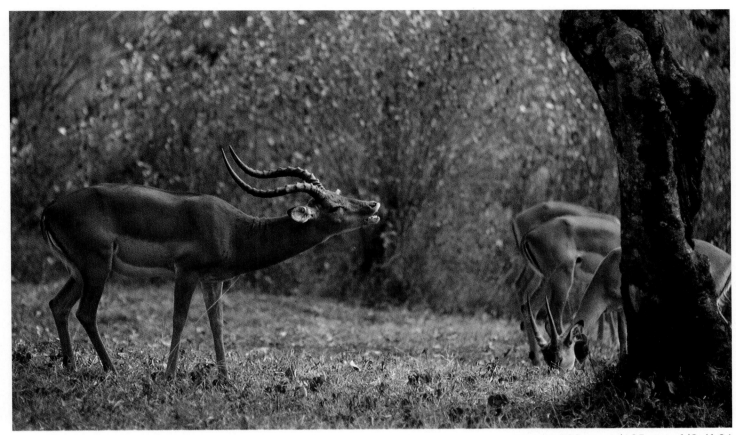

Impala: 300mm, 1/125 sec., f/8, K 64

Animal behavior is one of Daniel's specialties. She followed the actions of the fighting male zebras (bottom left) with a pistol grip and motor drive. The impala buck (top right) was caught alerting his harem to the presence of a nearby lion. The ocelots (bottom right) were engaging in sex play prior to mating. Daniel photographed the red lechwe (top left) in Africa's Lake Okovango, moving around them so that the late afternoon sun highlighted the hair on their backs.

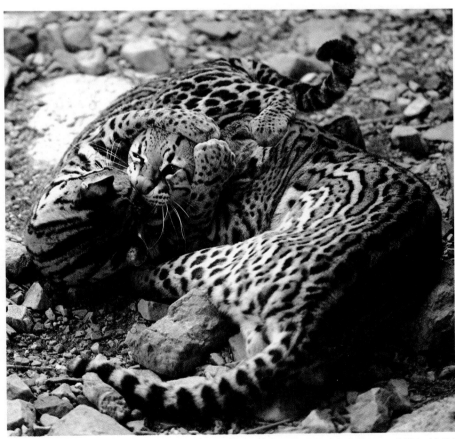

Ocelots: 400mm, 1/125 sec., f/11, K 64

127

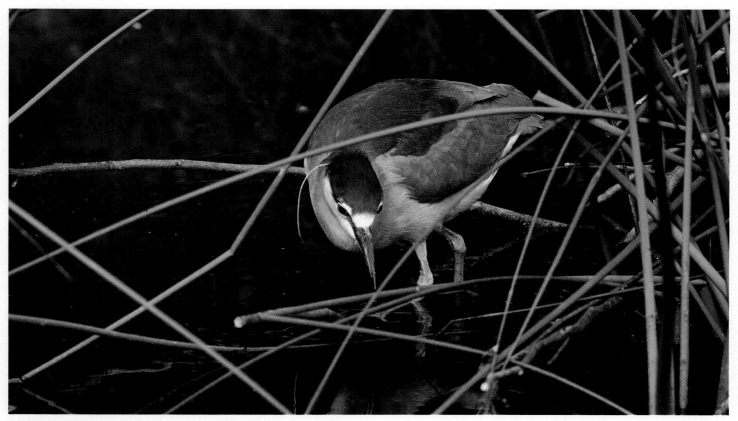

Black-crowned night heron: 400mm, 1/125 sec.,f/16, K 64

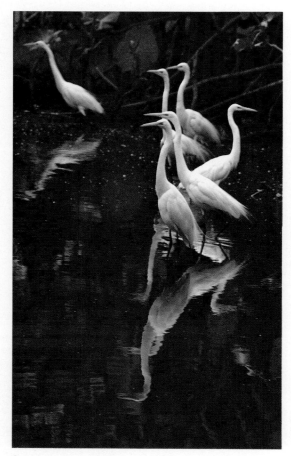

Great egrets: 400mm, 1/125 sec, f/16, K 64

Of the world's wilderness areas, Daniel's favorite places are wetlands and swamps. She stalked the black-crowned night heron (top left) through a Louisiana marsh. The little blue heron (right) was photographed from a blind. The dark bird and its dark reflection were perfectly exposed against the bright background. To convey the darkness of a swamp in Brazil, Daniel cut the light down further by shooting with a smaller aperture, which also served to emphasize the whiteness of the great egrets (bottom left).

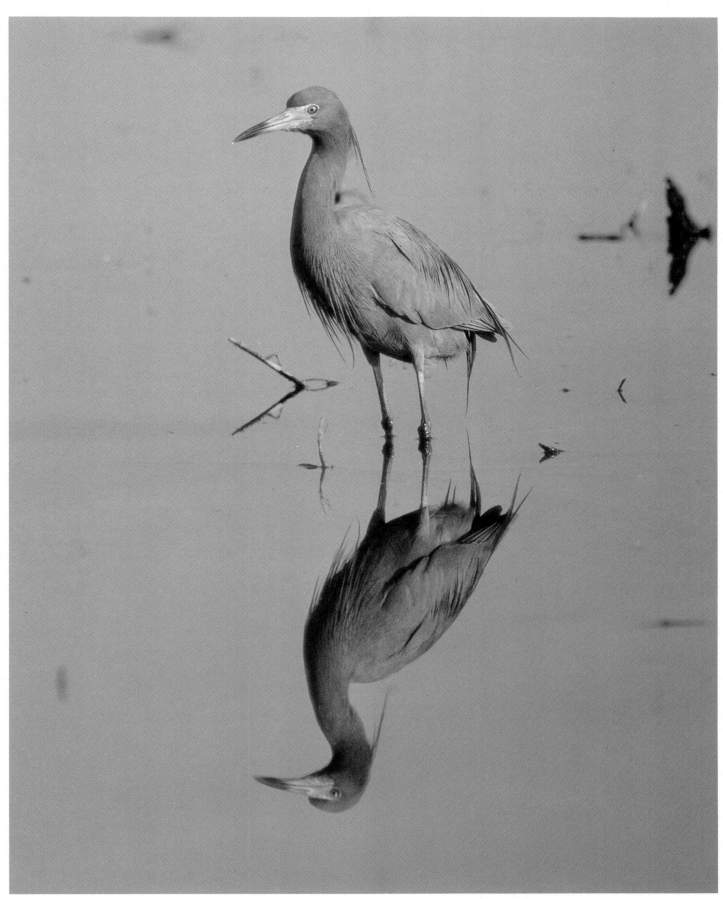

Little blue heron: 600mm, 1/125 sec., f/11, K 64

HANS D. DOSSENBACH
Explorer with a Camera

Deep in the Peruvian jungle, along the upper reaches of the Rio Mano, Hans Dossenbach woke at dawn to raucous screams and cries. He peered out of his small blind, 50 feet in the air, and saw a swarm of macaws, colorful members of the parrot family, gouging chunks of salt-encrusted soil out of the steep bank just opposite him. Dossenbach had been waiting four months for this moment. Macaws are extremely shy, clever birds that usually feed on fruit at the top of the tree canopy 200 feet above the ground, well out of camera range. He had searched the jungle for them, finally coming upon this steep river bank peppered with holes that looked like they could have been made by the beaks of large birds. That morning his hunch paid off and he was able to get the first closeup pictures of macaws ever taken in the wild.

Dossenbach has been observing and photographing wildlife in remote areas of the world for 25 years. Born in 1936, he lives in a 300-year-old farmhouse near Schaffhausen, among the rolling hills of northern Switzerland. His interest in natural history began as a child, and by the age of 16 he was writing nature articles for local newspapers. Their requests for photographs to accompany the texts eventually prompted Dossenbach to buy his first camera.

One of his earliest experiences with wildlife photography was an attempt to photograph a fox that lived a few miles from his home. Dossenbach spent many evenings sitting behind a tree near the den. The fox never appeared, although meat left at the entrance every night was always gone in the morning. Determined to get the elusive animal on film, he set up a homemade triggering device, consisting of a camera, small flash, and string attached to the food. The next day, he saw that the bulb had burned and a picture had been exposed. When the film was developed, however, Dossenbach saw that he had caught the neighbor's cat in the act of stealing the food, an event repeated over the next seven nights. Twenty years later, Dossenbach still hasn't gotten a single good picture of a fox.

Travel

His first photographic trip was to the Camargue, a large wetland area in the south of France noted for its bird life and wild horses, another subject Dossenbach likes to photograph. Pictures from the take appeared in several international magazines, shortly followed by his first book, on European swamp animals.

Soaring and diving herring gulls attacked Dossenbach as he attempted to photograph a breeding colony on the Faeroe Islands, in the North Atlantic between Great Britain and Iceland. He used a wide-angle lens to get bird and sun in the same shot, and a motor drive and fast shutter speed to stop the action.

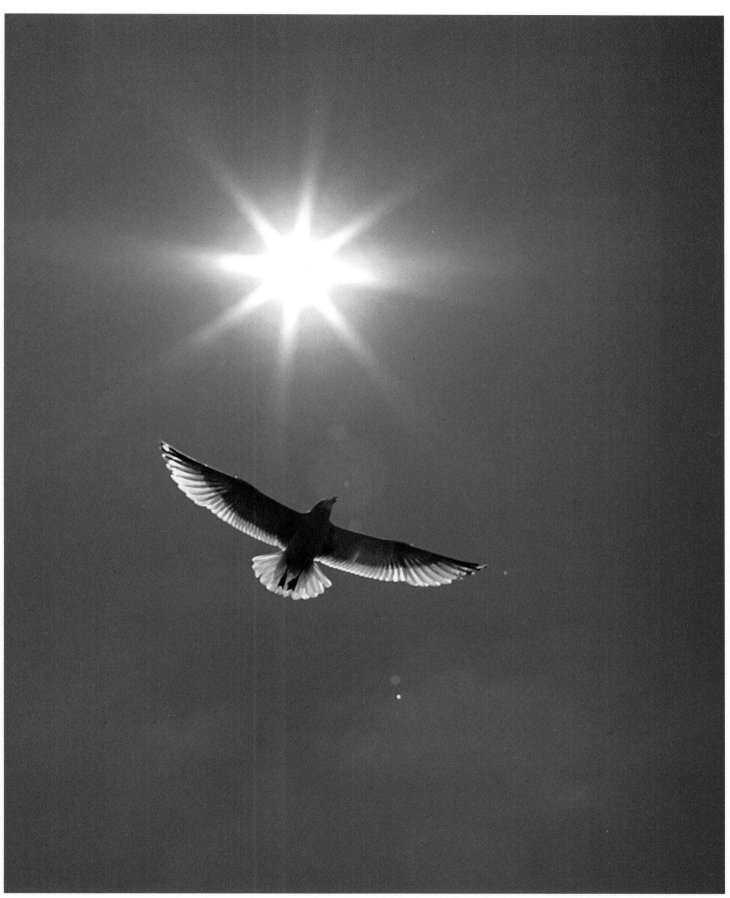

Herring gull: 24mm, 1/500 sec., f/11, K 64

Since then, Dossenbach has published 22 books and has made expeditions throughout the world's wildest regions, taking pictures for magazine articles, calendars, post cards and posters.

His favorite habitats are tropical swamps, sea bird islands and coastal areas, and he has traveled to East Africa, South America, the Galápagos Islands, the North Sea, all of Europe, Australia, and the United States, spending several months in the Everglades. Dossenbach and his wife, Monique, usually travel together, using Land Rover, camper or jeep, fishing boat, rubber raft or ponies depending upon the terrain.

Before embarking on a trip, Dossenbach spends considerable time reading about the animals he wants to photograph, and contacting specialists in the area he plans to visit. Since most of his trips are lengthy expeditions to virtually inaccessible regions, he plans a journey once every two years, often remaining four to

European photographer Hans Dossenbach combines perseverance, knowledge of animal behavior and luck to get pictures of rare wildlife. This elusive gallinule (right) called the king reed hen, was spotted by his wife Monique at Lake Naivasha in Kenya, when it suddenly stepped out of a clump of papyrus behind their blind. The macaws (below) were found after a four month search in the Peruvian jungle. Dossenbach set up a blind opposite a salty river bank which he believed they visited. When his supposition proved correct, he came away with some remarkable pictures of macaws in the wild.

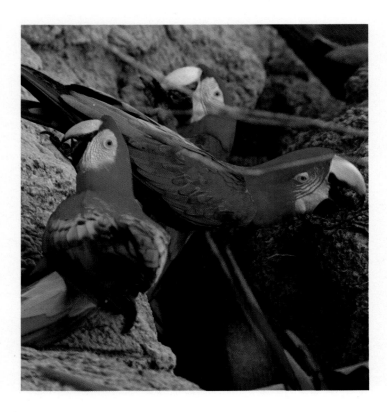

eight months at a time. He says, "Each journey is a puzzle of many small projects programmed in advance. We follow our carefully mapped route but fortune also plays an important part and often an animal comes along unexpectedly, so there are a lot of improvizations in the schedule to make the most of these surprise moments."

Regarding dangers encountered in the wilderness, Dossenbach feels that it is more hazardous to drive on a European motorway or live in a big city than in the African bush or jungle of South America. Nevertheless, he prepares for emergencies, always carrying a first-aid kit with medicine and serum to counteract tropical infections and snake bites. In all of his experience, Dossenbach has been bitten only once, by an African puff adder, and not in the wilderness but in his home in Switzerland, where he kept it as a pet. He treats drinking water with chemicals, never eats fruit that cannot be peeled, and boils vegetables before consuming them, particularly in tropical countries. He never swims in fresh water unless he is sure that it is free of bilharziasis, a tropical disease transmitted by a snail for which there is no cure. To avoid the possibility of a vehicle breakdown, perhaps hundreds of miles from help, Dossenbach carries important spare parts with him, as well as extra gasoline, water, food and fishing equipment.

Equipment

Dossenbach owns three automatic Minolta XD-7 cameras with electric winders, allowing him to shoot two frames per second. Although the winders use a lot of film, he finds them essential for catching fast action. When using the automatic feature, particularly helpful when the light changes rapidly, he sets the shutter speed, usually at a 125th of a second, and the camera adjusts the aperture accordingly, so that Dossenbach can concentrate completely on what is happening through the viewfinder, often prefocusing on the spot where he expects the animal to appear. He uses the manual setting when shooting in an unusual lighting situation, such as an animal backlit against the sun, where the automatic feature would tend to misread the correct exposure.

Dossenbach's favorite lenses are a Minolta 70–200mm zoom, used for many situations, including birds in flight, and 300mm and 400mm telephotos. Less frequently used lenses include 800mm and 600mm telephotos, as well as 28mm and 20mm wide-angles and a 16mm fisheye, for special effects. His 50mm and 100mm macro lenses are used in conjunction with a bellows and extension tubes.

In addition to Minolta equipment, Dossenbach owns a Canon F-1 camera body with motor drive that allows him to take from three to five frames a second. He bought the camera so that he could use a lens he considers indispensable for wildlife photogra-

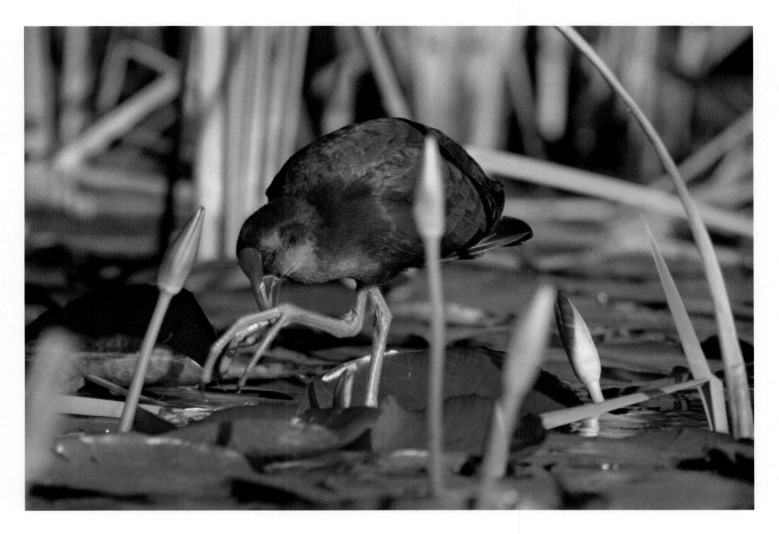

phy—the Canon 300mm fluorite f/2.8. He thinks it is the most powerful lens for its size and gives him superb results in difficult light situations. Other equipment includes two Minota flashes, a sturdy tripod, and an electric remote switch that can operate a camera 150 feet away. He uses the switch only as a last resort, however, preferring to watch the action directly through the camera's viewfinder whenever possible.

Most of the time, Dossenbach uses Kodachrome 64 film, switching to Ektachrome 400 if the light is poor. During short, intensive photography trips, he uses 10 rolls of 36 exposures a day; otherwise, he shoots three to five rolls, depending on the accessibility of wildlife in the region—the Galápagos Islands being five times more productive than a typical rain forest. He plans what he is going to do each day, and usually knowns how much film and exactly what equipment he will need, which he carries into the area in aluminum cases.

For the beginner, Dossenbach recommends a 35mm camera (two, if an extensive journey is planned), a standard 50mm or 55mm lens, a 200mm or 400mm telephoto, and a tripod, plus extension tubes for closeup work. "The quality of the equipment is far more im-

portant than the quantity," says Dossenbach, "but the most important thing of all is the one who stands behind the camera. It is easy to learn the basics but not so easy to develop an 'eye.' That is usually something you're born with."

Blinds

Most of Dossenbach's photographs are taken from a blind, which he considers to be his most important piece of equipment. His two handmade blinds are constructed of aluminum rods and green, waterproof material. Each is three feet square. A long, vertical slit serves as the entrance, and smaller, horizontal openings on each side accomodate the telephotos, with a peephole for watching the animals. Dossenbach also carries camouflage-colored material with him for times when he has to build a blind at the site, using branches and other natural materials. He has set up blinds on the tops of vehicles, in trees and on rafts or boats.

It was from a floating blind while working with his wife at Lake Naivasha, Kenya, that Dossenbach photographed one of the most elusive and beauti-

USING MOTOR DRIVES

The Swiss photographer **Hans O. Dossenbach** has written about animal behavior for 25 years. He has written 27 books on the subject and his photographs appear regularly in nature periodicals and books all over the world. Dossenbach travels to many remote and exotic wilderness areas in search of photographs and is currently anticipating a six-month tour of the Australian outback.

After their lenses, many wildlife photographers consider their motor drives to be their most useful accessory. Basically, a motor drive is a device that automatically advances the film, cocks the shutter, and fires the camera. Variable-rate motor drives are generally capable of shooting anywhere from one to five or more frames per second. Single-rate auto winders operate at a fixed number of frames per second, usually one or two. Either type of unit is fairly compact and generally attaches to the bottom of a 35mm SLR camera. Power is provided by a battery pack. Most newer cameras, such as Dossenbach's Minoltas, have the ability to be coupled to accessory motor drives.

When shooting fast action with a motor drive, it is important to remember that at four frames per second, it would take only nine seconds to use up a 36-exposure roll of film. Because of this, beginning photographers often run out of film at crucial moments. Experienced wildlife photographers frequently carry more than one camera, saving the one with the motor drive for times of peak action. Another practical solution is a bulk-exposure back that holds 250 (or more) exposures. For black-and-white work, Ilford now manufactures a film that fits 72 exposures into a 36-exposure-size cassette.

The faster the film goes through the camera, the faster the shutter speed must be, and the more important it is to support the camera firmly. When using flash, choose a unit that can keep pace with the motor drive, and remember that when used rapidly and repeatedly, the flash output will be lowered. The combination of flash and motor drive requires a great deal of power from the batteries; be sure they are fully charged.

Although a good wildlife photographer always tries to get as close as possible to the subject, there are occasions when the only way to get the picture is by setting up the camera and operating it from a distance. A motor drive or auto winder is essential for advancing the film in these situations. A minor drawback in such a setup is the high-pitched whine of the motor, which could frighten shy subjects.

As with all other camera equipment, keep the motor drive clean and dry, and protect it from hard knocks. In particular, make sure that all contact points are free of corrosion, grit and dust.

ful swamp birds in the world. He recalls, "For six weeks we had been working at the lake, one of the most exciting places for swamp bird life that I know. One day, I found a dead tree standing in the water with several anhinga nests that contained young birds about three weeks old. I had been looking for this because I wanted to show how the young push their heads deep into the necks of the parents to get the fish. As the tree was only 12 feet high, it was possible to get good shots from the water level, but the birds were shy. I had to build a deck on the boat, covered with papyrus plants, so that it looked like a drifting island. We floated it to the tree and, looking through the 600mm telephoto to figure out the correct distance, positioned it with two small anchors to keep the boat at the right spot. The edge of the papyrus jungle was only ten feet away. Usually I give the animals a few days' or weeks' time to get used to the blind before working, but this time I started immediately, mounting two cameras on tripods, one with the 600mm and the other with the 400mm lens. Within 20 minutes most of the anhingas were back on their nests, and about ten minutes later I took the first feeding shots, so clearly the blind didn't disturb them.

"In the middle of the afternoon, after filling five rolls of 36 exposures with feeding anhingas, I was still watching the birds while Monique had a look around in the other directions. Suddenly she grabbed my arm, a finger at her mouth to keep me quiet. I had a look through one of the peepholes and nearly stopped breathing. There before us was a Smaragd purple gallinule, or king reed hen. Its metallic blue, green and purple plumage and red bill and legs were dazzling. I had never seen good color photographs of this bird and it was one of the reasons for our visit to Lake Naivasha. The gallinule was walking across a carpet of water lilies, completely unaware of our presence. Naturally we got a little nervous, especially because there seemed to be a problem—the bird was much too close! In addition to the 600mm and 800mm lenses, we had only a 50mm and some wide-angle lenses with us, but the bird was between eight and 15 feet from the blind, perfect for a 200mm lens.

"After an agonizing hour of waiting for the bird to move into camera range, I realized there was only one thing to do—somehow move the boat back ten feet without disturbing the bird. With the greatest care, we pulled up the anchors and, while Monique kept an eye on the gallinule, I got on the other side of the boat and rowed with my hands toward the anhinga tree. Finally, after what seemed endless minutes, she gave me the signal that the distance was good. While I set the anchors again, I heard music to my ears—the click of a camera. Monique took ten pictures right away and then, until the sun touched the horizon, we exposed at least six rolls. The bird was in the best late afternoon light, with the sun to the left so that light and shadow were on the bird's shining feathers. To our delight, it was not only walking around but opening the fruits of the water lilies and eating the seeds by holding the food between the very long toes of one foot, like a hand—a form of behavior known only to these gallinules and parrots. I could not have asked for a more perfect picture situation."

Technique

Sometimes Dossenbach prefers to show the animal as a small part of its environment, but usually he tries to get as close as possible. "The greatest wish of all wildlife photographers is to be able to make yourself invisible," says Dossenbach, "and to get near enough to a wild animal to take good pictures without disturbing it or chasing if off. Each situation is very different, however, be it a crab, an elephant, an ibex or a poisonous snake. The problem with getting outstanding pictures is normally not technical but biological. You must know something about the habits of the animals and watch them carefully. Then you will see things that will bring you to where the action is."

Dossenbach had such an experience while photographing game at the Ngoro Ngoro crater in Tanzania. He recalls, "For weeks we had been looking for a good opportunity to get pictures of the 'health police'—hyenas, jackals and vultures picking a dead animal clean. It always happens in a very short time, and a dead zebra or antelope can be completely gone in less than an hour. One morning, a hyena came trotting across the flat crater floor right towards us. We stopped the car and watched because the animal was behaving strangely, pausing every 50 or 100 meters to look up. After awhile we could make out some vultures turning high in the sky, converging from all directions on one point, then spiraling downward onto a bushy part of the crater floor. The hyena headed directly toward the landing point of the vultures, and we decided to follow. Ten minutes later we found a dead wildebeest in the middle of some bushes, covered by dozens of vultures. The hyena was there ahead of us, and more were joining it. They must have watched the vultures too, because it was only possible to see the dead animal from the air. Vultures and hyenas were opening it up as fast as possible to get the meat. As the hyenas made their strange loud, howling and laughing sounds, some jackals joined the fray. The sight of all those animals with blood-covered faces, together with their eerie noises, was like a scene from hell, and we made about 200 photos in less than 30 minutes."

All his life Dossenbach has wanted to work with animals. He developed his skill as a writer but discovering a talent for photography was an accident, and an important one. Photography gave him the chance to realize his dreams: to work professionally with wild animals, travel, and write books. It also has given him the opportunity, through provocative articles with beautiful images, to interest people in the protection of wildlife and the preservation of nature.

Soft lighting creates an unusual portrait of an impala, photographed in a game reserve in East Africa. Most animals in the national parks are used to vehicles and will allow a close approach. Dossenbach shot this from 30 feet away, using a medium telephoto braced on the door of his Land Rover. Impala, one of the most common of the smaller antelope on the African plains, are noted for their prodigious leaps, in which they often jump eight feet in the air to get a better view of possible predators over the tall grasses.

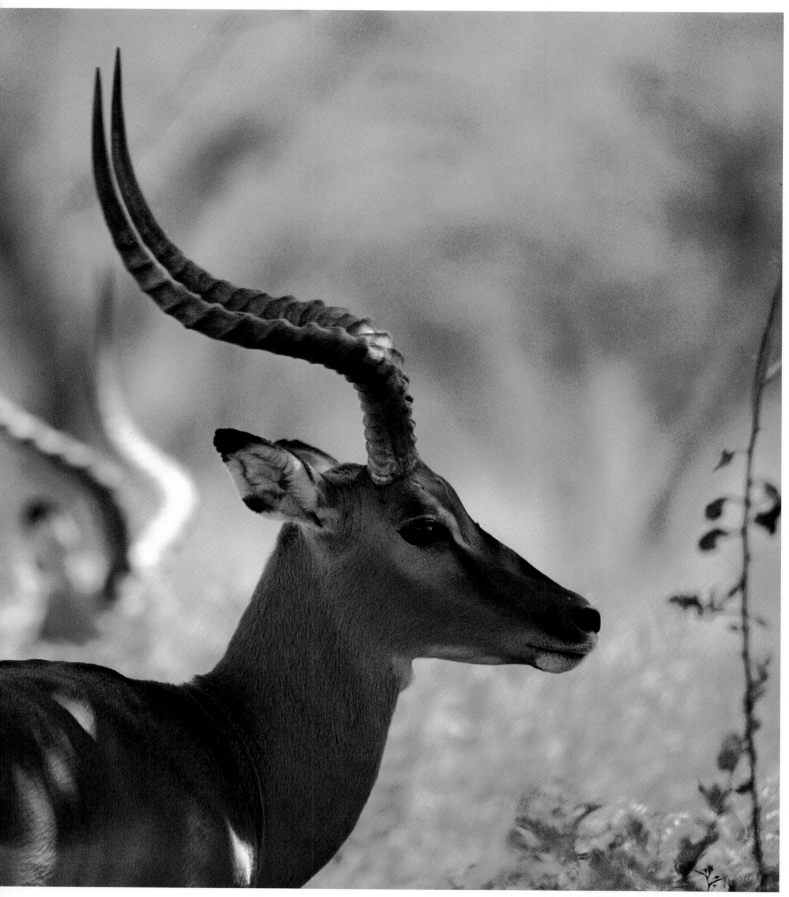

Impala: 300mm, 1/125 sec., f/5.6, K 64

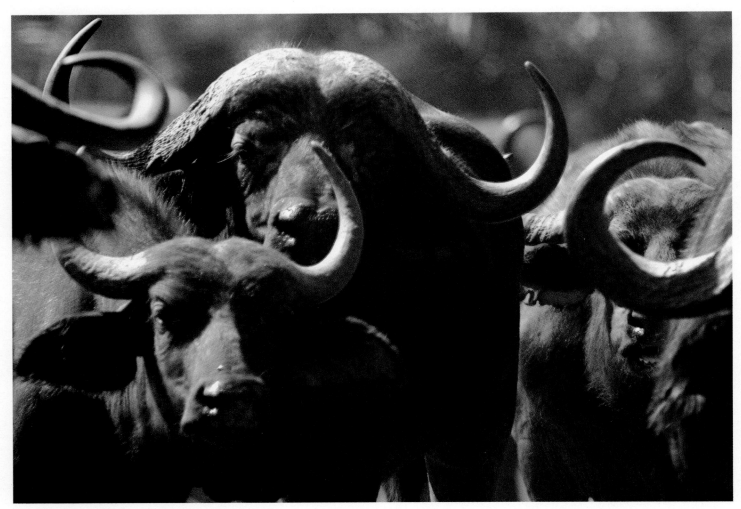

Cape buffalo: 400mm, 1/125 sec., f/5.6, K 25

Hunters claim that Cape buffalo are the most dangerous animals in Africa. Their dark color makes them difficult to photograph in clear, direct light but Dossenbach found these on a misty morning near Lake Manyara, Tanzania, shooting them through dust-filled air as they nervously pawed the ground.

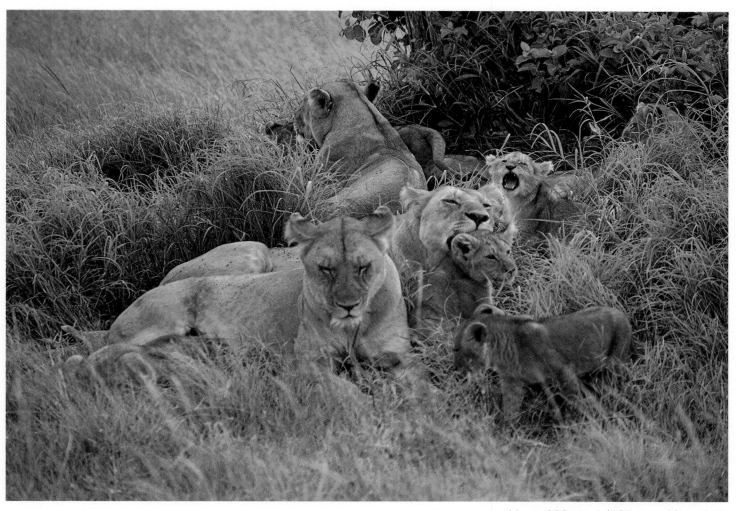

Lions: 300mm, 1/125 sec., f/11, K 64

A group of lionesses and young taking their ease at midday, present a picture of peaceful family life. Dossenbach easily could have gotten close enough to use a wide-angle lens, but prefers to keep some distance between himself and his subjects, for more natural results.

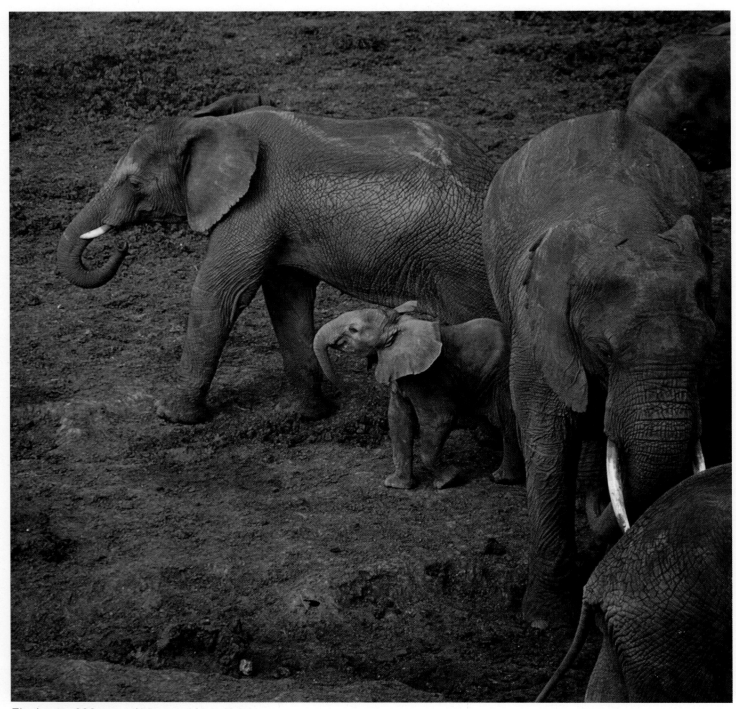

Elephants: 200mm, 1/30 sec., f/4.5, K 64

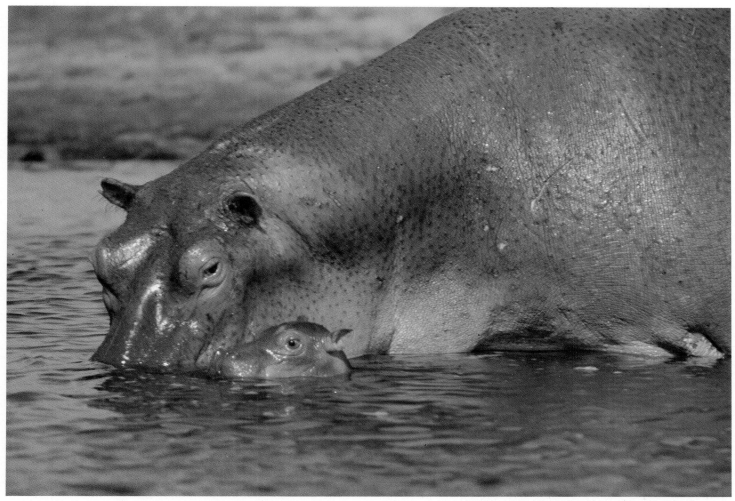

Hippopotamus: 400mm, 1/125 sec., f/11, K 25

Young animals can be most appealing subjects. Dossenbach shot the family of elephants (left) from the porch of Tree Tops Hotel in Kenya. "For a change, it was a pleasure to take pictures the way tourists do," he said. He came upon the hippo and her baby (top right) unexpectedly, while cruising down a river in Uganda. He was only able to get off two shots before she charged, nearly capsizing the boat. The blue-footed boobies, in the Galápagos, were so tame that Dossenbach photographed them without a blind, sitting on the ground just nine feet away.

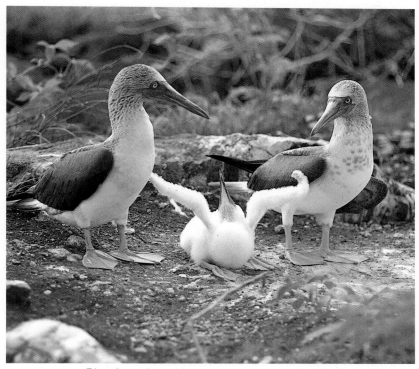

Blue-footed boobies: 130mm zoom, 1/125 sec., f/11, K 64

Green snakes: 600mm with extension tube, 1/125 sec., f/11, K 64

"Reptiles are fascinating," says Dossenbach, "but so strange, there is no way to communicate with them." He found this pair of courting green snakes (left) just 10 feet from his car at Ngoro Ngoro Crater. The one-inch-long poison arrow frog, photographed in Peru, is so named because Indians tip their arrows in deadly toxins extracted from its skin. To compensate for dim natural light, Dossenbach used two flashes: a main source at a 30-degree angle from the camera and a fill at a 45-degree angle farther back, to lighten the harsh shadows.

Poison arrow frog: 100mm with extension tube, f/22, K 25

Ghost crab: 100mm, 1/60 sec., f/11, K 64

For dramatic results, Dossenbach prefers working in warm morning and late afternoon light, with the sun behind or to the side of the subject. Ghost crabs (left) are usually quite timid but he was able to approach this one by moving very slowly. The low sun made long shadows, creating a striking image. Cross-lighting also makes the picture of the marine iguana (right) come alive.

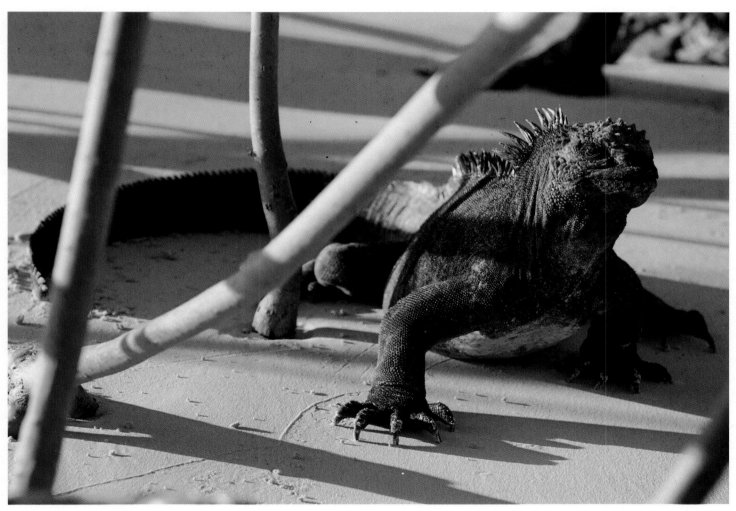

Marine iguana: 100mm, 1/60 sec., f/8, K 64

VALERIE TAYLOR
Underwater Realm

"Taking photographs under water is like working in a 60-square-foot room with no idea of what is behind the walls. Gravity ceases to exist and I float in a liquid world. Usually the subject appears for the first time moving very fast, some 30 or 40 feet away, in dirty water with very little light. It is entirely at home in the marine environment, where I am an alien, awkward and slow."

Australian-born Valerie Taylor, trained as a commercial artist, has spent much of her life in the water, photographing and filming the creatures of the sea. She and her husband Ron work as a team—he concentrating on cinematography, Valerie specializing in stills. Her pictures have been featured in many books and magazines, including *Life* and *National Geographic.*

Sharks

The Taylors began to film great white sharks in 1965, at a time when they had the field to themselves. It took many years to perfect the techniques required to work with the huge and dangerous animals and those early photographs, done before there were shark suits and protective cages, established their reputation. Since then, their sequences of sharks swimming free in their natural environment have been seen by millions in such films as *Jaws, Orca,* and *Blue Water, White Death.*

"Sharks hold a great fascination for me," says Valerie. "They are exciting and unpredictable. The work isn't easy, though. Photographing a great white from a rocking cage in cold murky water, surrounded by bloody chum bait, is perhaps the most difficult underwater situation of all. But I admire sharks. They have a presence in the water. They're the top of the food chain and they know it." Taylor feels that the fear of sharks is largely unwarranted. Most often the creature is swimming past and, although it might circle the diver once or twice out of curiosity, it will usually go away. If one comes too close, she routs it with a hard thump. The rogue sharks that do not back off, however, are among the sea's most dangerous adversaries. Once the Taylors were photographing blue sharks, off California, when one of them suddenly swam up and grabbed Valerie's leg. She knew better than to pull away, and held the shark until it released its grip. She was able to make it back to the boat where radio contact was made with the Coast Guard who flew her to a hospital. The cut, an inch-and-a-half deep and almost six

Grim reminders of World War II, gas masks are slowly obliterated by living coral 90 feet below the surface, on a reef off Truk Island in the Pacific. Wrecks are rich havens for marine creatures and Taylor finds them exciting places to explore and photograph.

Truk Island scene: 15mm, 1/60 sec., f/8, K 64

inches across, required hundreds of stitches and left a scar the width of the limb.

Another time, Valerie moved too close to a feeding frenzy when sharks were excitedly milling around, tearing indiscriminately at the bait and at times each other. One of the maddened creatures slammed into her and bit her in the face. Although Taylor was wearing a steel-mesh shark-suit, four of its teeth penetrated the gap in the mesh under her chin. She recalls, "The shark knocked my mask sideways and I got water inside, but the worst thing was that it took my mouthpiece and I had no air. I was about 25 feet down in 80 feet of water and I was nearly unconscious. I had a very hard time for a minute. I wasn't afraid though—I was too busy fighting for survival."

Diving

The Taylors have worked in all the tropical waters of the world, and have made cold-water dives in southern Australia, New Zealand, and California. They think the best diving area in the world is the Coral Sea of the southwestern Pacific, with its transparent water and rich fauna. Valerie prefers working where she can see the bottom. "The open sea is a great void," she says. "You can't see the ocean floor and you know you wouldn't go down there anyway because you'd never come back. It's something like flying high above the earth without an airplane."

When on location, the Taylors often work 15 hours a day. Valerie can snorkel down to 60 feet, and often scuba dives to 130 feet, although she has gone as deep as 260 feet on occasion. On a standard dive, the average person would run out of oxygen in an hour, but Taylor has learned to conserve it with controlled breathing, which doubles her time underwater. She traces her way back to the boat by remembering certain coral formations or pieces of kelp, just as she would use trees or rocks as landmarks above water. Taylor feels that most dangers in the sea are overrated. "The biggest threat to the diver is himself," she says. "A diver should be mentally and physically fit. If you panic you usually drown, and you can't rely on others because you can't talk and if they're not looking at you, they can't see your signals." Her only real fear is of strong currents and great turbulence. A surge can push one along helplessly, even 40 feet below the surface. Despite her caution and experience, Taylor once came close to drowning, when a pair of heavy denim jeans she was wearing to protect a new wetsuit jammed around her fins as she surfaced.

Dangerous and Friendly Creatures

Like most underwater photographers, Taylor has been stung by jellyfish and fire coral, and once was badly cut on an oyster. But she feels that very few divers die from encounters with marine animals. Even an accident with the supposedly deadly stonefish,

in waters off Australia, proved not to be fatal. Remembering the experience, she says "I might have wished I was dead, but I wasn't. I was by myself, down about 60 feet, and I saw a member of the stonefish family sitting on the bottom, with its poisonous dorsal spines raised. I was about to take a closeup when it jumped up and jabbed three spines into my hand. I didn't know they were able to do that. I took a couple of photographs, so they would know what got me, and set off back to the boat. By the time I got there, I was starting to feel really bad, and soon I was in terrible pain. It felt like gasoline burning its way up through my veins." She was treated with painkillers and heat, which breaks down marine toxins, and eventually recovered, although she was in agony for days.

Despite this experience, most of Taylor's encounters with marine animals have been pleasant. She met Harry, the moray eel, in 1970, on the Great Barrier Reef of Australia. Since then, he has appeared in many films. "Harry's quite a star and I love him," says Taylor. "He takes my hand in his mouth and nibbles, but never applies pressure, never sinks his teeth in. If I don't like the way he's posing, I'll put out my hand and turn his head, and he'll stay that way because he knows that if he's good I'll give him something to eat."

Taylor is also fond of sea snakes, whose venom, drop for drop, is ten times more potent than that of the king cobra. "Actually, they're the most easygoing little animals and they have such nice faces," says Taylor. "When I'm diving in the Coral Sea, I'll be really disappointed if one doesn't keep me company. They swim with me because I weave over the bottom and stir up animals that they eat. They'll twist around my arm or leg and stay with me the whole way, even coming right to the swim platform at the back of the boat. As I leave the water, they hang just below the surface watching me, as if to say 'Don't go, you're our friend.'"

People say that Taylor has a sixth sense when it comes to working with animals. She calls it an "understanding" and attributes it more to experience than anything else. "All the animals have different personalities," she says. "If there are ten fish of the same species, there is always one that is better to work with than the others. I am able to pick it out quickly because its attitude is more confident and its curiosity about me seems to override its natural fear. I can choose a shark from a group, bring it to me, and coax a performance out of it. This is not so easy with fish that have less confidence, but with a little patience I have achieved some suprising results. All the time I am saying things like 'Good fish, I love you fish, once more, fish.' Maybe all those squeaks coming up with the bubbles keeps them interested."

Unlike land animals, fish have evolved without an instinctive fear of man, and once they become accustomed to a diver's presence, provided he shows no aggression, they continue with their daily ac-

tivities as though he didn't exist. "Fish often exhibit human qualities, such as curiosity, surprise, fear and aggression," says Taylor. "I remember a wonderful orange cod that I trained to hover near a yellow coral by giving it bits of food. Once I had taken the required stills, I was finished with the fish and had no further interest in feeding it. The fish, however, had learned to associate me with an easy meal and whenever it saw me it would rush over to the coral and pose hopefully. Of course, I couldn't resist, and its little act earned it a few scraps of bacon rind whenever I was in its area."

Taylor advises returning to the same place day after day. With every dive she finds new creatures, and shy ones come out of their hiding places. Eventually she gets to know the animals in one location very well, and if she comes upon a particularly interesting creature, she will spend the entire dive with it.

Equipment

Taylor keeps her equipment to a minimum so that it doesn't interfere with her concentration on the subject. It forces her to find different ways to use each lens, and to achieve a variety of effects without carrying a lot of heavy gear. Even on a major assignment, she will take just a few cameras along, with no backup. "I have worked with many underwater photographers, particularly Americans, and compared to many of them my equipment is simple," she says. "They dive into the water like Christmas trees, with a dozen cameras and flashes, and I go down with just one or two. I am totally single-minded. If I plan to photograph a school of fish, using a wide-angle lens, I ignore all the small things around me that would require another lens. I don't even see them. If I'm after shark, I can be swimming over the most beautiful coral but all I see is shark."

She does most of her work with a Nikonos III, which resembles a standard 35mm camera, but is watertight and pressure-resistant. She recommends it for beginners because it is reasonably priced, reliable, and is made for use in the water, requiring no protective housing. Plastic or metal camera housings, which enclose standard cameras and have a glass or plastic port for the lens, have more surface area to maintain, are apt to leak, and tend to fog up for a few minutes when first plunged into cold water, during which time, Taylor says, "Six hammerhead sharks will pass by in perfect formation, I can guarantee it." Furthermore, the procedure for changing a lens in a camera protected by a housing is more complicated.

Taylor's favorite lens is a 15mm; her preferred flash an Oceanic 2001. For closeup work, she uses the same camera with a 35mm lens, special macro rings, and a weaker Oltron flash. Her other equipment includes two Nikonos IIs and a marine Rollei, a Hasselblad, and a Nikon F in housings, as well as 20mm and 28mm lenses, and a Metz flash, also in its own housing.

Taylor lavishes care and maintenance on her cameras and rarely has failure problems. She keep the O-rings clean by running her tongue along the out side to remove tiny salt grains or bits of fluff, and al ways loads and unloads the cameras with clean, dr hands, washing off the equipment after every dive.

She uses Kodachrome 64 for most of he work, switching to K 25 for extreme closeups and nigh photography, when she must compensate for th brighter reflection from the flash. She feels that th grain of higher speed films renders them unsuitable fo professional work. The Taylors often need a large boa to handle all their gear, which includes a compressor t fill the scuba tanks. However, they mainly work fron an aluminum dinghy that they tow all over Australi. behind a four-wheel-drive station wagon.

Technique

"When I decided to become an underwa ter photographer," recalls Taylor, "I said to my hus band, 'Ron, darling, I am not very clever so don't tel me too much. There must be one method that is bette than any other. Just tell me that way and I'll stick t it.'" Her fundamental approach is to keep her tech niques as simple as possible, concentrating on basi equipment, correct lighting, and good composition.

Lighting large underwater areas properl can be difficult because the visible distance is limited t 100 feet or less. Taylor tries to frame the scene to in clude an attractive, colorful object in the bottom fore ground, aiming the flash at it and shooting slightly up ward so that formations rise out of the picture an become silhouettes against the blue of the ocean. Sh usually shoots at a 60th of a second.

Most fish are not disturbed by flash, al though they may make a little jump when it goes of Some sharks can become frightened, however, and dar away while others ignore the flash completely. Silve fish reflect the light like mirrors, some appearing blac while others flare brilliantly, and can be difficult t photograph. Taylor shoots as rapidly as possible an brackets her exposures, but getting all the fish to refle the light simultaneously is largely a matter of luck.

Translucent objects, such as jellyfish, loo pale and the tendency is to close down the aperture an shoot at a higher f-stop. Since much of the light goe right through the animal and is lost, however, the aper ture should really be opened wider, to f/8 or even f/5.6 Front lighting of a clear subject will make it appea opaque; top lighting reveals its inner structure and ca be quite effective. Taylor prefers to backlight a clea subject, without flash, getting beneath it and shootin toward the surface, against which it looks as transpar ent as glass. In open water, she achieves a black back ground by using strong flash at a close working distanc from the subject; for a blue background, she uses weaker flash, farther away.

There are two methods of handlin

Valerie Taylor *and her husband Ron are Aus-
tralian divers who have earned worldwide acclaim for their dar-
ing photography of sharks. Their work with the dangerous white
shark was featured in* White Water, White Death, Jaws
and Jaws II. *Val began her career helping Ron and continues to
act as his assistant for motion-picture filming, but she is most
involved with still photography. Her evocative documentations of
underwater life have appeared in* National Geographic *and*
Life *magazines.*

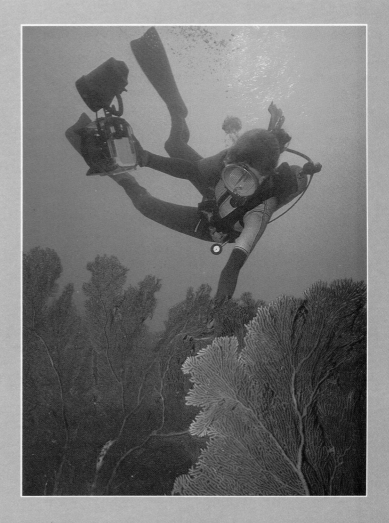

CAMERA UNDERWATER

The techniques for successful underwater photography are based on what happens to light when it enters water, which is 800 times denser than air: A diver's eye can adjust to the changes but the camera cannot, which is why so many pictures that looked good through the lens turn out to be dim, blue, poorly exposed images when developed. Since available light diminishes rapidly, flash is useful even a few feet beneath the surface and becomes essential at greater depths. As light waves enter the denser water they slow down and bend, distorting distance so that objects seem to be one-quarter closer than they really are. In addition, water absorbs light waves selectively, the red end of the spectrum faster than the blue, so that a brilliant red coral will appear dull red at ten feet and will lose its color entirely much below that. Furthermore, the suspended particles present even in the clearest water, such as bits of coral, sand, minerals, decayed organic debris, and bubbles, absorb and scatter the light, making it more diffuse and cutting down on contrast. The farther the camera's lens is from the subject, the more these problems are exaggerated. To compound the problem, weightlessness makes exact focusing difficult.

Taylor's technique is as simple as her equipment. Her most important rule is to get as close to the subject as possible. She points her Nikonos at it like a speargun, often thrusting the camera at arms' length to gain another few feet. Since the subject seems magnified to both eye and camera, Taylor focuses for the apparent distance, not the real one. Although the shutter speed and light generated by the flash remain constant, regardless of depth, the exposure varies with the clarity of the water, distance, and color of the subject.

Taylor prefers to work in shallow water with natural light whenever possible, as the shadows give the subject crisper definition. Her average setting without flash is a 60th of a second at f/8. Over a sandy bottom, where reflected light is brighter, it becomes f/11, or a 125th of a second at f/8. The best time for available-light photography is between 10 A.M. and 2 P.M., when the sun is directly overhead and the surface is calm.

Because many subjects live too deep for natural light, Taylor usually works with flash. She holds the flash at arms' length, and at an angle far enough away from the lens to prevent backscatter, when the particles in the water reflect light back into the lens and show up on the film as a blizzard of bright spheres. She uses a number 25 or 30 red filter to adjust for the shift to blue.

closeup photography underwater. A series of diopters can be placed over the front of the lens, instantly converting a wide-angle shot to an extreme closeup, or a macro ring can be placed between the camera and the lens. Taylor uses special rings designed by her husband. She can tell that a subject is in focus when it is between the tips of two wire measuring prongs that extend out on either side of the ring. She does not use a red filter for extreme closeups, altering the exposure according to the color of the subject. The flash is usually attached to the top of the camera.

Although Taylor does most of her shooting in the daytime, she finds night photography exciting. "Everything is different," she says. "The fish are asleep and you can get as close to them as you like. There are strange new creatures swimming around. A lot of planktonic life floats in the water, polyps come out to feed, exotic crinoids appear, and crabs, crustaceans and starfish are unafraid because the predators are asleep." Taylor carries a torch and is careful not to swim too far from the boat into the darkness.

Advice for Beginners

Taylor recommends that the beginner start with an easy subject like kelp, either shooting up past it toward the bright surface, or composing several fronds into an interesting pattern. She thinks that starfish—which come in a variety of colors and patterns, are harmless, relatively static and docile enough to be arranged like a still life—are almost a "can't miss" subject. They can either be shot with a flash or moved into bright, shallow water and placed on a background of the photographer's choice. This is true for many sedentary animals but, she warns, "Remember always to return any animal that you move to its original place."

Beginners tend to stay with one exposure for the same subject, regardless of its background. Actually, a fish feeding on dark coral has a different reading when it zooms across the sand or swims into open water, so exposures must be constantly adjusted. Taylor is so farsighted that she cannot read the numbers of her lens, but is so familiar with her equipment that she doesn't have to.

Unlike above-water photography, where the subject is usually familiar to the viewer, photographs of marine animals can pose quite a problem. In an underwater photograph, a one-inch sea slug can look as large as a horse, or a three-foot shark appear to be nine feet long. Taylor often includes a human figure in her pictures to give a size perspective easily recognizable to the layman.

The Underwater World

Taylor tries to minimize any ill effects she may have on the wildlife in areas where she is working. Although corals do get broken and territorial rights are sometimes disturbed, she respects the underwater world and its inhabitants, feeling they have as much right to live in peace as their above-water counterparts. She believes that a diver entering the water with aggression will find an aggressive, unfriendly environment. A calm, gentle attitude seems to produce the best results. Fish don't like fast movements; they become nervous and wary, which makes them poor photographic subjects.

Wildlife both above and below the water fascinates Taylor. "A female turtle laboring up a beach to lay her eggs makes me weep at the sheer, overall feeling of the thing," she says. "It's not that she is beautiful or clever or unusual. It's just that this great, awkward, most unlikely animal is performing an awesome task and has successfully done so for millions of years. A tiny fish protecting its eggs ferociously, attacking both me and my camera, wins my admiration as few other marine creatures can. The parent is undaunted by my huge size and nips at my face like a mad bee.

"I am often asked why I do what I do. It's a hard life, constantly fighting the elements to work in an unnatural environment, but I love it. Anyone wishing to become an underwater photographer has a lifetime of disappointments, frustrations, excitements and, when shots turn out well, great satisfaction. Working in a liquid, silent world, you learn to rely on your own judgment. To be a good underwater photographer, you must first be a good diver. Experience is important. If you do not feel completely at ease, your concentration will be divided and the photographic work will suffer. It's a hard business, on both the diver and his equipment. Many would-be underwater photographers give up after a short while. It takes a certain type of person. You must be fit, gutsy, and prepared to suffer a little. For Ron and myself, it's our play and our work. I, for one, wouldn't have it any other way."

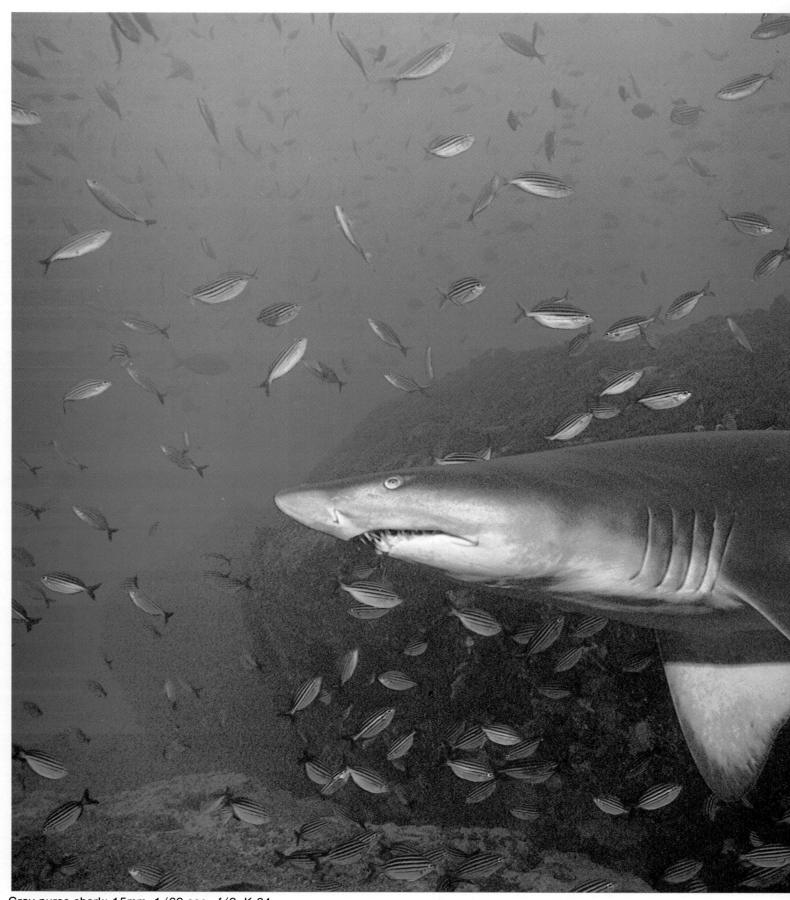

Gray nurse shark: 15mm, 1/60 sec., f/8, K 64

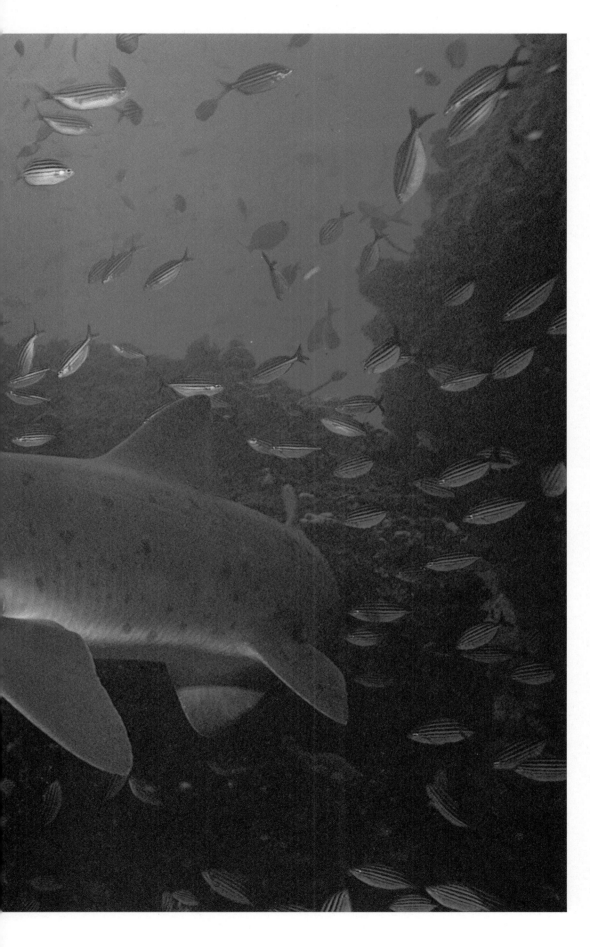

On the prowl at dusk, a gray nurse shark courses through the shallows off New South Wales, Australia. Although many of the world's 350 species of shark are potentially dangerous to divers, these ten-foot-long bottom dwellers have gentle natures that belie their fierce reputation, and Taylor has advocated their protection for many years. Sharks usually circle out of curiosity more than menance but should one get too close, Taylor routs it with a thump.

Orange cup coral: 15mm wide-angle, with closeup ring, 1/60 sec., f/22, K 64

False cleaner fish: 35mm with closeup ring, 1/60 sec., f/11, K 64

Many reef animals are easy subjects for a beginner to photograph. Coral closeups, such as this orange cup coral (top left) devouring a young fish in a cave on Australia's Great Barrier Reef, are readily obtained at night. Immune to the toxin, a clown fish (right) rests among the tentacles of a green sea anemone and will rarely leave its home port. When threatened, other creatures back into any handy hole; this false cleaner fish (bottom left) has sought refuge in an empty tube-worm case. Unlike the cleaner wrasse, which picks parasites from larger fish, this look-alike swims up and bites a piece out of its surprised victim.

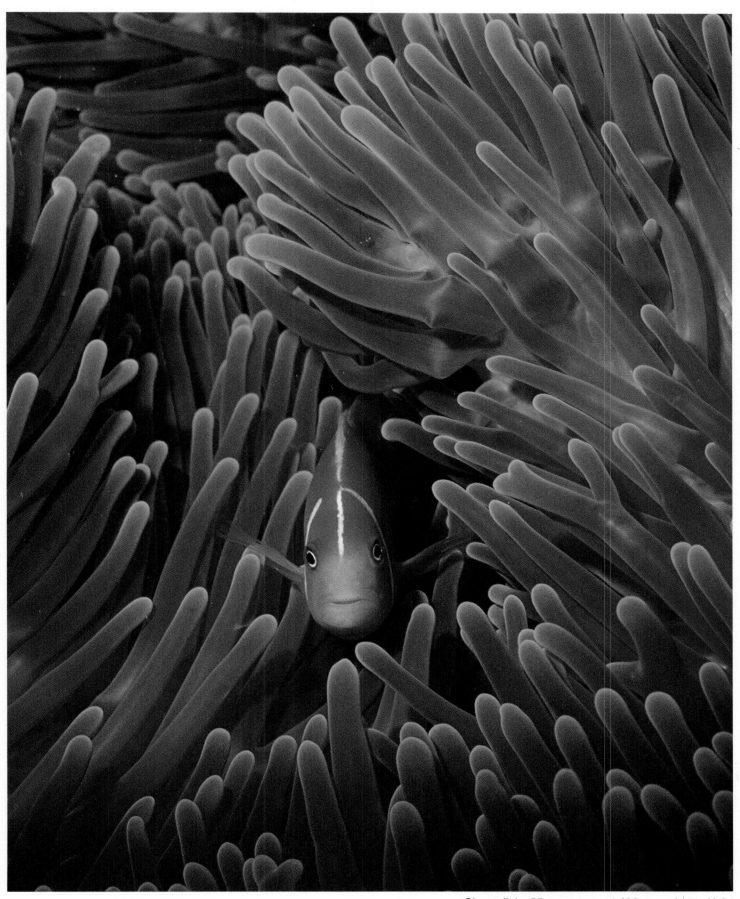

Clown fish: 55mm macro, 1/60 sec., f/11, K 64

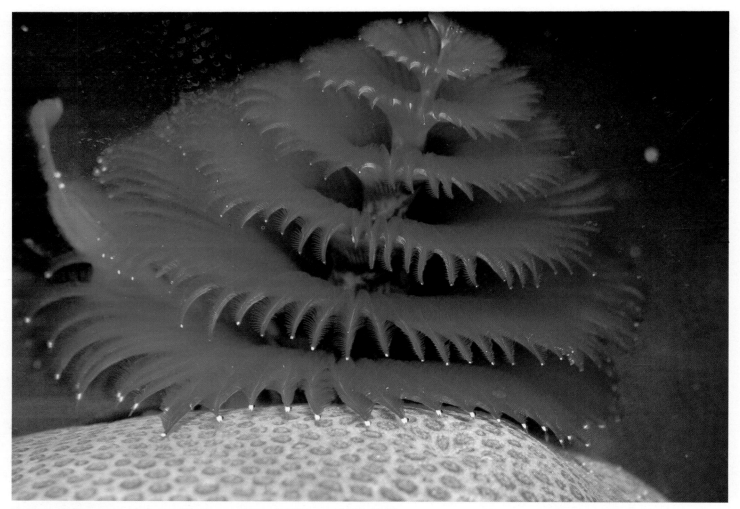

Feather duster worm: 35mm with closeup ring, 1/60 sec., f/22, K 64

Dead whip coral: 35mm with closeup ring, 1/60 sec., f/16,
K 64

At the slightest disturbance, the feather duster worm (top left) retracts and seems to disappear. Its delicate "plumage" is actually the animal's gills, which extract oxygen and food from the water. A dead whip coral (bottom left) has become host to an incredible array of marine life, including sponges, corals, hydroids, and algae. Briefly illuminated by Taylor's flash, a soft coral (top right) glows in brilliant contrast to the dark water. At night, soft coral polyps (bottom right) extend into the plankton-filled water, searching for small particles of food.

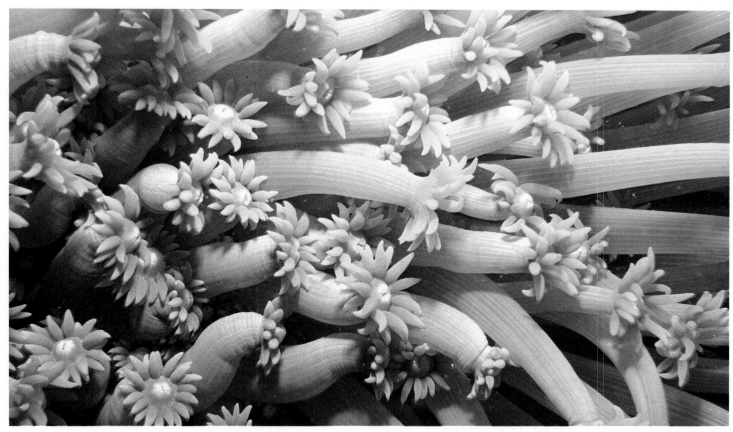

Soft coral: 55mm macro, 1/60 sec., f/16, K 64

Soft coral feeding: 35mm with closeup ring, 1/60 sec., f/16, K 25

Coral crab: 35mm with closeup ring, 1/60 sec., f/16, K 25

Normally timid by day, a coral crab shows no fear at night and continues to feed, despite the camera lens just inches from its face.

Giant clam: 55mm macro, 1/60 sec., f/11, K 64

Tridacna clams, which grow to be two feet across, live a long time and become encrusted with many other organisms, creating a colorful composition.

Sea wasp: 55mm macro, 1/60 sec., f/16, K 64

The transparent sea wasp (above) is one of Australia's most deadly marine animals, and has caused many more fatalities than sharks. The remains of a fish can be seen within the bell. One of the most bizarre creatures of the Barrier Reef is the harlequin wrasse (right) whose protruding teeth are used to crush snails, crabs and mussels, and to rip away coral to reach small hidden animals. To get this picture, Taylor lured the fish with a piece of bait attached to the top of her camera.

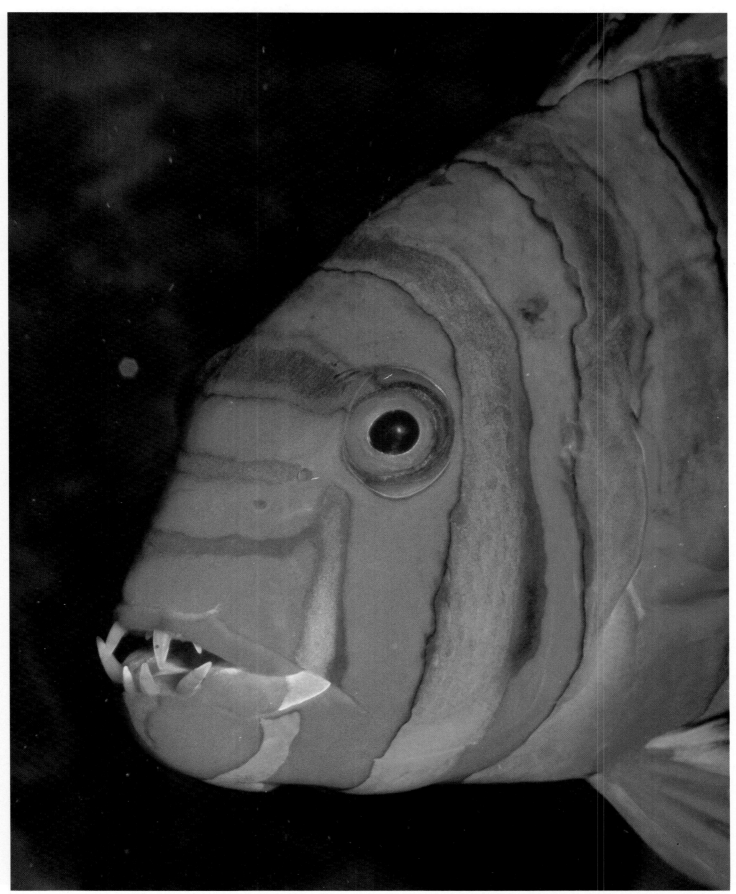

Harlequin wrasse: 55mm macro, 1/60 sec., f/11, K 64

This Spanish hog fish was photographed in the Caribbean, at a depth of 85 feet. Adults reach two feet in length; juveniles clean parasites from other fish. Like many members of the wrasse family, it has an aggressive personality and if food is offered will quickly become a willing subject.

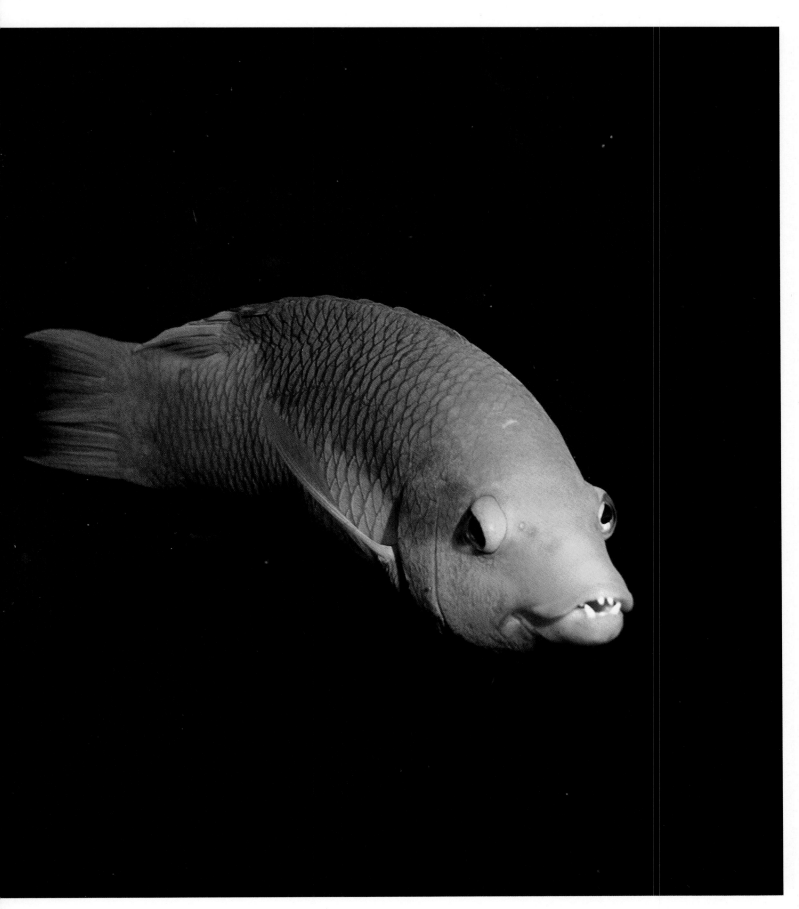

Spanish hog fish: 55mm macro, 1/60 sec., f/11, K 64

*From
the other
side of
the desk*

An Editor's Overview

The sale of wildlife photography is basically a stock operation and its rules are quality, quantity, variety and more of the same. The more good pictures of animals doing different things you have in your files, the more you will sell.

Work to add to those files. Periodically weed out inferior images and replace them with better. Compare your work constantly to that of published photographers. Those successful photographers are not resting on their laurels; they are out there in the field using new equipment, improved film and hard-won experience to add fresh material to their own files. Use the standards they have set for themselves as your starting point and try your hardest to surpass them. New photographers do it all the time. It helps to keep the pros on their toes and is the only guaranteed route to publication.

Be your own best editor; do not accept inferior work from yourself. Keep a photo log so that when you are successful you will know what you did right. Get a good photographic reference book, such as *The 35mm Handbook* by Michael Freeman, and use it—often. When you find that your equipment is not capable of delivering the kind of images that you are trying to make, save your money and buy better. Put your projector in the closet and start judging your slides with an 8× magnifying glass over a light box. The magnifying glass is the viewing tool used most often by the pros. It will tell you immediately if images are soft, grainy, missing in important detail, or weak in color. A common delusion among amateurs is that the printing process improves pictures. It doesn't. In fact, it does just the opposite. Detail and color balance suffer in reproduction. It is true that on rare occasions, such as the capturing on film of an abominable snowman, technological miracles can be performed. However, if you have a fuzzy picture of a gray squirrel eating a peanut, don't expect that miracle.

Try to understand the underlying pictorial themes of the publications that use wildlife photography. Put yourself in the place of their picture editor and figure out their photographic and editorial requirements. How would your own pictures stack up on those pages? What can you do to make pictures that would be valuable to those publications? No two picture editors see images in quite the same way. If you are personally truly partial to one magazine, you and that magazine's picture editor may share a visual point of view. Send pictures to that editor—regularly. Look over past issues and try to figure out what has not appeared that you would like to see *and* think that maybe you could supply. Go for it. Set yourself an assignment and

ll it. Submit a carefully edited take. If the pictures aren't accepted, do it again. If you are actively photographing anyway, you might as well shoot with a specific goal in mind. Learning to think like an editor will add important dimensions to the material in your files.

Wildlife photography is most often used to illustrate popular science books or articles. For every animal picture published that is only beautiful, fifty more will be used that also tell a story. Show your creatures in their environment. Capture unique characteristics, poses and behavior. Find them at their food sources or dens. Show them living their lives. This is what picture editors are looking for. Don't forget that photography is a tool for communication. The more you can communicate in one image, the better. Pay attention to overall composition. Does it help the picture to make its point or must the viewer search to figure out what is happening? If a picture is beautifully lit and artfully composed as well as informative, so much the better. An editor who sees it will be impressed and more likely to remember your work, even if that picture is not used. Striking images stick in the mind and picture seekers usually can remember where they are when they need them.

The relationship between picture editor and photographer is a mutually dependent one. Neither can survive without the other. The editor's job depends upon being able to find attractive, reproduceable, meaningful pictures. These can only be supplied by a photographer. Every editor wants to be the first to publish the photographs of an up-and-comer and is alert to the possible discovery of a fresh, new talent whenever a package of unsolicited material is received. On rare occasions when pictures indicate a new photographer has come forth, the editor is genuinely thrilled.

A picture editor wants and needs your pictures to be good and *if* they are good, will try to use them *if* they are right for the current needs of the publication. That editor will see at least 100,000 pictures every year. Too many of them will be just plain bad. Most will be at best mediocre. (Mediocre defined: ordinary pictures of ordinary animals doing nothing out of the ordinary. Mediocre further defined: pictures that are similar in content and quality to hundreds of others already seen by the picture editor.) To survive the onslaught of images, each editor becomes expert at quick evaluation. In the long run, most of the time, our techniques of review work. We are aided by the pictures themselves; superior images almost leap off the light table to announce their own presence! They are evocative and exciting and provoke the jaded eye. Be assured that your work has been considered even when it comes back quickly with a form rejection slip. Make regular submissions and the editor will become aware of your progress and may even encourage you to submit more work. If the work shows promise, that editor may also contact you with specific requests.

Pity the poor picture editor. Don't make a tough job any tougher than it already is. Every publication has a form that outlines photographic requirements. Get one and do what it says. It will tell you what is needed and in what form you are expected to present. Most editors want to see transparencies arranged in plastic file folders; it makes viewing easier. Once, when I was young and inexperienced, I did look through twenty Kodak boxes filled with slides, each one of which was carefully wrapped in facial tissue. I would not do that today. If the form says that they do not want to see any pictures of green-faced aardvarks, take them at their word. Pre-edit. Send a representative selection of your best images chosen with the specific publication in mind. When submitting black-and-white, send prints, not contact sheets. For color, always submit original transparencies. Send an introductory letter that explains the pictures and indicates why you think they may be right for that publication. Call attention to "special" happenings in any one of the pictures. Picture editors, no matter what we tell our friends, do not know everything. Put your name at the top of the picture and supply caption information giving subject, location and, if needed, a concise explanation of behavior.

In your perusals of published material become aware of common subject matter that has never been properly illustrated. I have never seen a good life sequence of the housefly or of the everyday, run-of-the-mill house mouse. Every spring and summer I look out of my city window and watch the English sparrows frantically building nests and gathering food for their young. I have never seen pictures that tell me how a city sparrow builds its nest or that incorporate the development of the young into a city environment. Use your imagination and you can wait until you are actually earning money with your pictures before trekking off to Africa.

As your files build, work to establish a system of retrieval. Any basic photography book will suggest a system that works for somebody. Look around until you find one that works for you. A system works if you can find a picture quickly when you need it and if it encourages you to put pictures back when they are not needed anymore. Key your caption system to your file system and keep good records. There is no predicting what an editor will want to know. Treat those pictures with respect. You worked hard to get them. Protect photographs from accidental damage and premature aging. In other words, don't set up a file system under the bathtub or too close to the furnace. Be wary of the projector. Its intense heat and bright light can damage transparencies. Your picture room should be air conditioned and/or humidity controlled for the sake of your photographs. You, of course, are prepared to suffer for your art.

Don't be afraid of the mails. I have been using them to send pictures back and forth for twenty

years and have only once had a package lost. The odds are on your side. Registered mail is by far the best way to send photographs. Registering a package guarantees your parcel will travel in a locked box and be signed for at several stops along the way. Certified is far cheaper but does not guarantee deluxe treatment, only hand delivery and a signature at either end. Whichever method you choose, be sure to request a return receipt so that you will know when your package has arrived at its destination. Include a check for return postage. Establish a standard method of mailing with a log out and log in system. Invest in a supply of sturdy, precut, corrugated cardboard that will fit inside a standard-sized envelope just a bit larger than your plastic slide sheets. Use masking tape to sandwich two pieces of cardboard around your transparencies. Use reinforced paper tape to seal the envelope. Don't, however, do such a thorough job that it takes a hacksaw to open the package. Do not expect to hear back for at least a month. After that you are within your rights to make a call to find out what is happening to your pictures. You will generally get best results using the telephone, even if you only speak to an assistant.

If you find yourself with a growing number of images, consider using a stock agency to sell some of your second bests. While you may not make a great deal of money from the pictures the agency sells, they will definitely be able to find you sales that you would not get yourself. Remember that just about every time one of your pictures is used, anywhere, your name is used with it. It is a small pronouncement to the world that you exist and are taking publishable pictures. A good photo agency can help to get your name around.

Aggressively pursue publications that use wildlife pictures. Do not limit your efforts to nature outlets. There are not enough of them and they do not pay well enough to keep any photographer in film. Branch out. Buy Henry Scanlon's *You Can Sell Your Photographs.* In it, he tells you everything a beginner needs to know to market stock photographs. *The Guilfoyle Report,* a quarterly newsletter for nature photographers, might also prove helpful.

Learn to live with rejection. It goes with the territory. All a "no, thank you" slip means is that a particular publication did not want a particular picture at a particular time. Send that picture out to another publication and see what happens. Don't ever let rejection stop you from taking pictures.

Each of the photographers whose work appears in this book began by simply taking photographs, working through techniques as they went along, picking up skill through experience. They sent their work in cold to picture editors and suffered through the inevitable rejection slips and lack of communication that hallmark any beginner's entry into an established field. In the end, they "made it" because their work got to be just too good to be ignored. You can do the same, if you are interested and determined enough to try.

—Ann Guilfoyle

Selling your pictures

Advice from the Picture Editors

There are a few major publications that are especially interested in wildlife photography. Without exception, the picture editors of these publications are receptive to the work of new photographers and go out of their way to encourage those who show promise. In the following interviews a few key picture people explain their pictorial philosophy and suggest a "way in." Before sending material to any publication, request their photographer's guideline sheet and read it carefully. Addresses can be found in *Photographer's Market.*

Martha Hill
Picture Editor, *Audubon*

"The biggest excitement is finding new photographers whose work has never been used before. It's a thrill to discover a photographer who really has an eye, who catches his subjects in nice lighting and imparts form to his imagery. It doesn't really matter what the subject is, a beautiful photograph is a beautiful photograph.

"I look at everything unless it comes in a huge carton filled with boxes of slides in chaotic order. Those go right back with a brief note saying, 'Do your own editing!' I check first to see that the minimal technical requirements are met. These are proper color saturation and critical focus with good light and composition, things that a lot of amateurs just don't seem to understand. They project their work or make prints and think they have something that is better than it actually is. It really annoys me when I see obvious evidence in a submission that the photographer has not carefully studied *Audubon.* It's part of the homework to study out the periodical that you're submitting to. *Audubon* is very straightforward and will continue to develop along the same lines as it has in the past. If someone studies a few years of back issues he will have a very good idea of the style of image we are looking for. I certainly don't want to see birds at the backyard feeder!

"I am looking for something that is unusual, a different look at a common thing. Perhaps this will be something that you don't see very often or simply an uncommonly beautiful photograph of a subject that everybody loves. Wildlife photography is the toughest because the subject matter is so unpredictable. It requires a good deal of knowledge of both animals

and their behavior. The more informed and observant the photographer is, the better his photography will be because he is able to create opportunities by putting himself into the situations where animals do interesting things.

"We particularly want brief wildlife essays ranging from one superb picture to a short sequence. If photographers can supply us with interesting information around which we can build a brief text, it makes it more likely that the pictures will be used. The short essay approach gives us variety in the magazine and allows us to use subjects like insects or reptiles which rarely get a full essay treatment. We want pictures that tell something about an animal's behavior or which investigate its character. For instance, predators hunting, not dozing in the sun.

"Then there's the other end, the purely artistic photograph. We are always looking for something that offers a strong graphic image. It may not necessarily be a realistic photograph. It may be mood-evoking or even a pure abstraction, the kind of photograph that alters your perception because the photographer is looking at something in a slightly different way. These to me are the most desirable photographs because we see the same things all the time. These provocative images challenge the perceptions, demand involvement with the photograph. They say things without needing words.

"On a first submission, I want to see how the photographer works. I like to see both an essay and an overall selection presented in plastic file sheets for easy viewing on my light table. I never project. The essay gives me an idea of how the photographer handles a theme; the overall selection shows his breadth, what subjects he can handle. If I already know somebody's work then I'd just as soon he called me before sending pictures, but if it's a first submission I need to see actual photographs. Originals only, no duplicates.

"*Audubon* is always looking for good bird photography. I think there is something to be pioneered here in terms of artificial lighting. I can't understand why a clever photographer doesn't come up with a diffused lighting system that avoids those awful harsh light effects on the body and flash reflections in the eyes. Zahm's picture of a meadowlark in the snow is my prototype, a bird at home in its environment photographed full-frame under interesting lighting conditions. There's a crying need for good bird pictures but it takes extraordinary patience as well as professional techniques and expensive equipment."

Tom Powell
Senior Illustrations Editor,
National Geographic
Special Publications Division

"When you send photographers out in the field after scenics and things like that, you just don't order up your neighborhood moose to get that glorious shot. With a ten- or twelve-week assignment schedule a photographer can't count on getting wildlife and we go to other files to get the spectacular shots that someone had the time and know-how to take. I especially look for 'two-fer' pictures that give a lovely, lovely view of the animal but also say something about habitat, behavior or the peculiarities of its character. We are only interested in superlative photographs that stack up to the work of the true professional.

"We use a lot of pictures here. Special Publications is responsible for *World* magazine, World and Young Explorer books, film strips and other school products. We also put together four adult books a year. Right now, there are twelve picture editors, all of whom are constantly looking for material, either to meet current needs or for future projects. Each editor is responsible for his own research and keeps records of photo sources. If a photographer is submitting cold, he should start by sending in a small representative selection of twenty to forty of his best slides. Group them in plastic sheets with a covering letter giving some idea of the extent of coverage. Send them to Bill Allen, Assistant Director, Special Publications. If he has time, Bill reviews the portfolio; otherwise, it is passed along to me. Interesting pictures are circulated to each picture editor to view on his own light box and name, address and type of coverage are noted for future reference. It is not a bad idea for a photographer to submit a new selection from time to time. Editors and projects change.

"*World* magazine is a place where young photographers can break in. They've got to be good and they have to come up with an idea. There are a lot of good photographers around but relatively few of them have publishable ideas. If someone comes in with a strong concept and shows us a portfolio that encourages us to take a chance, we may give him an assignment. Sometimes, when the story idea is good but we are not sure he will be able to pull it off, we supply film and processing; the photographer invests his time. Decisions are made on a case-by-case basis.

"Over a period of time any competent photographer can put together a competent portfolio, but when a photographer is trying for an assignment, I don't want to see file pickups. I want to see a self-imposed assignment shot in eight to ten rolls of color and I want to see everything in those rolls, not just what the photographer picks out. I don't much care about the subject matter. It can be as simple as a day at a flea market, something like that. What I am looking for is

how he thinks with his camera, whether he's shotgunning or really thinking the pictures through. I can tell more this way, and I think most picture editors can, than by looking at a portfolio that shows only the best. However, when selling file pictures, the more carefully thought through the portfolio, the better.

"We are always looking for bright new photographers and we really need fresh wildlife material because after a while you start to feel that you are using the same shot over and over again."

John Nuhn
Photo Editor,
National and International Wildlife

"Today's wildlife photographer is competing with television and all the specials done on animal behavior. Simple portraits, although nice on occasion, just don't make it anymore. Our readers demand to see something happening. They want to know about the behavior of the creature and not in the straight kind of way it is shown in a biology book. TV has become such a part of our lives that we expect to see things move. Try for techniques that imply action, blurred running legs, fur blown by the wind, things like that.

"I get excited by good pictures. It's a personal reaction, a reaction to the material in front of me, especially if the image is colorful and well-exposed. We are particularly interested in new photographers. There are always people out there who have been shooting for a couple of years and have a little bit of a file built up but may not realize how good the stuff is or have decided to hold back and get more of a stock file before trying to market anything. Any time we find photographers like that and their images are really good, we try to use them as much as we can to get the most out of their new eye. It gives a little different look to our magazines.

"The work has to be technically excellent. If the subject is supposed to be in focus, it should be in focus. If it's supposed to be blurred then it should be blurred in the right way but not so much that you can't even recognize what is going on. There are all kinds of techniques that you can use to try to improve the picture and get some kind of poetic feel to it, but it's got to do what the photographer intended it to do and it has to communicate. With most mammal pictures, you are faced with variations of brown. A spot of color can make a difference. There are ways of adding a colorful note to even a dull-looking creature. A flower can do it or the right lighting conditions where colors are intensified by a touch of sun or fog.

"Mary Goljenboom, my assistant, screens submissions before I see them. If they are not good technically or are of subjects that are of no interest to our magazine, such as garden flowers or squirrels at a feeder, they are returned with a standard slip. If they are right she passes them on to me. Everything is looked at. We receive about 1,000 pictures every week, and really appreciate photographers who submit their work in plastic sheets with clear captions. It cuts down on our editing time. Mary hates it when people tape their transparencies to cardboard, and I have trouble with unprotected transparencies in Kodak boxes. I will look at good pictures no matter how they come in but it is an easier, happier process with less likelihood of damage to the transparencies if they are presented in plastic viewing sheets.

"Captioning is important. It can be on the mounts or on separate sheets, but don't send in pictures without any captioning whatsoever. I may deal with animals on a year-round basis, but there are many species that I don't run across very often. Besides, some species can be confusing because they look alike; is it a female mallard or a male mottled duck? It also helps to know where the picture was taken. For instance, I receive a nice picture of a duck on a lake. I may not need anything on ducks but have a story idea on the lake where it is swimming. If I know the locale, I can pull the picture to be considered with the lake story. Point out any specific behavior. I hate to miss out on that.

"A cover is definitely something for a beginner to concentrate on. We've had a number of people just starting out that have made it. In some cases it has been a once-in-a-lifetime shot. Other people seem to make our covers on a somewhat regular basis. We want interesting animals in interesting positions with good color, but after that it's hard to say what will make it. One problem is that there are physical restrictions. There has to be room and a somewhat even background for the magazine's logo on top, and to get the proper proportion for our page size we must crop ⅛th of an inch from either the top or bottom of a 35mm slide. These physical requirements put a lot of good pictures out of the running for front covers but they are still eligible for back covers.

"A new photographer should try to figure out a picture story idea, work it through and then send it in with the pictures. If we like the idea and the pictures are good then there is a real chance that the story will be used. Study the magazines. Follow them in chronological order and you will see how photos have improved over the years and which direction our magazines are heading. It works to the photographer's advantage to send in pictures instead of a query. If the pictures are good, even if they are not what we are looking for at the time, the photographer will be listed in our subject file and receive a later picture request when I am looking for those subjects.

"I try to give a different look to our magazines. I like to surprise our readers, keep 'em hopping. One of their favorite shots is of a lion sleeping in a tree. It was a cover and a real reader grabber! But it was not just a cute picture. It was a realistic portrayal of lion life

that the photographer caught at the right time. It's the kind of image that we are always looking for."

Jane Kinne
President, Photo Researchers, Inc.

"Once we are within the framework of a properly exposed, properly composed shot, I look for information, the picture that tells me something that I don't already know from other people's pictures. I've seen altogether too many absolutely breathtaking portfolios that really don't teach me anything. Most of our pictures sell to the information market so I get much more mileage out of documentary pictures, but after they tell the story, the more artistic they are the better. I need behavior or details that show something important about the animal. I think of how long I waited, how many tons of pictures I saw, before someone was smart enough to take a picture looking down the nose of an albatross. This is certainly something important and interesting about the bird that wouldn't show up unless the photographer thought about it and knew something about the animal. My biggest point is that I want knowledge behind the camera.

"Every new photographer wants to do the exotic, but I want the guy who, as Will Beebe used to say, covers the one square mile around his house. Chipmunks, English sparrows, field mice. How many good robin pictures are there? Or starlings? Illustrate the common principles: food, habitat, creature. There's a constant call for that kind of picture.

"I think new photographers should try to meet the professionals in the field, not just go to them and talk, *but listen*. One of my biggest complaints is someone who comes in and asks for advice and then comes back in six months and hasn't followed any of it. Photographers must learn something about the basic business and the approaches of the various magazines. However, the photographic community is large and the photographer may not be able to get to everybody; maybe he shouldn't even try. Marketing pictures can be a frustrating and debilitating experience and the time it takes can cut into picture-taking energy. When a photographer is really into a project and it's his current thing, he should hang onto it himself. When he's that enthusiastic, he's the best salesman. But if he has tried and tried and nothing has happened, then maybe he should let an agent have it and go on to the next thing.

"Don't send unsolicited pictures to agents. It is dangerous and unproductive. I like initial contact to be by mail and want to know the physical details, such as camera, equipment and film, as well as the extent of the coverage. This indicates to me whether or not I am dealing with a potential pro and whether or not I should take a look at the pictures. Film is especially important. I don't want an inferior film that will be beautiful today and fade tomorrow.

"I am most interested in files that are fairly comprehensive, but if a photographer understands that a small file is not going to generate remarkable income, then I am willing to take him on fairly early in the game if the pictures are that good. I am always looking for the young ones and try to help bring them along.

"Some of our photographers make as much as $35,000 a year from agency sales, but if a collection is small the income may be only a few hundred a year. It may not be much money but it is exposure that he would not get otherwise, and the little bit of action may encourage him to do more. As the collection grows, the money should go up. This is a game of numbers. With enough pictures and variety available something will go out on just about every wildlife call; sooner or later the money will begin to roll.

"Wildlife is a good field, with endless possibilities for the person who looks at what has been done in the past and decides what needs to be done better or what is missing altogether. The market grows larger every year."

Editor's note: While Jane Kinne is not strictly speaking a picture editor, she is definitely one of the most experienced picture viewers in the business. As president of a stock agency with more than two million transparencies in its files (40 percent of which are of nature), she personally sees at least half a million slides a year and has been in the business for 33 years. Few people in the picture industry are as familiar with the realities of the marketplace.

Bibliography

The following listing represents an editor's sampling of helpful books and periodicals. In the main, it is a selection to inspire and educate the eye, a well-rounded dose of excellence, with a few practical titles added for balance.

Angel, Heather. *Nature Photography:* Its Art and Technique. London: Fountain Press, 1972.

Audubon. New York: The National Audubon Society.

Blaker, Alfred A. *Field Photography.* San Francisco: W. H. Freeman and Company, 1976.

Caras, Roger A., and Graham, Steve. *Amiable Little Beasts.* New York: Macmillan Publishing Company, 1980.

De Roy Moore, Tui. *Galápagos.* New York: The Viking Press, 1980.

Faulkner, Douglas. *This Living Reef.* New York: Quadrangle/The New York Times Book Company, 1974.

Freeman, Michael. *The 35MM Handbook.* New York: Ziff-Davis Publishing Company, 1980.

Gray's Sporting Journal. A quarterly publication. South Hamilton, Massachusetts.

Holmåsen, Ingmar. *Nature Photography.* New York: Ziff-Davis Publishing Company, 1979.

Hoskings, Eric, and Gooders, John. *Wildlife Photography.* New York: Praeger Publishers, Inc., 1974.

International Wildlife. Vienna, Virginia: The National Wildlife Federation.

Johnson, Peter. *As Free as a Bird.* Cape Town, South Africa: C. Struik Publishers, 1976.

Kinne, Russ. *The Complete Book of Nature Photography,* revised edition. New York: Amphoto, 1979.

Kodak Guide to 35MM Photography. Rochester, New York: Eastman Kodak Company, 1980.

Lariviere, Susan, and Schiffman, Ted. *Guide to Backpacking Photography.* New York: Amphoto, 1981.

Lefkowitz, Lester. *The Manual of Close-up Photography.* New York: Amphoto, 1979.

Line, Les, and Reiger, George. *The Audubon Society Book of Marine Wildlife.* New York: Harry N. Abrams, Publisher, 1977.

Line, Les, and Ricciuti, Edward R. *The Audubon Society Book of Wild Animals.* New York: Harry N. Abrams, Publisher, 1978.

Line, Les, and Russell, Franklin. *The Audubon Society Book of Wild Birds.* New York: Harry N. Abrams, Publisher, 1976.

National Geographic. Washington, D.C.: The National Geographic Society.

National Wildlife. Vienna, Virginia: The National Wildlife Federation.

Natural History. New York: The Museum of Natural History.

Nuridsany, Claude, and Pérennou, Marie. *Photographing Nature.* London: Kaye & Ward, 1976

Photographer's Market, The. Cincinnati, Ohio: Writer's Digest Books.

Photographing Nature, revised edition. Alexandria, Virginia: Time-Life Books, 1981.

Porter, Eliot. *Birds of North America.* New York: E. P. Dutton, 1972.

Ricciuti, Edward R. *The Peaceable Kingdom.* New York: Macmillan Publishing Company, 1979.

Russell, Franklin. *Wild Creatures.* New York: Simon and Schuster, 1975.

Scanlon, Henry. *You Can Sell Your Photos.* New York: Harper and Row, Publishers, 1980.

Shaw, John, and West, Larry. *Visions of the Wild.* Lansing, Michigan: Michigan Department of Natural Resources, 1980.

Sierra Club Calendars. New York: Charles Scribner's Sons.

Truslow, Frederick Kent, and Cruickshank, Helen G. *The Nesting Season.* New York: The Viking Press, 1979.

Index

Italics indicate photographs.

WILDLIFE PHOTOGRAPHY

Edited by Ann Guilfoyle, Jeanne Fredericks, Michael O'Connor,
 Sheila Rosenzweig, and Judith Royer
Interior pages designed by Nigel Rollings
Graphic production by Ellen Greene

Set in Baskerville by American-Stratford Graphic Services, Inc.

Printed and bound by Toppan Printing Company